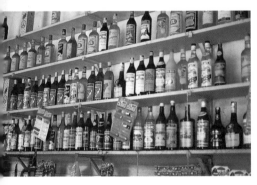

AMERICA STARTS HERE

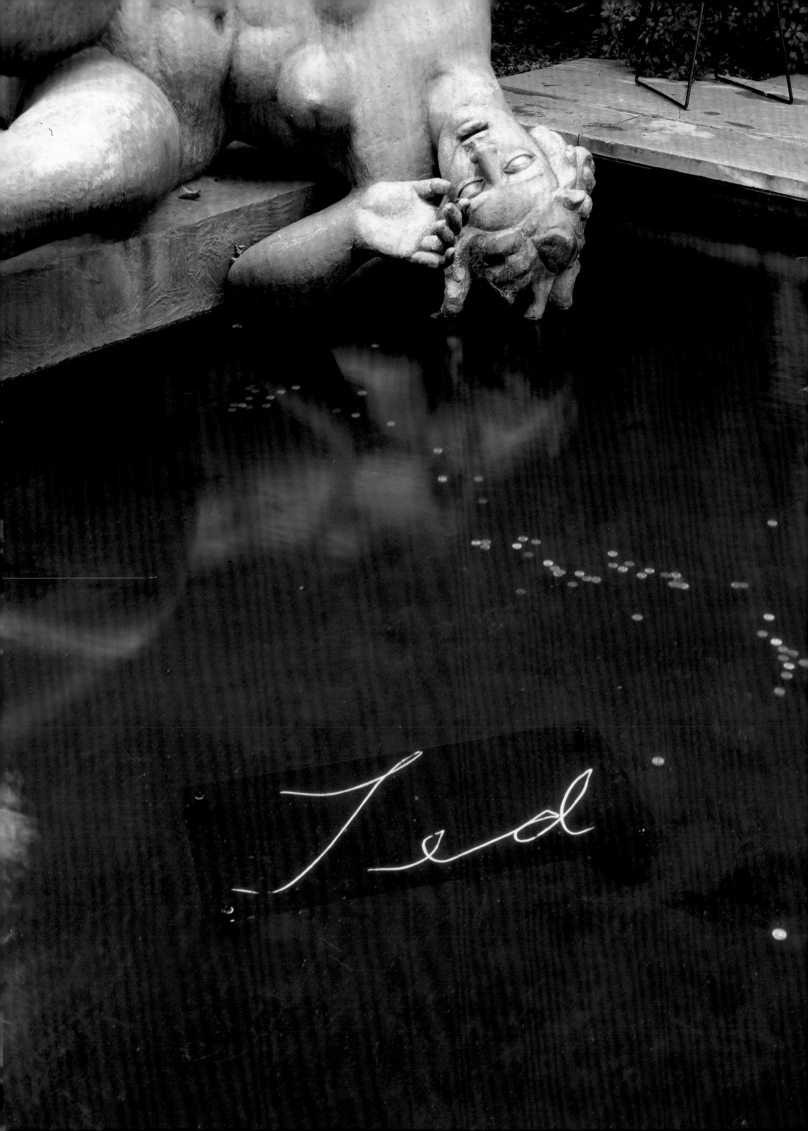

EDITED BY
Ian Berry and Bill Arning

WITH ESSAYS BY
Bill Arning, Judith Hoos Fox, Kathleen Goncharov,
Mary Jane Jacob, Patricia C. Phillips,
Lane Relyea, Ned Rifkin, Valerie Smith, and
Judith Tannenbaum

INTERVIEW WITH
Mel Ziegler by Ian Berry

AMERICA STARTS HERE

KATE ERICSON AND MEL ZIEGLER

The Frances Young Tang
Teaching Museum
and Art Gallery at Skidmore
College

- -

List Visual Arts Center
Massachusetts Institute of
Technology

- -

The MIT Press
Cambridge, Massachusetts
London, England

First MIT Press edition, 2005
© 2005 Massachusetts Institute of
Technology, The Tang Teaching
Museum and Art Gallery at Skidmore
College, and MIT List Visual Arts
Center

MIT Press books may be purchased
at special quantity discounts
for business or sales promotional use.
For information, please email
special_sales@mitpress.mit.edu or
write to Special Sales Department,
The MIT Press, 55 Hayward Street,
Cambridge, MA 02142.

Designed by Barbara Glauber and
Beverly Joel/Heavy Meta, New York

Printed and bound in Italy by
Conti Tipocolor

10 9 8 7 6 5 4 3 2 1

This catalogue accompanies the
exhibition
America Starts Here:
Kate Ericson and Mel Ziegler
Ian Berry and Bill Arning, Curators

- -

The Frances Young Tang Teaching
Museum and Art Gallery at
Skidmore College
Saratoga Springs, New York
October 1–December 30, 2005

- -

List Visual Arts Center
Massachusetts Institute of
Technology
Cambridge, Massachusetts
February 9–April 8, 2006

- -

Austin Museum of Art
Austin, Texas
February 10–May 6, 2007

- -

H & R Block Artspace
Kansas City Art Institute
Kansas City, Missouri
July–October, 2007

- -

Cincinnati Contemporary Arts
Center
Cincinnati, Ohio
November 10, 2007–January 13, 2008

Library of Congress Cataloging-in-Publication Data

America starts here : Kate Ericson and Mel Ziegler / edited by Ian Berry and Bill
Arning ; with essays by Bill Arning ... [et al].— 1st MIT Press ed.
 p. cm.
Catalog of an exhibition held at the The Frances Young Tang Teaching Museum
and Art Gallery, Skidmore College, Saratoga Springs, New York, Oct. 1–
Dec. 30, 2005, and at the MIT List Visual Arts Center Cambridge, Mass.,
Feb. 9–April 9, 2006.
Includes bibliographical references.
ISBN-13: 978-0-262-01228-7 (hardcover : alk. paper)
ISBN-10: 0-262-01228-6 (hardcover : alk. paper)
1. Ericson, Kate, 1955–1995—Exhibitions. 2. Ziegler, Mel, 1956—Exhibitions.
3. Artistic collaboration—United States—Exhibitions. 4. Conceptual art—
United States—Exhibitions. I. Ericson, Kate, 1955–1995. II. Ziegler, Mel, 1956-
III. Berry, Ian, 1971– IV. Arning, Bill. V. Frances Young Tang Teaching Museum
and Art Gallery. VI. MIT List Visual Arts Center.
 N6537.E75A4 2005
 709.2'273—dc22
 2005029193

**The Authentic Colors of Historic
Philadelphia**
1993
Latex paint, sandblasted glass
jars, antique wooden bench
25½ x 81½ x 12½ inches
Courtesy of Mel Ziegler, Austin,
Texas

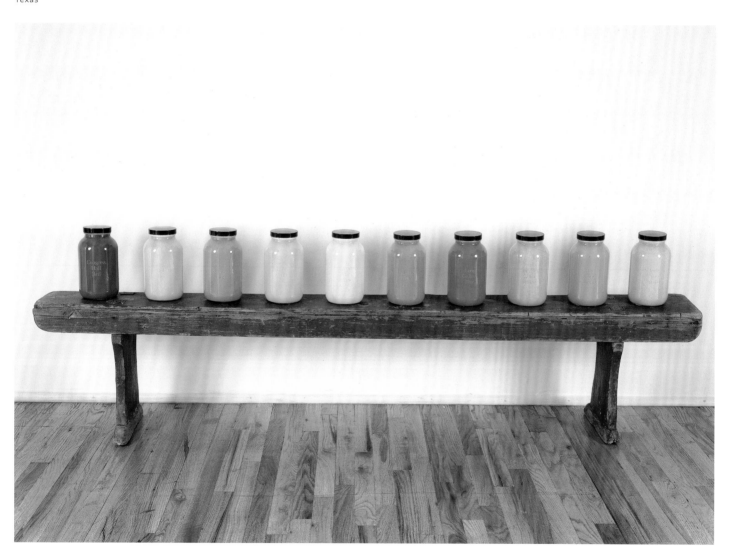

DIRECTORS'
FOREWORD

IT IS A PLEASURE AND A PRIVILEGE TO PRESENT *AMERICA STARTS Here: Kate Ericson and Mel Ziegler* at the Frances Young Tang Teaching Museum and Art Gallery at Skidmore College and the MIT List Visual Arts Center, and to publish the artists' work in such depth in this book. The originality and prescience of the work that Kate Ericson and Mel Ziegler made between 1985 and 1995 has never been fully registered, and this project was undertaken to fill this gap.

As *America Starts Here* reveals, as early as the late 1970s, Ericson and Ziegler were already thinking deeply about issues championed by a new generation of artists today. Their art is marked by a commitment to creating works that live in public and social space, an interest in collaborating with their audiences, and an understanding of the socially constructed nature of all sites. Likewise, Ericson and Ziegler's blend of the highly conceptual and the socially engaged is now an accepted mode of artmaking. Their projects were infused with a distinct and elegantly spare blend of analysis, serial form, language, and wry, understated humor that made their work uniquely successful and still relevant today.

As it quickly became clear to all of us involved with *America Starts Here*, no one but the artists themselves saw or even realized the full extent of their far-flung site-specific installations, projects and activities. And since much of Ericson and Ziegler's work was by nature uncollectible, institutions and collectors could and can only partially represent the range of their concerns through the exhibition of objects conceived for the gallery. As such, few critics, curators, scholars, fellow artists or other viewers could appreciate the breadth of their thinking. We believe, therefore, that this exhibition and catalogue will come as a welcome and engrossing revelation.

Our thanks to Ian Berry, the Susan Rabinowitz Malloy Curator of the Tang Museum, and to Bill Arning, Curator of the List Visual Arts Center, for their vision and effort in bringing *America Starts Here: Kate Ericson and Mel Ziegler* to fruition. Thank you to all of the lenders to the exhibition, and to our catalogue essayists. We extend our special appreciation to Roger Conover and everyone at The MIT Press, who joined with us to co-publish this fine catalogue. Our sincere thanks also to the staff of the Tang Museum and the List Visual Arts Center for their work on this project, and to our respective institutions, Skidmore College and Massachusetts Institute of Technology, for supporting our efforts.

America Starts Here: Kate Ericson and Mel Ziegler adds a vital, thought-provoking chapter to the record of twentieth-century American art. Our deepest thanks are extended to Mel Ziegler for his cooperation during every stage of this project and his unflagging willingness to revisit the work and life that he and Kate Ericson shared.

John Weber
*Dayton Director, The Frances Young Tang
Teaching Museum and Art Gallery
Skidmore College*

Jane Farver
Director, MIT List Visual Arts Center

FOR KATE

Kate Ericson and Mel Ziegler
working on *Loaded Text*,
Durham, North Carolina
1989

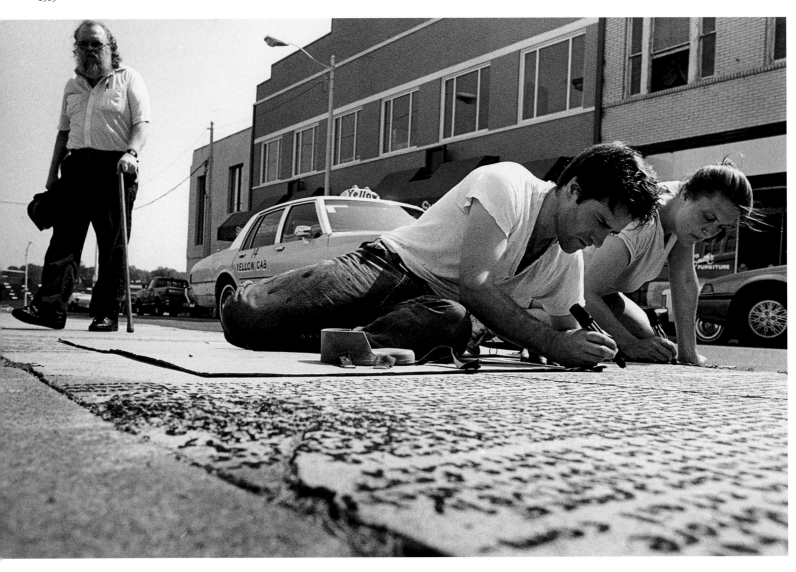

BILL ARNING

HISTORY OF A COLLABORATION

INTRODUCTION

THE TEN YEARS OF KATE ERICSON AND MEL ZIEGLER'S ACTIVE collaboration, 1985 to 1995, were extraordinarily rich and busy. They created nineteen major public works and scores of gallery- and museum-based projects, as well as many independent objects and sculptures.

When their collaboration began, conceptual art practices were consigned to the past, belonging to the previous generation; instead, young artists were encouraged to make big, funky paintings. The rules of the marketplace were strictly upheld, and unrepentant artistic ego emerged as a good career strategy intrinsic to art-making. New York's art world marked the focus of international art discourse and only Germany's advanced artistic milieu could compete with it on the world stage. The rest of the United States—with the possible exception of Los Angeles—remained virtually invisible as artistic producers, receivers, collaborators, and subjects. Americana-based iconography could only appear ironically, if at all. Political art limited itself to a confrontational mode most appropriate for crisis situations, and artists rarely worked within communities to achieve political or ethical goals. The idea that the benefits art produces should outweigh the resources it consumes, that any effects a work creates should be social improvements, or that artworks could disappear completely yet still maintain their artistic value was almost totally unheard of.

But by 1995, when Kate Ericson and Mel Ziegler's collaboration ended with Kate's tragic and premature death, the conditions of cultural production had radically shifted. Ericson and

Ziegler's works were a catalyst for those changes, as well as participants in a larger cultural shift. Their work deftly illustrates a crucial time of flux in conceptual and political art practice. For this reason, a careful investigation of Ericson and Ziegler's practice may help to clarify the origins and intellectual framework of much current cultural production.

Those in the art community who watched Ericson and Ziegler's projects as they unfolded remain fierce supporters of the work, continuing to refer to it in lectures and articles. Yet many younger artists have never experienced their projects in person and cannot fully apprehend what they accomplished from merely seeing their names as footnotes in conceptual and public art literature. Access to this work seems more important now than ever, when contemporary art discourse has again turned toward collective art practice and community-engaged initiatives. While the degree of Ericson and Ziegler's influence remains conjectural, the prominence of much-discussed projects like Utopia Station (curated by Rirkrit Tiravanija, Molly Nesbit, and Hans-Ulrich Obrist for the Arsenale at the 2003 Venice Biennale) suggests manifestations of a visionary discourse that emerged as a direct result of Kate Ericson and Mel Ziegler's efforts.

Ericson and Ziegler's projects vitally bridge the conceptual and political art of the sixties and early seventies, and the return to conceptualism in the late eighties and early nineties. They learned from conceptual art pioneers such as Michael Asher how subtle interventions into found situations could create a great impact, and from Douglas Huebler how humor and a focus on "regular folks" could make rigorous conceptual work experien-

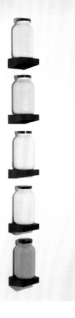

Statue of Liberty
1988
Latex paint, sandblasted glass jars,
metal shelves
Five jars: 8½ x 5 x 5 inches each
Overall dimensions: 63 x 5 x 5 inches
Collection of Michael and Leslie Engl

Paint was matched to the major color
areas of the Statue of Liberty on Liberty
Island, New York Harbor. The commercial
names of the paints were sandblasted
onto glass jars. The three lower paints
represent levels of the building,
museum, and base structures of the
statue, while the penultimate green
layer corresponds to Lady Liberty's body
and the gold to her then-recently
restored torch.

tially richer and more resonant. Like the Earthworks pioneers, they adopted the whole country as their working space, but not to challenge previous art practice around issues of "scale" as Robert Smithson, Michael Heizer, and others had done in a masculinist mode. Rather, Ericson and Ziegler engaged the country as a beautiful patchwork of poetic narratives and histories awaiting excavation, as writers such as the landscape philosopher J. B. Jackson had done in the sixties. In today's art practice, Mark Dion's archeological investigations, Felix Gonzales-Torres's freely available works, and Jim Hodges's projects with collected signatures, to name but a few, extend discourses first explored by Ericson and Ziegler.

The kind of enterprise Ericson and Ziegler undertook is highly resistant to museumification and historicization. The functional aesthetic of their work incorporates into its foundational logic transience, ephemerality, site-specificity, and the recognition that certain pieces have particular, non-interchangeable local audiences. Though Ericson and Ziegler's objects are beautiful and crucial aspects of their work, they tell only part of the story. But since museums bear the charge of telling stories via objects, it is those objects and accompanying gallery installations that are necessarily over-represented in exhibitions of their work. This catalogue is an attempt to remedy that situation by assembling the panoply of participants' voices, the results of Ericson's and Ziegler's project-researches, and descriptions of vanished works to complete the story that future students of art should have at their disposal.

I use the word "story" in full awareness of how narrative constitutes hazardous territory in discussing art, since a good story can overwhelm the work under discussion. Yet with Kate Ericson and Mel Ziegler stories become crucial. In their most significant works the final presentation state—the form viewed at the opening night celebration—is only one stage among many, with each playing a crucial role in the larger construction of meaning. In the last decade institutions have bravely tried to mount retrospectives of artists whose work is essentially time-based, and have needed to think outside of standard museum practice in

order to do so. Ericson and Ziegler's work belongs to this ephemeral, time-based category, despite the many handsome, relatively stable objects they produced.

Any re-creation or representation of Ericson and Ziegler's projects for new audiences in new locales will, by the nature of the work, misrepresent them to some degree. They consistently made work that challenged institutional norms. Their work remains a stretch for museums or art spaces, with features such as wall paint, liquids, smells, and dirt included in their objects, in addition to the challenge of presenting works that no longer physically exist. Yet their installation demands no longer appear as strange as they once did. As the first-person narratives in this volume make clear, once institutions made the commitment to stage an Ericson and Ziegler exhibition, in most cases the staff enthusiastically greeted the unusual demands on their time and energy. Ericson and Ziegler displayed energy, personal commitment, and a willingness and desire to share the limelight with those assisting them. These qualities made developing and implementing projects a positive experience for all participants.

Many of Ericson and Ziegler's main themes and methodologies emerge clearly, at least in retrospect, in the major works from the early years of their collaboration. The list of strategies Ericson and Ziegler used to make artworks seemed very unusual at the time, though today's young artists regularly employ these methods, which include the following: **1**) Researching arcane areas of knowledge and pursuing a passion for the aura of the archive; **2**) Using mapping and other similar ways of schematizing life; **3**) Creating a system that dictates all significant visual decisions about a work's presentation; **4**) Employing found elements rather than causing something new to be made; **5**) Viewing the entire country as a text to be read, engaged, and decoded; **6**) Using natural materials, like stone, leaves, and water, as they are inflected or coded by culture; **7**) Critically engaging decoration and architecture for what they reveal about society; **8**) Using Americana as topic, material, or motif; **9**) Engaging cultural institutions, museums, and monuments, such as the Supreme

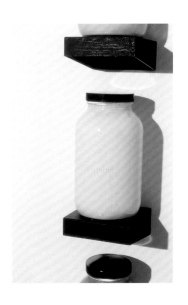

Court, libraries, and universities; **10**) Investigating governmental decisions about urban space and making them public; **11**) Collecting and collating found language, which can subsequently function as a type of found poetry; **12**) Using the practical business decisions of others as a structuring device for works; **13**) Designing projects so they exist in multiple states, each of which creates meaning, from the first research to the final use of materials; **14**) Inserting delays into a process that unnaturally extends the in-between period of a simple task such as landscaping or cleaning, rendering otherwise invisible processes conspicuous and examinable; **15**) Allowing works to disappear through transformation, making them cease to be "art" and instead begin to fulfill a useful function; **16**) Cooperating with people outside the specific disciplines of the art world in a way that gives them a non-artistic reason to participate; **17**) Choosing to work with each other as collaborators.

In retrospect, Ericson and Ziegler's becoming a collaborative team seems inevitable. As independent artists and individuals, their trajectories seemed destined to intertwine. But it behooves us to remember that this joining occurred slowly. Their time in each other's immediate orbit before explicitly becoming "Kate Ericson and Mel Ziegler" lasted almost as long as the period of their collaboration. This collaboration is also a love story between two like-minded artists. Despite the apparent inevitability of their pairing, their slowness to officially join forces testifies to each half of an artist-couple's need to fiercely protect his or her individual artistic autonomy.

Artistic collaboration denies the myth of the solo artist working best when unencumbered by others' input. Working with others entails a significant decision, and collaborative authorship becomes part of the works' meaning. For Kate Ericson and Mel Ziegler the process was much more organic. Each had developed working methods requiring cooperation with others, and neither wanted to compete with the other for commissions and exhibitions. As a couple, they discussed every artistic decision, so clear demarcations of authorship had disappeared well before they became "Kate Ericson and Mel Ziegler."

1976–1984

Kate Ericson and Melvin Ziegler met in 1976 when Kate Ericson was an undergraduate studying painting at the Kansas City Art Institute and Mel Ziegler was studying sculpture at the Rhode Island School of Design in Providence, Rhode Island. Mel transferred to Kansas City the following year, and within a year the two began dating.

Many characteristics of the couple's later work together first emerged in Kansas City. It was there that Ericson learned to negotiate with people who had no interest in or experience with art. She wanted to produce work in the area quarries, and found that her vivacious personality could persuade the most dubious business owners to help her achieve her goals. At the same time, ready-made industrial products featured prominently in Ziegler's works. An interest in manufactured materials and the value of manual labor surfaced in many of their individual undergraduate works.

Ericson and Ziegler presented their thesis show as a collaboration. Ericson had been working with coal chutes and Ziegler with wall-like structures, so they installed these objects together. This temporary, situational sculpture referred to the history of a specific building on the campus of the Kansas City Art Institute. Vanderslice Hall, which housed all of the administrative offices of the school, had once belonged to the family of August Meyer, a wealthy industrialist who had made his fortune in mining interests. Ericson and Ziegler installed their coal chutes and corrugated aluminum walls in front of this building, juxtaposing and contrasting their industrial object with the elaborate and somewhat ostentatious Queen Anne-style façade. With this undergraduate work Kate Ericson and Mel Ziegler had already begun to consider the particular economic, social, political, and literary history of a place as a way to generate art.

Ericson and Ziegler shared an attraction to the grand nature-challenging scale and industrial materials recently explored by the artists associated with Earthworks and large scale Post-minimalism, especially Robert Smithson, Gordon

Matta-Clark, Mary Miss, and Alice Aycock. In particular, the ghost of Smithson hovers over many of their early works. Kate Ericson created *Rock Extension* in 1979, in which a classic stone wall that might normally encircle a house instead intrudes through the home's center, like a domesticated, scaled-down version of Smithson's *Spiral Jetty* (1970).

Despite the commonalities between their projects and works by the Land artists, Ericson and Ziegler never worked in a landscape as wild as that of James Turrell's *Roden Crater* (begun 1972—ongoing), and they felt uncomfortable with the self-mythologizing in which that group indulged. The Land artists worked in areas of the country difficult to access. They required viewers who wished to experience their works to make grueling pilgrimages, enhancing the artists' status as mythic cowboy-seers, a role as clichéd as that of the swami on the mountain peak. Because they mostly picked unpopulated sites, the Land artists could use them as *tabulae rasae*, with no need to consult history or community. For Ericson and Ziegler such a landscape had no appeal. What made places interesting for their purposes was the thickness and complexity of the local human history.

Ericson and Ziegler found a corrective to the cult of remote sites and untouched nature in the great writer of the American landscape, J. B. Jackson. Jackson founded and edited the influential journal Landscape, which was published three times annually from 1951 to 1971, and then intermittently until 1974. In the writer's New York Times obituary in 1996, William Grimes wrote, "For nearly fifty years he roamed the nation, surveying field and forest but also registering the changes wrought by human beings, regarding it as a kind of language." Grimes quoted Jackson as saying that for him "the beauty of landscape derives from the human presence."[1] Along with their later reading of John Stilgoe, who was also known for going out into the landscape and decoding the complex histories embedded in simple things like the design and placement of gates and sheds, Jackson provided a strategy for Ericson and Ziegler to work with the American landscape. This methodology allowed them to make works that were poetic in a matter-of-fact way, like conceptual art versions of Walt Whitman's poetry.

Even in their youthful years, Ericson and Ziegler's works were always tempered by a generous spirit and a dry wit. Kate's experiments with grand scale, such as *Twin Towers* and *Suspended Brick Wall* (both 1979), were already subtly subversive of the Land art tradition, partly because she was a woman playing a masculine game, like Miss, Aycock, and Nancy Holt before her. In *Suspended Brick Wall*, Ericson created the surreal spectacle of a brick wall hovering in space, tweaking the most macho artists' preoccupations with moving great weights. The grid of bricks is reminiscent of a Carl Andre sculpture, but Ericson wanted to change Andre's taciturn statement into something magical. The work was realized at the Austin campus of the University of Texas only after the frustrated Ericson could not receive the official go-ahead for her proposal. She coerced her way into the university president's office by claiming to be bearing his love child, adding to the comic spectacle of Ericson's phallic power grab implicit in the work.

After graduating from KCAI, Ericson and Ziegler moved together to Houston. There Mel convinced the owner of a normal home in a sedate and conservatively-hued neighborhood to let him paint his house a vivid red for *Red House* (1979). Ziegler made large, dramatic works with the tools of a decorator, and his sense of humor allowed him to tear open the suffocating web of normality that governs daily life.

In these early solo works, the *modus operandi* that characterizes the artists' later work came into focus. To find a home they could bisect with a stone wall or paint bright red, they needed to find people outside the art world willing to see their lives upturned and their homes made into spectacles. The artists would contact communities with advertisements in the local paper or written solicitations slipped into mailboxes. They found that participants were even more agreeable if their engagement provided them something of value, such as landscaping or a paint job. Though always cash poor, the young artists had their construction and painting skills to offer. And while in SoHo in the late seventies painting one's naked body red and lying down

on West Broadway might be required to garner any attention, in Houston, Texas, Ericson and Ziegler's more modest provocations would attract significant newspaper and television coverage. The media helped to identify many of the anomalous situations the artists staged as art projects.

Significant ethical issues arise in making art within the fabric of people's everyday lives. Working within communities, and with socially necessary resources such as homes, requires that artists remain self-critical at every stage of the process. Artistic acts that render homes uninhabitable, for example, could incite anger unless, at the end of the process, more homes became available, or some other tangible benefit materializes. To restrict a public project's benefit to art world concerns—the delectation of conceptual art enthusiasts, the stroking of artistic ego, or career advancement—would be indefensible. Ericson and Ziegler addressed these hard questions by creating works that left the situations they encountered better places.

In 1979, Ericson and Ziegler decided to attend the California Institute of Arts in Valencia. They applied to pursue sculpture, rather than post-studio practice, an emerging specialty at the school. CalArts was developing a reputation for producing fully formed artists ready for the art world, well-connected and aware of art world politics, but also with a solid grounding in cultural theory. A friend had recommended CalArts as the place to learn about Conceptualism, but neither Ericson nor Ziegler knew the faculty, then dominated by three major conceptual artists—Michael Asher, Douglas Huebler, and John Baldessari.

John Baldessari was CalArts' philosopher prince. Ziegler recalls him listening intently for long periods of time during seminars as his charges discussed their work, and then muttering a few cryptic, often brilliant words, oracular announcements the students would spend the next hours deciphering.

Michael Asher remains today one of the least understood and least appreciated of the great American artists who emerged during sixties Conceptualism. His work rigorously investigated the specific conditions of particular cultural sites where he had been invited to intervene. Like Asher, Ericson and Ziegler explored

strategic relocations, removals, and durational extensions throughout their working career. But although these strategies characterize much of their later works, the artists had already explored these unusual art-making strategies prior to coming to CalArts, in projects such as *Red House* and *Rock Extension*. Rather than a case of young hungry artists absorbing the master's wisdom and then needing to fight their way out from under his influence, they found in Asher a perfect match who licensed the type of activities they had pursued on their own in Kansas City and Houston. Not surprisingly, Asher took Mel Ziegler on as his teaching assistant, and also became Kate Ericson's mentor.

Douglas Huebler also belonged to the celebrated first wave of conceptual artists. His works employ the conceptual strategies of setting up systems, writing out instructions, and following them with seeming disregard for the visual outcome. A typical description of a work reads, "With Eyes Completely closed the photographer sat on the corner of Vanderbilt Avenue. Each photograph was made at the instant that the sound of traffic… stopped."[2] His text and document works, while rigorous in their structure, do not avoid emotional resonances. Kate Ericson and Mel Ziegler's work, like Huebler's, often foregrounds its humanity.

While attending CalArts, Ericson and Ziegler each devised many solo projects outside the school environment and became more entangled with each other. In *Front Lawn* (1981), Ziegler suspended the front lawn of a house in mid-air for a month. A new homeowner, who had not put down sod for financial reasons, was happy to participate in this project. This process functions similarly to Ericson's earlier *Rock Extension* in its simple shifting of an unremarkable home design element to give it a surreal or uncanny quality, like a house sized-version of Meret Oppenheim's fur tea cup, *Object* (1936), infused with a profoundly memorable uselessness.

Front Lawn, like *Red House* before it, challenged the idea of normality within a neighborhood and every homeowner's desire to fit in with but also stand out from the neighbors. The tiny lawns of many urban homes serve little function: they are too small for picnics, barbecues, or games. They function only as a

Public project for Pioneer Street
Station, Seattle Transit System,
1985

The artists built clocks from
materials excavated when construct-
ing the new subway tunnels and
materials used in the construction
of the new stations. Workers' tools
from different trades became the
clocks numbers.

performance of normality. *Front Lawn* de-naturalizes lawns, those strange hybrids of nature and culture. A lush green lawn might replicate the comforting color and smell of nature, but in actuality commercial sod's rolled-sheet form more closely resembles a carpet. (Additionally, *Front Lawn* foreshadows Kate Ericson's 1984 sculpture for Art on the Beach, wherein she covered a section of sandy landfill with preternaturally and perpetually green indoor/outdoor carpet.)

Front Lawn also invites the viewer to examine how natural materials decoratively coat human constructions—in this case the property surrounding a house—to disguise their social constructedness. The ground under that lawn is not only a commodity as "property," but also something sacred as "land." The fiction of "land" becomes harder to maintain when property lies under asphalt rather than sod.

Meanwhile, Kate Ericson was exploring other aspects of the home as commodity in *House Sign* (1981). She constructed a blank wooden sign in the shape of the silhouette of a typical ranch house. She installed the piece twice, once in front of the house whose silhouette it described, and again a few months later, with the backdrop of a high-rise subsidized housing block. In the initial installation, one particular vantage point left the ranch house completely blocked by the sign, thus becoming a physical manifestation of the semiotic substitution of a sign for its referent. With its billboard-like construction, *House Sign* constituted a strangely minimal advertisement for new homes of the "if you lived here you would be home by now" variety. Such advertisements frequently feature seductive images of the "good life" that awaits you in the new housing development, usually ornamented by splashes of natural green as in Ziegler's raised front lawn. Here Ericson reduced the concept of "home" to a shape that is blank except for the natural wood grain, alluding to the sign's being made from wood, the potential building material for a home, a material-based theme that recurs throughout their career. She gambled that the desire for "home," whether cultural or instinctual, was strong enough to be triggered by this blank ideogram.

Ericson and Ziegler relocated to New York in 1982. Once there, Kate was invited to install a piece in the window of the New Museum of Contemporary Art, while Mel went to work as assistant for Dan Flavin, an artist known for his elegant arrangements of light produced by commercially available fixtures.

During their first year in New York, Ziegler's artworks explored the nominative function of the artist: to make art by locating and naming a situation without altering it, a strategy derived from Duchamp's ready-mades but also identified with Michael Asher's work. While still a student, Mel had exhibited a self-storage space as a found sculptural environment by merely opening the usually closed and locked doors, and exhibiting his lease for the space at the school gallery. In New York, he identified three quotidian objects as a work. With no immediate leads as to how to crack the New York art world, Ziegler noticed a yellow bulldozer, red trailer, and blue bridge within blocks of their Chinatown loft. He printed the words "YELLOW BULLDOZER," "RED TRAILER," and "BLUE BRIDGE" on heavy card stock, along with a fourth card detailing the location of this random constellation. These packets, each with four cards, were then mailed to approximately 150 people. By identifying his colors through these three large objects, Ziegler announced the palette he would use to make art for the foreseeable future: the real world.

In another audacious move, Ziegler did a series of works involving the claiming of space by parking trucks in public spaces. For *Pastellus* and *On Broadway* (both 1984), he rented a box trailer and painted it in unusual ways, black and red stripes for *On Broadway* and various pastel hues for *Pastellus*. He parked the vehicles in conspicuous sites. *Pastellus*, parked without a permit on Wall Street, across from the New York Stock Exchange and in front of the Federal Hall sculpture of George Washington, was towed away in the middle of the second night. Frederieke Taylor of the Lower Manhattan Cultural Council helped Ziegler obtain a permit for *On Broadway*, and the piece stayed in its very public site for a weekend. Its red and black bands served as a type of abstract camouflage, mimicking the colors of the Skidmore, Owings, and Merrill office building, designed by Gordon Bunshaft, and the bright red Isamu Noguchi

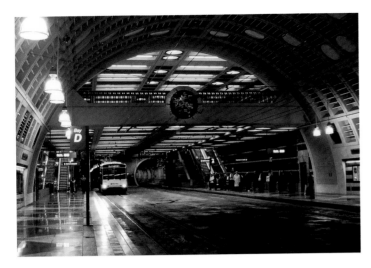

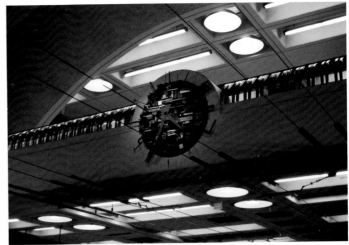

sculpture, *Red Cube* (1968), located at 140 Broadway.

These two works were public art, located on busy urban thoroughfares linked to American history, economics, and business. They attest to a more innocent time, when an oddly painted truck in a public parking space would not spark fear of a bomb inside. Parked vehicles create crisis points between the public and the private. When legally parked each car or truck becomes a little island, a private domain within the public sphere, and such explorations of boundaries and limits attracted Ericson and Ziegler.

Ziegler's *Instant Landscape*, presented as part of one of Artists Space's *Selections from the Artists File* shows, used similar exhibition logic. Ziegler's work, a flatbed truck loaded with eighty juniper trees, sat outside the exhibition space on West Broadway. Each tree had its roots wrapped in soil balls, ready for planting. Just as *Front Lawn* used suspension in a literal sense, *Instant Landscape* unnaturally extended the in-between status of plants raised in nurseries. The artists explored this strange and unnatural situation once more in their collaborative *Unplanted Landscape* (1985), for which they arranged plants in their soil balls on a Long Island suburban lawn for a month. Casual viewers of both works would assume they were witnessing a stage in the landscaping process.

In *Instant Landscape*, *Front Lawn*, and *Unplanted Landscape*, Ziegler also destabilized one of the more powerful metaphors concerning plants in human environments, that of rootedness. The fact that a large tree does not meander gives it unique power. It stands as a marker of place, a witness of one location over time, something that makes a spot unique while all human creations appear transient. A landscape wrapped for transport creates anxiety for a generation already feeling ungrounded and alienated from the values associated with land, family, place, and the natural order.

With their roots wrapped in soil balls, the abstract formal qualities of plants become more apparent, making them sculptures of themselves. The way landscape architects arrange plantings on a particular landscape involves a similar abstraction: the plants seem no longer living or unique, but endlessly reproducible elements.

Kate Ericson had been invited to participate in the same show at Artists Space but chose to situate her work indoors. On a section of the floor, she installed standard wood flooring cut to form the silhouette of George Washington as derived from a sculpture depicting the first president in Roman garb. This piece continued her investigations of façade-like structures and outline form begun in House Sign, enlisting the absent presence of a public monument.

Artists Space had selected Ericson and Ziegler as independent artists. In retrospect we can understand that the division of Artists Space's Tribeca location—the sidewalk and the floor—was a proto-collaboration; the couple realized working together just made sense.

The face of public art began changing in the early eighties. "Plop Art," dropping artworks into public situations without prior discussion with the affected community, had come to be seen as an arrogant recipe for disaster. Instead, the idea of artists, architects, and communities working in concert became the new paradigm. The Seattle subway system sought such collaborations and selected Ericson to create a project. Ziegler had applied for the project as well, and after many late nights debating their next course of action the two officially decided to become "Ericson and Ziegler."

- - - - - - - - - - - - - - - - - - - -
1985–1990

Ericson and Ziegler's Seattle subway project, *Traveling Stories*, differed greatly from their later works in formal terms but still used some of the strategies for which they became known. On the sidewalk outside the subway system's passageways they installed medallion-like silhouettes of Seattle residents, most, but not all of them, lesser-known figures. On the stairways risers they inscribed quotes dealing with movement, beginning their tradition of anthologizing multitudinous voices in a Whitmanesque celebration of the poetry of the common folk. The

project also added two clocks to the Pioneer Street station, one made from the materials used to the build and renovate the station, another from the material originally excavated while the station was being built: old cobblestones, cast iron pipe, rough granite, and brick.

In 1986, *House Monument* took place in Los Angeles at the invitation of the Los Angeles Institute of Contemporary Art (LAICA). A number of the themes and methods that first appear in *House Monument* remained significant for the artists, such as the collection of words from many sources, the transformation of material through multiple states, and its culminating disappearance as art. It remains one of their best-known projects, largely because *Artforum* used it as a cover image to illustrate an article by Patricia C. Phillips on public art.[2] This moment of early celebrity makes clear that these savvy artists understood the need for powerful photographs of their artworks—often made at their own expense—to document their far-flung locations and disappearing objects. *House Monument* circulated within art world discussions well beyond the people who saw it at LAICA.

Issues of upkeep appear in *Half Slave, Half Free* (1987). For that work, Ericson and Ziegler paid a private homeowner to not mow half of his property, and photographs document the strangeness of his bisected lawn. This work also raised the specter of normality that Ziegler had first made visible in *Red House*. The artist reports that the homeowner quite enjoyed the consternation of his neighbors at his semi-unkempt property. A few years later they revisited the strategy by asking Swiss Rail to leave one half of the façade of a Swiss train station uncleaned for *Half Monument, Half History* (1991).

If Landscapes Were Sold (1987) was staged at Diverse Works, Houston's alternative arts space, then located in a marginal area of the city's downtown business district slated for redevelopment. In this work Ericson and Ziegler added two important elements—color and an engagement with local politics around real estate.

Artists and artists' spaces tend to revive abandoned urban spaces so successfully that the artists themselves get priced out.

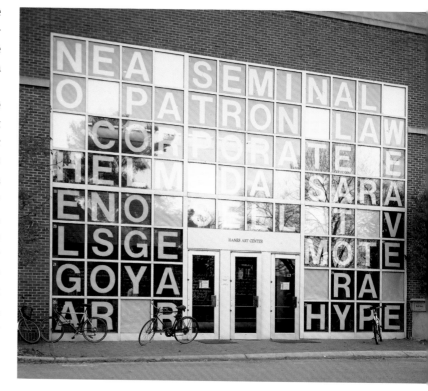

Collaboration with students,
University of North Carolina, Heinz Art
Center, 1988
Interior/exterior crossword puzzle
based on current events

Heinz Art Center, 1988,
interior view

The situation in Houston was a complex version of that old story. When Ericson and Ziegler lived there in the late seventies it had been a boomtown exploding with new building projects. With the oil bust of the early 1980s all that stopped.

The artists were fascinated by all the new buildings produced in the corporate style of the day, a brightly colored and extremely optimistic architecture. By the late eighties that optimism seemed naive. Taking a color chart out to what Ziegler today describes as an Emerald City ghost town, they color-matched all the buildings in the central business district and ordered a gallon of paint in each color. They displayed the paint cans in the gallery in the form of a map of the city's buildings, leaving the lids off to view the colors. The new paint smell filled the space and typified an area booming with positive changes and civic betterment.

They also replaced the windows of the old school building that housed Diverse Works with tinted and mirrored glass that matched the new glass of the downtown corporate buildings. (Replacing windows as a combined civic improvement and art project resurfaced the next year in *America Starts Here* at the Institute of Contemporary Art in Philadelphia.) In Houston, the artists sandblasted the replaced windows with outlines of mountain peaks and poisonous plants, referring to a landscape very different from the one outside the window. The combination of these landscape elements provided a commentary on the complexities of the relationships between arts groups and urban and corporate economics, and the dangerous seduction of speculative real estate.

Real Art Ways, Hartford, Connecticut's alternative arts space, faced a similar gentrification dilemma in 1989. The building's owner, Oak Leaf Development Corporation, had originally received tax breaks to house the revered yet needy arts space, but now wished to reclaim the building. Ericson and Ziegler responded by producing an unlimited edition of doormats cut in the shape of oak leaves. Selling this low-cost, functional edition to people who otherwise could not afford art contributed to the work's meaning. Each leaf was stenciled with the scientific name of the White Oak, *Quercus alba*. Connecticut's foundational narrative includes the story of the Charter Oak, a majestic hollow tree where colonists hid the state's charter from the agents of England's King James II in 1687. The work thus resonated with Real Art Ways' history-minded Connecticut audience through its air of revolution and liberty.

Ericson and Ziegler added one more layer by titling the work *Hollow Oak Our Palace Is*. The line comes from a poetic sea shanty written by Allan Cunningham (1784–1842), "A Wet Sheet and a Flowing Sea," which tells of the romance of leaving civilization behind.[3] Cunningham was an early English settler in Australia and an eminent botanist, memorialized in the scientific name of a species of pine tree (*Araucaria cunninghamii*).

All these layers of literature and history would appeal to only the most curious members of the audience. More casual viewers experienced a sea of welcome-mats in leaf shapes, conjuring the twinned concepts of home and the outdoors. In this case "home" meant a new site for cutting edge art in Connecticut: the mats sold at twenty-five dollars each to raise money for Real Art Ways' move.

Ericson and Ziegler also addressed notions of home in *Picture Out of Doors* (1988), a project for a show called *The Home Show* at California's Santa Barbara Contemporary Arts Forum. Inspired by the well-regarded 1986 *Chambres d'Amis* exhibition curated by Jan Hoet in Ghent, which invited artists to work in private homes, *The Home Show* attempted to translate that provocative curatorial framework to an American environment. The instructions for *Picture Out of Doors* were simple: "Remove every interior door in a private house and stack against a wall." It was surprising to learn how many doors a typical house contains, and to experience the psychological resonances when those doors are removed. Indeed, in every house messes are much easier to deal with when one can close the door and conceal them, even to oneself and one's housemates. The curatorial premise explicitly envisioned all the indignities and intrusions of strangers wandering through private homes.

In their artist statement, published in the exhibition catalogue, Ericson and Ziegler foregrounded the discomfort of view-

ers forced into voyeurism. The same framework allows for voyeuristic pleasures too, as anyone who has spent a Sunday visiting open houses without an actual intent to purchase a new home well understands. The homeowners, David and Pat Farmer, focused in their statement for the catalogue on their experience of their home suddenly made strange and admitted their nervous response to tidy and artfully arrange heretofore hidden spaces.

- -
THE MUSEUM OF MODERN ART

Though never interested in the solipsistic enterprise of making art about art, Ericson and Ziegler did, however, want to investigate power relations, specifically the ways art institutions manifest their power. One particular art location served as a major catalyst for their thinking. The artists created three major works about New York's Museum of Modern Art: *Signature Piece* (1988), *Leaf Peeping* (1988), and *MoMA Whites* (1990).[4] They made the first for exhibition at the museum itself, while the other two entered MoMA's galleries by invitation for a later exhibition, *The Museum as Muse*. Although each offered criticism of the institution, Ericson and Ziegler made their mode of institutional critique loving, non-hierarchical, and sometimes quite funny. Also, as opposed to the somewhat splenetic form of institutional critique popular during Ericson and Ziegler's early career, they always understood that an institution like MoMA invited critique precisely because it had succeeded in becoming a beloved component of the same art system in which Ericson and Ziegler were working. To pretend that they did not need or desire the institutional stamp of approval MoMA offered would have been disingenuous. An invitation in 1987 to present their work in MoMA's influential *Projects* series led the team to dig deep into the specific text of the Museum of Modern Art.

The works Ericson and Ziegler created took the arrangements of trees in the sculpture garden, the white paint on the walls of the galleries, and the design products and labor used in MoMA's 1980s renovation as catalysts that allowed interested viewers to reconsider the museum's seamless production of exhibitionary power. Below the radar of most architectural writers on the museum, each of the design decisions reframed by Ericson and Ziegler had a pervasive effect on the experience of high modern art the museum delivered.

Signature Piece left the newly finished Projects Room adjacent to MoMA's main lobby largely empty, except for a few signature signs and a rack holding the accompanying exhibition brochure. The artists took the room as a starting point in physical, conceptual, and visual terms. Working outward from the location of the room into its immediate environs, Ericson and Ziegler catalogued building materials and hardware installed at the museum. They contacted manufacturers and service providers who worked on elements of the space, such as the exhaust vents, smoke detectors, and door handles. After the recent renovation (1980), these functional fixtures in the exhibition space were still new, and their manufacturers and installers traceable. Ericson and Ziegler asked the service providers to nominate an employee who had significantly contributed to the manufacture of the products used in the room, and to have that employee sign and return a card provided by the artists. The signatories received fifty dollars from Ericson and Ziegler's exhibition budget.

Ericson and Ziegler then enlarged the signatures and silkscreened their first names in white on clear Plexiglas. They placed the plaques on the objects to function as labels, though what was being attributed was sometimes in doubt, since it might refer to one of many functional objects nearby. What was being attributed to "Thomas" or "Diane" could often be subject to conjecture. The workers' first and last names appeared in the brochure, along with more complete descriptions of what they had signed, such as "Door: Arthur J. Oliver" and "Chair: Jim Hill." The brochure became a significant part of the piece. The artists felt that it was there that the craftspeople's full names belonged, while the plaques testified to the comradely spirit of workers on a team, calling each other by first names.

Art museums like MoMA are heavily invested in systems of attribution. Labels never appear far from objects meant to be

seen. An unlabeled object in a museum context remains below the horizon of visibility. MoMA object labels at the time used upper case typography to emphasize last names—for example, Pablo PICASSSO. The labels functioned as remedial lessons in classic art-speak, referring to artworks and artists by last names only: "This Picasso is a fine example of analytic cubism," which rendered both "Pablo" and "a painting by" as unspoken and superfluous. The only other names on the walls of the museum are the names of benefactors formally inscribed on plaques and signs.

The author-function given to Ericson and Ziegler's signatories was deliberately confused by the use of facsimile reproductions of handwritten signatures rather than the house-style typeset version of museum labels. This decision recalls the fact that artworks are almost always hand-signed, and the nature of those signatures becomes crucial for proving authenticity. Artists have signed artworks since the late medieval-early Renaissance period. The practice developed specifically for trading on the reputation of particular artists' workshops to increase sales, functioning more as a product brand-name offering assurances of quality than as a claim to the modern author-function of a unique, highly individuated sensibility.[5]

The Projects Room stood near MoMA's Abby Aldrich Rockefeller Sculpture Garden and offered views out to that beautiful space. Ericson and Ziegler located many of their signs outside in the garden and even placed some across the street on the facing building. In leaving the museum's boundary, Ericson and Ziegler anticipated the Mexican artist Gabriel Orozco's MoMA *Projects* work from 1993, for which he placed fresh oranges in the windows of private apartments across the street.

With *Signature Piece* the artists were already considering the special dynamics of the MoMA garden within the whole structure of the museum. For *Leaf Peeping*, Ericson and Ziegler matched the colors of autumn leaves from each of the garden's significant trees. They mixed liquid paint to match the leaf colors and put it into clear glass jars. Each jar was sandblasted with the shape of the leaf whose color matched the paint and stood on a small metal shelf, like a scientific specimen. The configuration of the shelves on the gallery wall mapped the location of each tree in the garden.

Many of Ericson and Ziegler's main themes operate in this project, including mapping, color matching, and specimen display, which were among their favorite means of conveying the information gathered in their researches. By matching the leaf colors and displaying the paint in all its vibrant glory, Ericson and Ziegler's *Leaf Peeping* resembles a large diagram for decorating in autumnal colors. This trace of the trees reminds us that the Abby Aldrich Rockefeller Sculpture Garden is both a garden and a home for sculpture. The beauty of trees is both sculptural— the deployment of forms in space—and painterly, with the leaves catching light like real-world corollaries of brushstrokes, especially during autumn. Each revision of the garden's plantings has considered how particular trees visually frame and present three-dimensional artworks. Some of the chosen trees were later deemed "too leggy," competing too strongly in their graphic, linear visual qualities. Others had foliage meant to act as either screens—visually blocking background visual distractions—or canopies—meant to help the neighboring skyscrapers fade away. Various plants were tested *in situ*, and some worked while others failed to showcase the modern sculpture. One resulting configuration of this ongoing experiment is recorded in *Leaf Peeping*.[6]

Returning to the plan of trees now frozen in time in Ericson and Ziegler's *Leaf Peeping*, we see a record of a MoMA past. The folksy craft activity of preserving leaves in their full fall color, which this work evokes, is itself a memorial gesture. When one saves fall leaves in their most vivid coloring—the process involves baking them in ovens at low temperatures or infusing their cells with glycerine—the act itself becomes a bittersweet way of both resisting and marking the cycle of life. This work of Ericson and Ziegler's, saving both the color and configuration of lost trees, has accrued a similar bittersweet quality over time. The actual trees that Ericson and Ziegler treated with a type of reverence have not in fact survived.

Certain types of landscape, floral, and botanical paintings deal especially with preserving in painterly form the evanescent

seasonal changes that nature manifests in things like leaf colors or floral blooms. Scores of Matisses, Bonnards, Cézannes, and works by other modernists in MoMA's permanent collections celebrate the flow of time in nature. Ericson and Ziegler's *Leaf Peeping* likewise preserves a particular garden's fall colors in paint, and as the paint remains in its most luscious liquid form, we can freely consider the arrangement of paints on the wall as a pseudo-scientific, deconstructed landscape.

MoMA Whites (1990) presents a somewhat different case, as its dynamic rests on the revelation of a heretofore unknown fact about MoMA's exhibition design stratagem: that many of the curators and directors had particular shades of white paint that they used for their exhibitions. These preferences came to light during Ericson and Ziegler's researches when they befriended a member of the museum's painting crew. The workers casually referred to the white paints by the names of the curators, giving them labels such as Rubin White and Riva White. Those paints—which were named for director William Rubin and curator Riva Castleman—only slightly differed from each other, but either one, when painted over the vast expanse of gallery walls, would have a pervasive effect on the actual appearance of artworks and the viewer's experience of the space. The names that referenced real people were interspersed with official paint company names, such as High Hide White, and simple descriptive language mirroring the free-wheeling yet functional taxonomies employed by the MoMA painting crew.

MoMA Whites exists in three forms. In the widely exhibited version, eight clear glass jars filled with the white paints sit on a black shelf. The differences in the specimen-like display of whites range visibly from a creamy parchment color to an icy white. A second version features the varying shades of white painted on paper. Both have the names of the paints included with the samples. In a third version, fully realized for the first time in this exhibition, each gallery wall is painted a different white. This version, perversely both the most grand and the most invisible, resembles the discourse of whiteness itself.

Another play with visibility that used only white is *Whisper*

(1987), in which a gallery wall was repainted in a specific color, "Whisper White," and labeled with a nearly invisible glass plaque sandblasted with the word "whisper."[7] Ericson and Ziegler intended this white-on-white work for inclusion in group exhibitions wherein other artists would have their art hung on top of this non-intrusive white variant. With this piece the artists conjured the image of minimalism and a Zen-like suppression of content, but as with the seemingly emptied-out appearance of their MoMA Projects Room, it is a false impression. The political content was shifted and hidden, but not removed, since Whisper is the name of the white paint covering the White House in Washington, D.C. This seeming homage to quietude instead frames an aspect of the loudest platform in the world, that of the American presidency.

In the art world, Brian O'Doherty's *Inside the White Cube: The Ideology of the Gallery Space* (1976) made inarguable the artificiality of and only recent acceptance of the clean, white-walled space as the most appropriate venue in which to show modern art. In wider museum practice, the white space remains the norm only for modern and contemporary art museums, with science, anthropology, and craft museums, as well as museums of traditional non-western art having a full palette to pick from. While he never asks what shade of white covers this archetypal wall, O'Doherty makes clear that the wall has become an inseparable part of the visual experience of Western contemporary art:

> *"Once the wall became an aesthetic force, it modified everything shown on it. The wall, the context of the art, had become rich in content that it subtly donated to the art. It is now impossible to paint up an exhibition without surveying the space like a health inspector, taking into account the aesthetics of the wall that will inevitably 'artify' the work in a way that frequently diffuses its intentions."*[8]

Ericson and Ziegler's investigations into the exhibitionary power of MoMA constituted a generous and knowledgeable form of institutional critique. They neither intended their examinations to change the institution fundamentally, nor pretended disinterest in their participation in MoMA's exhibition program.

Ericson and Ziegler never stopped pushing the boundaries of public art, even while their works were finding favor within the museum structure. Direct public address once again played a major role in Ericson and Ziegler's *Wall of Words*, a project for the Harold Washington Library in Chicago. Washington, the first black mayor of Chicago and a popular hero, had died suddenly at his desk on November 25, 1987. When invited to make a work for the new central library, the artists began creating a signage system that others could later perpetuate. The piece started with large letters arranged inside the upper windows that spelled out addresses where the late mayor had lived. Librarians then worked with community residents to create new displays of text, a prime example of what has been labeled "New Genre Public Art," in which the community, once merely the audience, becomes part of the process and provides content for the work.[9]

Also in Chicago, Ericson and Ziegler began *Eminent Domain*, part of curator Mary Jane Jacob's *Culture in Action* project. For this work the artists collaborated with public housing residents to create a commercial paint chart that was based on the history of public housing and housing legislation in the United States. Color names such as "Authority White"—the color prescribed by the housing authority—and "Urban Renewal Lime" undoubtedly did not match what marketers would have chosen to appeal to more affluent clientele. The final aspect of this work, which never occurred, involved printing and distributing this alternative paint chart at True Value hardware stores across the country. The layout for the *Eminent Domain* paint chart was completed by the artists and is partially reproduced in the *Culture in Action* catalogue. It was never printed and distributed because Sculpture Chicago ran out of funds, causing a severe conflict between the artists and the commissioning organization.

Ericson and Ziegler's method of working with communities other than the relatively prosperous visual arts and academic communities—a method that all the artists in *Culture in Action* shared—remains controversial today. Art historian Miwon Kwon,

in her study of the ways artists and curators of Ericson and Ziegler's generation revisited and redefined the 1960s and 1970s versions of site-specificity, critically examines the ethics and efficacy of New Genre Public Art, particularly regarding issues of power relations, the sustainability of the artists' contributions, and the limited nature of community involvement. She questions the degree to which the rhetoric of community creates and controls the very communities that such projects claim to empower, at least at the level of curatorial statements and press releases.[10] While such investigations need to be made to refine and improve future public art practice, Kwon never actually states what the alternative version should have been; she does, however, praise those participants who already lived in Chicago and had more sustained relationships to the communities with whom they worked.

Ericson and Ziegler emerged into the gallery world through the crucible of public art and their studies of theoreticians such as J. B. Jackson, and their temperaments would not allow them to impose their artistic desires on an unwilling community. In their practice, they experimented with different models of engaging non-art communities. Their commitment to such exchanges began with their student work, when Kate Ericson would contact quarry owners for admittance to work on site with their materials. Their methods frequently involved enlisting collaborators by writing letters and leaving notes for homeowners. This firmly established working method involved overcoming people's instinctive distrust of strangers by explicitly identifying themselves as "artists" and directly asking community members to participate in a "piece."

Similar criticisms of the artists' methods arose concerning one of their most recognizable temporary works, *Camouflaged History*. That work was created for *Places with a Past*, a project that asked artists to engage the history and culture of Charleston, South Carolina, as part of the Spoleto Festival of music, theater, and dance. Ericson and Ziegler found a house that needed work and had it painted first in a conspicuous camouflage pattern, then in a more traditional way. As outsiders pursuing this project in a predominantly black and poor neighborhood,

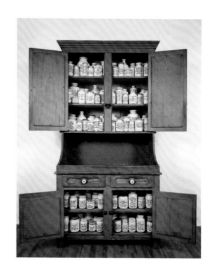

they were attacked along predictable lines. Both *Camouflaged History* and *Eminent Domain* made visible the race- and class-based divisions within the two host cities, and criticism both at the time and retrospectively has been pronounced.

Regardless, officially funded public art needed to start crossing race and class lines to address the significant issues of the day, and many artists responded to the call, including Group Material, Tim Rollins and K.O.S., Gran Fury, and RepoHistory. Ericson and Ziegler took an active, visionary, and trailblazing role. Given the hot political debates of the time, it was not unusual for one group of artists to stage protests against another artist's well-intentioned work. But to criticize today the conceptual flaws of Ericson and Ziegler's collaborative models seems both mean-spirited and forgetful of historical context.

Among Ericson and Ziegler's many object-based works, a large number deal with Americana through the language of food and recipes. *The Smell and Taste of Things Remain* (1992) is an attempt to find domestic equivalents for our national monuments such as the Statue of Liberty. The piece makes a memorial to times and sensations from the past through familiar scents and the evocative names of pies. The artists sandblasted the names of recipes collected from around the country on jars that contained a master perfumer's interpretation of the smell of books and documents housed at the National Archives in Washington, DC. They then placed the jars in an old pie safe equipped with a perforated metal door. The air holes would have broadcasted the smell of the pies to hungry members of the household, as the sculpture today exudes the captivating smell of old books and obscure information into its environment.

Ericson and Ziegler were always suspicious of the sculptor's traditional desire to make and add objects to an already cluttered world. By buying and employing antiques like this pie safe, they found that they could add another conceptual layer to a work through the residues of history contained in reused objects. The names of the pies sound robustly poetic, and when read together make up a synaesthetically complex found poem, with cryptic pie-names such as "Mystery," "Funeral," and "Kiss,"

juxtaposed with more descriptive ones like "Wine," "Rhubarb Honey," or "Virginia Cheese." For readers, the smell of the library contained within the work's jars invites reverie, conjuring the universe of multi-sensory pleasures encountered in books.

Ericson and Ziegler's other works with recipes included making wines, such as *Case of Levittown Dandelion Wine* (1994–95), made from dandelion flowers collected from the front lawns of the archetypal planned suburb, Levittown, New York. Others involved making vinegars and soaps, or preserving seasonal fruit. A late work, *Peas, Carrots, Potatoes*, displayed three types of baby food in 364 clear jars. Ericson and Ziegler sandblasted the jars with new parents' phonetic interpretations of the sounds made by their babies, and displayed them in the form of a color-shifted American flag.

The domesticity of these later works reflect a growing and more personal concern with the comfort of home and family. It is impossible to look at the artists' flag made of baby food and not think about how Kate Ericson's diagnosis with cancer in 1994 altered not only the course of their work, but also the course of their lives. Her illness progressed rapidly, and Kate and Mel devoted themselves full-time to her recovery. Friends and supporters found ways to sell Ericson and Ziegler works quickly to raise money for her medical bills.

Simple daily routines became a treasured part of Ericson and Ziegler's lifestyle. When Kate grew too sick to undertake large-scale projects, the pair would draw, often on coffee shop napkins. The group of drawings known as the *Dianna Drawings* was named after Dianna's Place, the restaurant where they sat and worked over breakfast each morning. The drawings offer evidence of a collaborative team with more clever and poetic ideas for future works than most artists have in an entire career.

Ericson and Ziegler's final sculpture counts among their less visual but most poignant works: a pile of wood scraps left over from the process of building a house. The fragments piled roughly on the gallery floor recall post-minimal scatter art, but with a very different content. If one theme has run through their works from the very beginning it is their conception of the physical, material,

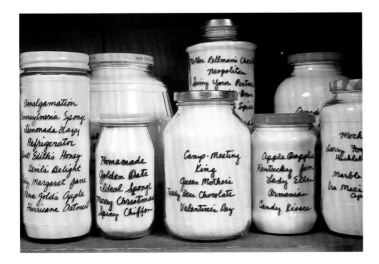

Sift Before Measuring
1993
Flour, sandblasted glass jars,
antique wooden cabinet
Open: 84 x 67 x 20 inches; closed
84 x 42 x 20 inches
Collection Albright-Knox Art
Gallery, Buffalo, New York, Gift of
Nell and Jack Wendler, London, 1995

Domestic jars filled with flour are
sandblasted with over four
hundred names of cakes collected
from around the United States.

built world as a solid record of human thought, hopes, dreams, and ambitions. A million pragmatic decisions based on reasonable hopes for happiness and self-betterment make up the substance of our lives; they are all we have. Each piece of wood gathered for *From the Making of a House* (1995) was cut off in an effort to shape reality into the builder's dream for his home and future.

When a partner dies, all future plans disappear. These things happen all the time, but the knowledge that one's partner may be taken away cannot shape how one lives life. Since the subjects of Ericson and Ziegler's work so often dealt with dreams of the future, the tragic way their collaboration ended is experienced viscerally through their work, even by those who are now encountering it for the first time.

- -
ARTISTS RESPOND

Ericson and Ziegler's artistic legacy is great. Their impact on working artists has proved profound. Joe Scanlon, an artist who performs some practical function for his work, such as building himself a coffin from Ikea parts or designing a bookcase for people who move frequently, recalls his experience with their work:

> The first time I ever saw a work by them, I was trying to figure out what art was for me, or could be. In that state of mind I walked into Feature Inc. when the gallery was still in Chicago and saw a white wood shelf with six or seven containers of canned peaches on it. The jars were classic Mason jars with self-sealing, two-piece metal lids. The peaches inside looked perfect, pale orange, unblemished and nestled on top of each other from the bottom to the brim. I didn't realize it at the time, but I think that experience gave me the confidence to have my art be whatever I wanted it to be, whatever I was skilled at, whatever I thought was necessary and beautiful.[11]

Mel Chin, who often works collaboratively and with expanded notions of site-specificity, was also affected by his contact with Ericson and Ziegler, whom he met when they all lived in Houston in 1979, and remained a close friend of the artists over the years:

> Without the work of Kate and Mel, I don't think I would be the artist I am today. My view of conceptual art and my methods of research and production were expanded through my association with them. I saw them developing a critical approach that considered sociological insight, as opposed to pure theory, as a basis for work. That certainly spoke to me. They worked with humility and ambition, a powerful combination. I feel Kate's and Mel's influence to this day in my expanding, mutating strategy because of the new territories they exposed and presented with incredibly elegant restraint.
>
> They exercised a rigorous examination of their own efforts as they worked. That critical stance continues to make me feel that the unexamined art is not worth making.[12]

The artist David Cabrera, who studied with them at CalArts, remembers their presence well:

> Kate and Mel were like bookends—strong supporters of knowledge, theory and information—holding their often monumental art for us to experience within a constructed frame. I always took delight in visiting with them, to see them in their usual uniforms of khaki pants, work boots, and plaid flannel shirts. Kate and Mel helped shape my attitude of working collectively, and I value our early years in the contemporary art world.[13]

Ericson and Ziegler were also influential teachers. They actively lectured at art schools throughout the country and served as adjunct professors on occasion including at the University at Albany in 1991. One of the many students they had a profound impact on was artist Michael Oatman, who is best know for his heavily researched installations and meticulous and epic collages. He remembers:

> One of my favorite hobbies is visiting artists' studios, an interest that I think started around the time I made my first visit to Kate and Mel's barn in Pennsylvania. Walking into it was such a surprise, it was as if they were "bad" Amish: a

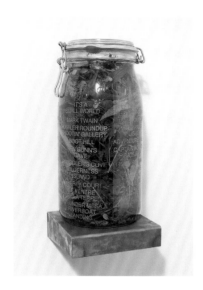

Vinegar of the 48 Weeds
(single jar version)
1992
Weeds, vinegar, sandblasted
glass jar, metal shelf
Courtesy of Mel Ziegler,
Austin, Texas

totally empty barn with a desk in the corner, a phone or two and a fax machine, and filing cabinets. What were they doing? It was so incongruous.

I learned a great deal from Kate and Mel in the short time they were my teachers during my graduate studies at the University at Albany. One of the things that I learned from them was how you could be an artist in a stealthy way. When you visited their home in Greenwich Village on Morton Street it looked like a normal apartment. When you visited their barn, save for that desk, it seemed like a normal barn. There weren't any of the outward trappings of the artist's studio: the smell of paint, the presence of tools around. It was just two people working as hard as they could and as closely with each other as they could. It was a new model for me of a way to be an artist, one that inspired me as I began to move away from painting and into installation and site-specific work. More than anything else, I believe it was the kind of joy that Kate and Mel had that I wanted access to, both as a couple and as people who had found a way to spend their lives making art. [14]

New York artist Suzanne Bocanegra remembers their influence and emotional connection:

There is a literalness to Mel and Kate's work that translates into a strange kind of beauty and a sincere compassion for people and how they live their lives. I had just arrived in New York City from San Francisco when I first met Mel and Kate. I was perplexed but at the same time fascinated by their idiosyncratic way of making art. What they noticed in the world, how they processed what they noticed, and how they made art of those ideas was utterly unique to them, and made a strong impression on me and how I approached my own work.

I got my first teaching job in the eighties in Vermont. As I was feeling lonely and homesick for New York, a package arrived in the mail. It was full of little odds and ends that Mel and Kate had picked up off the city streets. There was a long, rusty metal strip with an address stamped on it, a nut-

cracker doll's head with peeling paint, a scrap of shiny paper with a harlequin pattern, a rusty, twisted wire, and a bright, broken bicycle reflector. It was all there in that envelope: a sampling of what they noticed in the world, and for me, a touching example of their consideration and real concern for the people in it. [15]

Painter and friend, Betsy Friedman remembers:

Kate and Mel were wonderful artists. They were also very good friends. I met Kate when we were about twenty years old, during a summer spent in St. Louis between semesters at different Midwestern art schools. We became fast friends and thankfully remained so. I was always sharing stories of Kate and Mel with my family. I was very interested in what they were doing and making, and as the years went by, there were many opportunities for me to talk about their work in detail: Kate and Mel did this, Kate and Mel were doing that. One day, while I described yet another of their pieces to my father, he started to smile in amazement. He said—I kid you not—"I always thought 'KateandMel' was one person." To me, that sums up a nearly perfect collaboration, one whose memory I will always treasure. [16]

And Mark Dion, whose work employs archeological methodologies within institutional spaces, celebrates how Ericson and Ziegler followed their passions and desire to make beautiful objects and installations:

Ericson and Ziegler were the first artists I met who brought together disparate tendencies in visual art to force a single complex practice. They took the rigor of conceptual art's research mandate, combined that with a subtle but focused political agenda, and wound that round a body of issues and concerns that were deeply personal and motivated by pleasure. They simply made art about the things which were most important to them, rather than proceeding as though it were a disinterested academic endeavor. They never were embarrassed or made excuses for the lush visual nature of their

work. They challenged convention and proved that intellectu-ally motivated art need not be materially puritan. As an artist and a person there are very few colleagues I owe more to.[17]

Historically, Ericson and Ziegler epitomized and catalyzed an epochal shift in art practice grounded in a fundamental recon-sideration of what an artist's job description could be. Earlier attempts to disrupt the entrenched hierarchies in art often relied on the romantic ideal of the artist as having a unique claim on truth. Previous self-described art-workers only handed over small parts of their authority in efforts to showcase their own dubious humility. The actual poetic resonance of being a "worker among workers" still sits uncomfortably within the museum, and this process of redefining terms and identities remains incom-plete. Yet Ericson and Ziegler's contribution to disrupting that status quo remains crucial.

This text is far from exhaustive. Each of Ericson and Ziegler's public works deserves a chapter, and even their small-est objects would inspire a few paragraphs of text. Or perhaps not. Their working method was scientific, literary and poetic, politically and socially engaged, but the facts surrounding their work may prove extraneous for many viewers, for whom the knowledge that these works can be read into deeply may suffice. The power of the work may ultimately lie in a paradigmatic shift that led them into innovative ways of working, away from the personages and places of the art world. Their practice licensed others to reconsider how and where art happens, and that is the legacy the next generation of artists would do well to heed.

- -

NOTES

1. Grimes, William, "Brinck Jackson, 86, Dies; Was Guru of Landscape," The New York Times, 31 August 1996, 27.

2. *Artforum* 27, no. 4, December 1988.

3. *There's tempest in yon hornèd moon,*
And lightning in yon cloud:
But hark the music, mariners!
The wind is piping loud;
The wind is piping loud, my boys,
The lightning flashes free—
While the hollow oak our palace is,
Our heritage the sea.
Francis Turner Palgrave, ed., *The Golden Treasury of the Best Songs and Lyrical Poems in the English Language* (London: Macmillan, 1875).

4. A fourth piece dealing with the Museum of Modern Art, *Fall at MoMA* (1988), was a variation on the themes addressed in *Leaf Peeping*.

5. See, for example, Louisa C. Matthew, "The Painter's Presence: Signatures in Venetian Renaissance Pictures," *Art Bulletin*, 80 (December 1998): 616–648.

6. For a description of the decisions about planting during the first three versions of the garden, see Laurie D. Olin, "The Museum of Modern Art Garden: The Rise and Fall of a Modernist Landscape," *The Journal of Garden History* 17, no. 2 (Summer 1997): 140–162.

7. In another form, *Whisper* has been shown as a gallon of Whisper White paint on a shelf.

8. Brian O'Doherty, *Inside the White Cube: The Ideology of the Gallery Space* (Santa Monica and San Francisco: Lapis Press, 1976), 27–29.

9. See Suzanne Lacy, ed., *Mapping the Terrain: New Genre Public Art* (Seattle: Bay Press, 1995).

10. Miwon Kwon, *One Place After Another* (Cambridge, Massachusetts: MIT Press, 2002).

11. From an E-mail to the author, 2005.

12. From an E-mail to the author, 2005.

13. From an E-mail to the author, 2005.

14. From a note to the author, 2005.

15. From a note to the author, 2005.

16. From an E-mail to the author, 2005.

17. From an E-mail to the author, 2005.

Half Monument, Half History
1991
Biel/Bienne, Switzerland.

At the request of the artists, Swiss
Rail agreed to leave one half of
the front façade of the Biel/Bienne
train station uncleaned for the
duration of the exhibition. At the
close of the project the rest of the
station was cleaned as originally
planned.

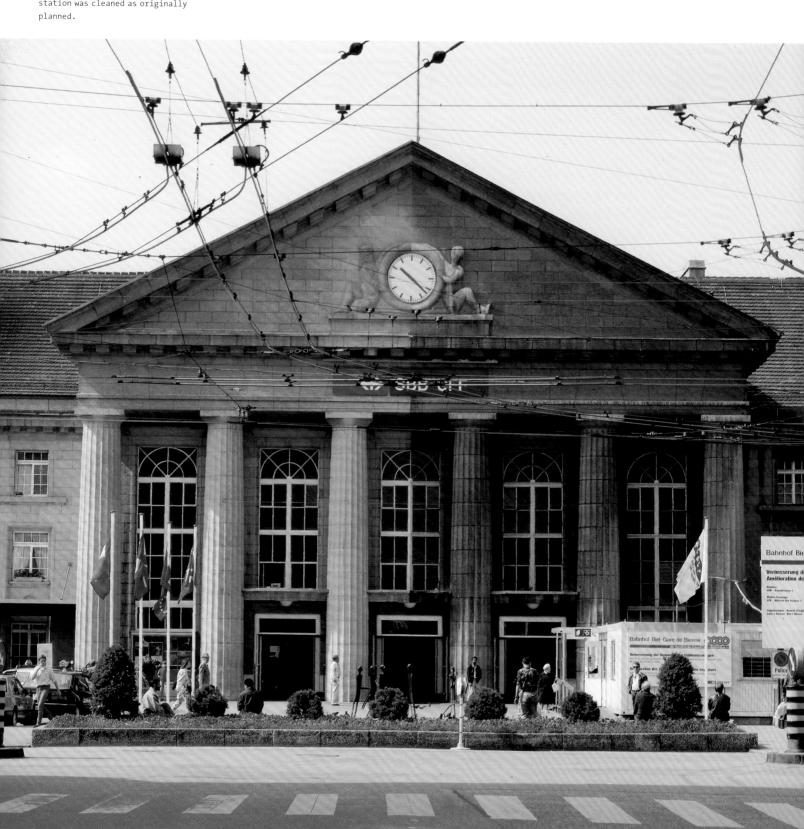

IAN BERRY

COMING CLEAN

A DIALOGUE WITH MEL ZIEGLER

IAN BERRY: How did you and Kate first meet?

MEL ZIEGLER: We met first by phone. I was at Rhode Island School of Design, and my girlfriend went to the Kansas City Art Institute for six weeks in the winter of 1976. In Kansas City she happened to room with Kate. I would call to talk to my girlfriend and Kate was usually there. I ended up talking to Kate, sometimes for an hour or more on the phone. This was someone I had never met, but somehow we had a connection. Later, at the urging of my girlfriend, I decided to transfer to Kansas City. My relationship with her mutually ended, and after a year or so Kate and I became a couple.

IB: Did you immediately start talking about working together?

MZ: At that time she was in the painting department and I was in sculpture. I visited her studio often, and we would talk about painting and issues of art. I talked about my work, and she talked about the fact that she wanted to do things with her painting outside, a sort of three-dimensional painting. That was the beginning of her interest in sculpture. Even at that early period we had similar ideas. Our first collaboration was our graduation show, *Coal Chutes and Wall Piece* (1978). She was working with coal chutes, and I was working with corrugated aluminum walls with scaffolding, and we simply merged the two ideas.

IB: What were some of those ideas?

MZ: That piece faced Vanderslice Hall, the site of all of the administrative offices at the Kansas City Art Institute. We were trying to focus on the fact that the building was originally the home of a wealthy mining family—we wanted to block out this elaborate facade with an industrial looking object, playing off of what was visible and what wasn't. It had to do with power, money, and labor, and how those things can intersect with art and architecture.

IB: Many key elements that you developed later in your career arose in that first collaboration.

MZ: Yes. I think a lot of the themes started at Kansas City. At that point we also began to regularly work outside. Kate was doing things in quarries around Kansas City. She would convince quarry owners to let her do projects right in the quarry, so she had an abundance of available materials. She would go out to the site and build things. I was doing things that attempted to get the public involved in my projects, like *The Front Page* (1977) that I tried to do with the Kansas City Star. We both wanted to extend beyond the Art Institute to a much larger community.

IB: You always had collaborators, for example, the quarry owner or the newspaper owner, and you decided very early not only to use materials from these people, but to bring the work to their places. How did that strategy help you engage your activism?

MZ: In the mid-seventies in Kansas City, we weren't seeing the actual exhibitions happening in New York and Los Angeles and places like that. But we did see what was published and talked about by curators and critics, these included works by artists like Mary Miss, Alice Aycock, and Gordon Matta-Clark. We were thinking also about Robert Smithson, Michael Heizer, and Earthworks. There was a sense of isolation in Earthworks that Kate and I disliked. We wanted to engage groups of people but without constructing our spaces like Miss and Aycock. We found materials and places already existing that we could use and manipulate

Collaboration with students,
Minneapolis College of Art and
Design, Minneapolis, Minnesota,
1989
Façade of house painted to match
the colors of a Cheerios box.

like Matta-Clark, but we were still searching for socially active spaces in which to work. How could we bring those two together, and how could we create work based on that combination of things? That was a real key to our early development.

A good example in our early work is *Red House* (1979). You could paint a house and make an artwork out of it—not a decorative thing, but a conceptual project. It meant advertising in the newspaper, finding someone who would let me paint the house the color red that I wanted, which would grate against what was socially acceptable in a neighborhood where most of the houses were either white, beige, or gray. It was an attempt to break down some of those neighborhood barriers and alert people to a pervasive but unspoken convention.

IB: How did you find the homeowners to collaborate with? Did you always use newspaper ads?

MZ: We actually used two different methods, one was advertising; the other was soliciting with a one-page information sheet saying we were interested in using "your" house for a project. We never shied away from the fact that we were artists; we always wanted everyone to know that we were artists and that we were making art. That was important to us. We would interview those who responded. In the house projects Kate and I did, we never wanted to alienate the people from the rest of the community, so their participation and their relationship with the rest of the community was important. In the case of *Red House* or most of the other projects, the homeowners talked to all the neighbors and asked them if they objected to the project, so everyone knew it was going to happen. It was important not to make them feel like outcasts for working with us, but to emphasize a broad community awareness and participation. Now, of course, *Red House* was the only project that was more semi-permanent than the rest.

IB: Did the Red House remain red after your project?

MZ: It stayed red, but it didn't have to. The idea was that it had to be red for three months. After that they could do whatever they wanted. They kept repainting it the same color red for fifteen

years. I went by recently to check it out. It is no longer fully red, but there are remnants of the paint in areas.

IB: Was it important at the outset that the house needed a paint job?

MZ: Not necessarily in this case, although there was a kind of pragmatic economic exchange which is the basis for much of our work, you do this for me and I do this for you. They paid for the paint. I did all the labor. Time and labor were things I had to give.

IB: How was it announced as an artwork; how did you alert people to what was going on?

MZ: We were idealists, thinking these projects could somehow retrofit into the gallery system. We took documentation of our work to a dealer, and he looked at it and said, "There is nothing I can do, there is nothing for sale here." It was a big blow. So Kate and I took that as a challenge to figure out how to do it ourselves. We put together a mailing list and announced our projects, inviting people to come see them. I think we often had Sunday afternoon openings and invited a lot of the artists from the community. There was press coverage for some projects and there was even a newscast on one. We had a lot of energy. We were young artists and ready to go. We had just moved to Houston from Kansas City, and within a two-year period we did quite a bit of work there.

IB: Who were you picturing when you and Kate imagined talking to the community? Who was the audience you imagined?

MZ: It's an issue we discussed all our careers. We felt we had two audiences. There was the art audience, and we addressed them by way of documentation or having announcements and discussions about the work. But we really felt the necessity and importance of engaging the community where each project was physically located. Now the question was, how many people does that include? Our feeling was that just one street was plenty. We didn't have to engage more than that. We wanted to have some form of visual seduction that would pull people in. Whether or not people completely understood our artistic discourse wasn't

so important: what they could understand was painting a house, or the idea of a front lawn. So there were different levels of entry, different ways in which people could engage, think about it and discuss it.

IB: Tell me about your early influences—do you remember the pieces early on that you saw or heard about?

MZ: Well there are plenty, including many of the dynamic instructors we had. Dale Eldred and James Leedy, who taught us about the meaning in materials and the process of building, and Michael Asher, John Baldessari, Doug Huebler, and Jonathan Borosfsky, who honed in on our conceptual skills. And of course there is Gordon Matta-Clark, who's work itself has been a great inspiration to us. One important thing stands out at an early stage of development. We looked at the Maysles Brothers' films on Christo, most significantly the one about *Valley Curtain*. *Valley Curtain* only stayed up for twenty-four hours or so, and that was such a great realization, that you could do something and it didn't matter whether it was permanent or not. The photographs and documents looked great and that is all you really needed. I can't say that I am crazy about Christo's end products, because I think that it is mostly about being big, beautiful, and visually expansive. But everything else that goes behind it, all the social aspects of convincing governments, convincing people, convincing land owners—to me that is the most interesting part of it.

IB: …the conversations with all those people.

MZ: Yes, that really appealed to us. At that point they weren't Jeanne-Claude and Christo, it was just Christo. Jeanne-Claude was behind the scenes helping make these deals and suddenly they both realized that this aspect is as much a part of their work as the final product. I am glad that finally was addressed through their acknowledgement of Jeanne-Claude as a collaborator.

IB: Were they a model at all for you and Kate as a collaborative team?

MZ: No—I don't know if we could say that we had a model in that way.

IB: Did you have any model of what a collaborative team looked like or was? Did you have a picture in your mind—that's what we can be, this is what it is going to look like?

MZ: I don't think everybody can collaborate. I think it requires a certain sort of personality. We worked together during the summers, painting houses together and doing other construction work. I remember one job where we made a stone fountain for a retirement home. I would place a rock in different positions and think "This is it," and I'd be happy with it, but then Kate would come along and say, "Oh no, I see it differently." That was intriguing to us—to produce a work and to think you've come up with all the solutions, and then someone else has other ideas you hadn't thought of. That sparked an interest in collaboration, which led to the first piece. But we didn't collaborate right away. It just sort of happened.

IB: Were you intending or understanding your projects as taking place within the realm of public art?

MZ: We were always interested in engaging the community. There are many varying levels of public art. We started getting very involved with the dialogue of public art in the 1980s because one our first big commissions was in Seattle. At that point the Seattle model of the design team was just getting started. In the eighties there were so many public art conferences, and Kate and I were often invited to those to talk, but not necessarily to confirm what was already happening. We were often the odd people out because we were suggesting there were other ways to think and work. We weren't happy with the design team model, we always felt that the artwork got too subdued. Even though our work could be subtle, there was an edge to it, and we felt that a lot of public art had lost its edge through the design team process.

IB: Let's continue talking about public art through a later piece of yours, *Loaded Text* (1989). Maybe you could walk through the process of first visiting Durham, North Carolina.

MZ: We were invited to do a project for a public art conference. They didn't give us any parameters, they just told us, "Here is the city, do what you want to do." That was an ideal situation for us as artists. Our process usually began by entering a city and involved a lot of looking and observing. We thought a lot about the work of J. B. Jackson and John Stilgoe, this idea of just looking at things that seem to have meaning, but might be hidden within the context of where it is placed. We also subscribed to the local newspaper so that when we were back in New York we could see what was going on locally. We would research the economics and history to see if anything sparked our interest. In Durham they were trying to renovate the downtown, to do something to spruce it up. One of the first steps they took was to replace a lot of the broken sidewalks. This idea of pragmatic improvements seemed meaningful to us. We also discovered that the City Council had just passed a draft for a revitalization plan for Downtown Durham, and placed two copies in the public library for the citizens to review. With the help of the Durham Arts Council, Kate and I got a City Council member to give us a copy of the draft. We read it, and felt it was important that the community really know all the details. The way the council was making it public, only through the two copies in the library, wasn't enough.

So we combined the ideas of the broken sidewalk and the downtown revitalization plan; it had to do with civic improvement and upgrading. We found a one hundred fifty-foot section of sidewalk near the main Post Office downtown that had never been replaced. The Postmaster told us he had been after the City Council for years to replace it, but they never did. So we said we had a ten thousand-dollar budget, and if we could get permits, we would use that.

The plan was to take the sixty-five-page text of the downtown revitalization plan and to make it public by handwriting it on the broken sidewalk. It was a performance. We used magic markers and bought ink to keep filling them until they'd get worn down against the sidewalk. It took us about five days of writing on our hands and knees. The text was visible for several days, and then we hired a contractor to remove the sidewalk and

break it up into smaller pieces, which we then loaded in three rented dump trucks that we parked in front of the Cultural Arts Council for the duration of the public art conference. While the art conference was going on we had the contractors pour a new sidewalk. We felt it was a practical gift to the city, but it turned into a huge controversy because people in the city felt that somehow this was not art and that we had ripped them off. But all the money except for our fee, which was about two thousand dollars, went back into the city. We had hired local contractors, and the trucks were rented locally. Nevertheless, people would drive by and shout at us and so on. It was interesting as a public art phenomenon. At the end of the project, the sidewalk rubble went to form a riprap wall in an eroding riverbed downtown, and by the Post Office there was just the new sidewalk; there was no plaque or any other indicator. What was important was that this project was what Kate and I had been trying to do most of our career—infiltrate these systems or conventional forms of the urban or suburban fabric, and make art out of what's already there.

IB: *Loaded Text* **is a great example of you and Kate using the materials and issues of a specific community to make your piece.**

MZ: *Loaded Text* is one of my favorites. Every part fit, everything came back around to itself, everything had its place. It disappeared in an interesting way—we got to do an artwork, the people got a new sidewalk, there was a place where the erosion was being stopped because of the rubble; there were no loose ends. We were always looking for ways to fit into pre-existing systems. A lot of times we would just throw out ideas that we liked simply because we really wanted to stick to this particular way of thinking and working. Even with objects, we weren't really comfortable making our own objects from scratch. That's why we used antique cabinets later on, because the cabinet already has a social history to it, it has a desirability as a thing, as an object. Kate and I weren't creating the aesthetic; it already had the aesthetic.

IB: **Why not make objects?**

A Long Line
1995-96
Text from used history books
sandblasted on black marble, used
toy dump trucks
Overall dimensions variable
Courtesy of Mel Ziegler, Austin,
Texas

MZ: That's a tough one. I like to quote Douglas Huebler: "The world is full of objects, more or less interesting; I do not wish to add any more." What was important was the research or the histories we uncovered—we set the parameters and let everything else come together, including the objects.

IB: **You've talked about the predetermined aspects of your work, ready-made situations, methods, and forms. Can you talk a bit about choosing an institution or the museum as "ready-made"?**

MZ: I don't think it was something in which we were overtly interested; we were just given situations in which the possibility existed. It is no different than if we had worked in any other institution or a suburban context.

IB: **A museum you investigated for a number of pieces was the Museum of Modern Art in New York. For *Signature Piece* (1988) at MoMA you focused on workers.**

MZ: Right. That piece was about observation of things that already existed, the things that were made and determined the institution itself on a very pragmatic level. Luckily for us, the Projects Room had been just renovated in the early 1980s and the history of that particular place was not as complicated as some of the older parts of the building. We ultimately traced the origins of the materials that made up both the garden and the Projects Room gallery. So we would trace the sheet rock or the paint to a particular factory, and in the end we identified forty-two elements for which we located the manufacturers. Then we asked the managers of each factory to choose someone who worked with their hands, actually producing that material. Of course there was no way to say definitively who made which product, but we made sure that each person was working in the factory during or just prior to when that material was installed at MoMA. We used our budget to pay every person they chose fifty dollars, and asked each to write his or her signature, first and last name. We blew up just the first names and silkscreened them onto Plexiglas plaques that we then placed around the museum like labels for each product they helped produce. It was

important that people could take a brochure that indicated both the first and last name of all the participants. We also invited all those people to the opening.

We were working with a critique of the idea of labor and production, and what becomes ensconced as creative work. There were layers to that piece that raised a lot of issues about the act of making, and the acts of preserving and sanctioning as defined by an institution like MoMA. What was the relationship between all these "makers" and the larger community? We included a person named Ruth Ann Soffe who worked on the electrical sockets, and she was actually featured on the cover of her factory's newsletter. It read: "Ruth Ann Soffe at MoMA." She was one of the people who came to the opening, and she took photographs of herself in front of MoMA. It meant a lot to Kate and me to have that kind of participation. The only additional thing that we wished was that we had a budget to actually fly in every person for the opening. Only about five or six of the participants showed up to the opening, which was unfortunate, because I think that congregation of people would have made the project that much more successful.

IB: Were you able to measure if the piece had an impact on MoMA or the people who worked at the museum?

MZ: I don't know if the people at MoMA really liked it. We were uncomfortable with the idea of working within the structure of the institution, so we did what we could to question or break that system. We placed three signatures across the street from the museum, labeling things that were made in the windows of those buildings. We wanted to say something to MoMA about the fact that the world didn't begin and end within its confines. That gesture, even though it was subtle, was really about looking beyond the museum. In the eighties that was difficult to do, to convince museums to go off-site. For Kate and me, it was a symbolic gesture about breaking down those barriers.

IB: How did your conception of the role of the artist fit into *Signature Piece*?

MZ: I think our job as artists was to make people conscious of things that weren't so readily visible, the subtleties and meanings within things we do every day that we don't even recognize. That's where our interest in the kinds of things that might not be so obvious came from. We would take things like the idea of monument, but then circumvent the idea of its own monumentality, and make it somehow undermine what it was actually supposed to do. It's about consciousness, about making people aware of things that they might not normally be aware of. Not just an aesthetic consciousness, but a political, economic, or social consciousness. That is why we were interested in the socially active space and why we were interested in getting our work out into the community.

IB: In your work there is an interesting redefinition of the term monument. Can you explain that a bit?

MZ: To us the idea of monumentalizing can alter history. Once you monumentalize something you change the course of history, simply by saying this is significant enough to monumentalize. Case in point is the Vietnam Veterans Memorial, which I think is one of the most important works of public art in this country. Look at how that changed the history of that war—just giving it a place in which we could collectively engage the psychological issues of the war suddenly gives it another kind of history: it changes it. It is almost like drawing a line in time; from that point on the Vietnam War was looked at differently because it had been deemed worthy of a monument by the United States government.

Also, a new form of historicism emerged in the late seventies or early eighties—it was this idea that history was suddenly an economic factor; it was for sale in one form or another. Rather than giving money to regions to build infrastructures or superhighways the government was suddenly giving money to areas to "save history" and then promote it for tourism. Tourism was to us another form of monumentalizing. With that in mind we asked ourselves, how do you create a monument that really becomes what it is monumentalizing—a living monument? Talking about the fact that you lived with the monument, or even in it, was really important to us. It was very different from a bronze statue or

Oldgloryredbleachedwhitenationalflagblue
1995
Latex on paper, sandblasted glass
15½ x 40½ inches
Microsoft Art Collection, Seattle,
Washington

Ericson and Ziegler calculated the
percentages of each of the United
States flag's three official
colors—Old Glory Red, Bleached
White, and National Flag Blue—and
mixed them into one composite
color.

some other symbolic gesture towards monumentalizing; it simply was the monument.

IB: In some ways much of your work could be read as revolving around the idea of a living monument. Which of your works addressed these issues of the monument most directly?

MZ: Certainly that's what we tried to acheive with *House Monument* (1986) and the Central Park piece, *If You Would See the Monument, Look Around* (1986). When we were asked to do a project for Central Park we had mixed feelings, like how do you place something in this park? Through our research into the history of Central Park we learned about discussions at the very early stages of the park's development as to whether or not there would be any sculpture allowed in the park. To me it seemed like social arrogance to place a sculpture in that park. What we wanted to do was frame the park as a work of art in and of itself. But how do you frame the park, how do you make the park the work of art that people are supposed to look at? The only reason the park is so beautiful today is because there is a labor force that keeps it well maintained. So we got examples of every tool used in the park from the volunteers, the Central Park Conservancy, and the maintenance crew. We took a bronze metallic paint that had real bronze in it and coated all the handles of these tools, and then polyurethaned them so they would last longer. Then we gave them all back to the different groups maintaining the park and asked those people to use the tools just as they would use any others. We also distributed postcards in the park that encouraged people to walk around and look for the tools, knowing full well that they would probably never find the tools. What we hoped they saw was the beauty of the park while also being conscious of the labor and the necessity of the upkeep of the park. In essence, they were just walking around the park looking at nature; the monument was the park itself.

IB: Your ideas about monuments and history and research seem related to the piece *America Starts Here* (1988). Could you describe how you found your way to the sources in Philadelphia that inspired that piece?

MZ: We were invited by Judith Tannenbaum to be part of the Investigations series at the Institute of Contemporary Art at the University of Pennsylvania. She said to us, "Here's the city, do a project." We really enjoyed when that happened, when curators didn't have a particular idea in mind. It was always really great; it actually produced some of our best work.

America Starts Here basically began with driving around Philadelphia; we just wanted to look and look and look. I grew up outside of Hershey, Pennsylvania, so Philadelphia always seemed like a scary city to me. It was a big place that had a lot of problems—just going in on the train you would see communities just devastated. There were empty factories and broken glass everywhere. It always had an impact on me to think that in the central part of that city were lots of tourist attractions, like the Liberty Bell and Independence Hall, where the Declaration of Independence was signed, but outside that area there was lots of economic devastation, and the social ills were so evident. I think that our idea really came about just by thinking about the city and the problems it had, contrasted with the fact that it was a popular tourist attraction. We also loved the tourism slogan for the state of Pennsylvania—"America Starts Here." It really brought to mind that relationship again, between what you see in the isolated tourist area and the rest of this city. The idea of a crack in a bell could have so much meaning, so much symbolic meaning for the U.S. and the starting of the country, yet cracks are about decline as well. There was a nice symbolic relationship between the idea of the crack in the Liberty Bell and then all this broken glass and deterioration. So somehow in the course of driving around Philadelphia we came across an abandoned factory with nearly all of its windows broken. It was a typical early twentieth century building that was just a box of windows to breathe in light. It was called the National Licorice Factory. I think we liked the fact that its name had the word "national" in it, and that it evoked the sweetness and innocence of candy.

Kate and I removed all the broken windowpanes and green fiberglass replacement panels from three sections in the front of the factory underneath the National Licorice sign and

replaced it all with new glass. We had a fifty-foot wall to work with at the ICA, and that space determined the size of the piece. There were 105 panes that we marked and kept track of in terms of their arrangement on the building façade. Then we photographed cracks in significant buildings and monuments around the three historical national capital cities—Philadelphia, New York, and Washington, D.C.—and we also incorporated a series of lines that had to do with the expansion of the U.S., things like railroads, trails, rivers, and new roads, all dealing with Americans going west and expanding the country. We sandblasted the lines of these trails and cracks onto sheets of glass so they looked almost like breaks in the panes, and also indicated the name of what each line represented. The result was the broken glass of the factory with an overlay of lines that told of the expansion of the U.S. The title just made sense because it was about the idea of tourism—"America Starts Here"—juxtaposed with these blown out and abandoned factories.

IB: Can you talk about leaving situations better than you found them, in this case, a building in which a homeless person might be living that now has better windows?

MZ: If someone was going to give something to us to let us make art we felt like we wanted to give something back. That exchange created a reason for them to engage with us. We were always conscious of the fact that we didn't want to feel we were using people and using situations, but instead that we were giving something back. Giving something back also allowed us to extend the work and highlight the consciousness of what we were doing. Often it was something very simple and pragmatic, like painting a house that might need painting as part of a project, like *Camouflaged History* (1991). That was something really important to us. We wouldn't have just done that project and walked away from it; we felt like we really had to complete it by repainting the house the way the owner wanted it painted.

IB: So about *Camouflaged History*— can you describe what you saw when you were first looking around Charleston?

MZ: I have a lot of respect for Mary Jane Jacob. She was able to amass a lot of money, and ultimately was one of those curators who gave the artists she enlisted a lot of freedom. The Spoleto Festival was a music festival, but they also decided to include an art component and invited Mary Jane to curate it. There were roughly twenty artists in it, and as the show was titled *Places With A Past*, she wanted us to deal explicitly with the history of Charleston. That was almost inevitable if you were dealing with Charleston because that's really what the city is all about. One reason for that prominence is that Charleston had one of the first historic preservation laws in the U.S. In the city there is also an incredible military presence, not just in the past, but also a contemporary thing. A lot of money gets sent down to that area because of the nearby military bases, so to us the two major factors in the city were the military, both historically and in contemporary times, and the tourism.

We were shown a lot of sites, buildings that we could use or put something inside. One of the things that interested us was that everyone there has a ghost story. So one of our first ideas was to actually try to get the sounds of a ghost in a historic house. We were convinced that we were going to camp out and have recording material and everything else, but ultimately we chickened out and decided not to do it. But through our research and through looking around the historic homes, we discovered a paint chart put together by the Board of Architectural Review. They had invited color experts to put together a color chart based on the history of colors used in Charleston, and now they use it as a basis for what colors people can paint their houses when renovating. They are very strict about it, and homeowners have to get approval from this Review Board in order to paint the outside of their houses.

After they put together this chart, Dutch Boy Paint actually produced it commercially, cornering the market for exterior paint in that particular area. The Review Board named the colors on the chart as well, with names that really idealized the history of the city and acknowledged only those things that were deemed worthy of remembrance. We were very interested in that.

In this case we decided to focus on the line that was drawn between the "old city" and the "historic city." The areas had two different kinds of preservation laws in response to the gentrification that was happening in a lot of Charleston due to the severity of those laws. More economically challenged people were being moved out of the peninsula as their houses became very desirable, and the differences in the preservation laws were meant to address that. In the historic district, if a hurricane came through and damaged your roof, you had to basically reproduce it the way it had been. It became almost impossible for a lot of people who owned houses there to actually keep up with the preservation law, and so it was slowly becoming a very wealthy peninsula. That was curious to us, and we were interested in the injustices that might go on because of it. The laws in the "old city" district were a little less severe, so we decided to choose a house just over that line and paint it with the seventy-two colors of this historic paint chart. Our idea was to create this project called *Camouflaged History* in which we engaged the military to design a camouflage pattern on a historic and distinctively Charleston-style house, merging both the history and the economics of the area with the military presence. We looked at a lot of different houses, and we found an elderly gentleman and his daughter whose house needed to be repainted. One of the reasons that we really liked this particular house was because it was right on that line between what's historic and what's not. That line is going to move eventually, it is just temporary, and so to us that was sort of like the front line of a military operation. We got the owners' permission to paint their house with a camouflage pattern and had a sign painter stencil all the color names on the house as well.

IB: The camouflage pattern was designed by the military for your artwork?

MZ: It was actually designed by the U.S. military. We took a fifteen-foot plan of the house to Fort Belvoir, Virginia, where there is a special camouflage unit of the U.S. Military. They have a hotline to call if you are on the front and need to know what to use to camouflage X, Y, and Z; they will come up with a plan based on the geography. And so based on the geography of South Carolina they came up with a pattern that they drew for us on the big plan. That was what we used to translate the shapes onto the house. We hired local house painters who scraped the old paint off the house and primed it all white, just as you would paint a house, and then we had set designers come in and draw the lines, interpreting the camouflage pattern from the fifteen-foot drawing. Then we numbered each section, one through seventy-two, and the house painters came in to fill all the spaces. It was paint by numbers. At the end the sign painters came in and added the color names.

IB: Some of the words used in the paint names refer to Charleston's Civil War history. Did you intend to reveal or comment on that era?

MZ: There was a "rebellion blue black." They were charged, but they were subtle at the same time. They couldn't be overly charged because Dutch Boy was also trying to sell paint. The names employed the idea of taking history and turning it into something else.

Our position was that we were raising a question, not so much indicating a right and a wrong. I think that has been true in all of the work—we weren't there to have our own judgments. In essence we were trying to allow the work to provoke and bring these issues up in order to question them, to generate dialogue, which to me is more important than looking the other way.

IB: Is art the best way to ask those questions? Did you and Kate ever think about questioning the status quo in other ways?

MZ: We had thought about it, but I don't think we were necessarily true activists. I think art has become more and more a place where those questions are easier to ask and the work is much more socially engaging for that reason. I am involved in Austin city government now because I am committed to this idea of being active and trying to change things. I think art allows us to work privately on public concerns, and perhaps within the framework of art you have an ability to do things without words

and without necessarily always answering to the public. It allows you a certain freedom, but then there is a certain point where you have to be responsible for what you produce.

IB: Did the neighborhood like *Camouflaged History*?

MZ: Actually yes, surprisingly. I mean, it was not something that was hated. I think here we took what we learned in Durham and put it to use. We made three different community presentations and went to community meetings and told the people exactly what we were doing and why. We tried to inform them of what the project was.

IB: Was there ever discussion of leaving the house painted that way?

MZ: The people from the neighborhood it was in wanted to keep the house as it was, and the owners wanted to keep the house as it was at least for a year. Interestingly enough, it was the community organization from the opposite side of the street, from the historic district, that fought it. Their comment was that the house was an eyesore and that the camouflage had to go. So in the end that helped the piece fulfill its own destiny, that is exactly what the project was trying to point out.

IB: You and Kate employed mapping as an aesthetic or organizational strategy several times, particularly in the first five years of your work. How did mapping help you sort out the content of these found histories?

MZ: Maps represent a particular place or region or set of abstract ideas about a particular place that is based on some kind of social formation. And even if it is an imposed system, like latitude and longitude on geology, it is still a social construct. The map was also a kind of container—you could talk about something much greater in a small space and the information was contained in a format that was presentable and transportable.

IB: When you and Kate came up with a system or a mapping strategy as part of a project did you ever alter the system for formal reasons?

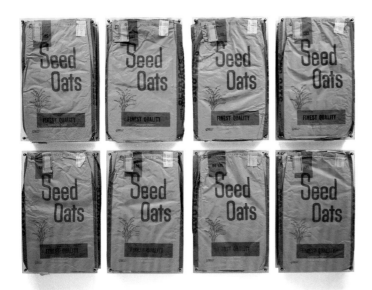

Feed and Seed
(Gelsinger Farm, Oats)
1989
Private Collection

MZ: We always followed it through all the way; in fact, there are some pieces that I think failed because they didn't resolve so well formally. In some ways, we were already thinking ahead and thinking what the map might look like before we chose it. But again we never manipulated it once we set the parameters.

IB: Would there ever be a reason to manipulate the final product or the material to make it more visually seductive or attract more viewers?

MZ: No, because then we would not have been true to what we believed. I think the seduction comes from what the work is made of.

IB: How did your project at EuroDisney come about?

MZ: We were invited to do an exhibition in Paris, and rather than taking work over we decided to react to what we found there to produce the show. One of the things that interested us was that EuroDisney had just recently been completed. It was brand new and everybody in Paris was talking about how much they hated it.

One reason the Disney Corporation was so hated was that they bought up lots of little farms and then just planted this thing right in the middle. They had bought up so much that they could have expanded ten or twenty times more and still not covered all their land. There was a lot of anger from the community because they bought all this French countryside and just plopped the park down. It was embarrassing how insensitive the Disney Corporation was.

IB: It is also interesting how Disney creates fictional "history" displays, creating American history through fake old towns, and so on.

MZ: EuroDisney has nothing to do with the French; it is really just American imperialism in another form. We were interested in perfume at that time and through our research we learned of a vinegar made with eight herbs that was supposed to keep away the plague. So we created a work based on this notion. We went out on the outskirts of the EuroDisney property and collected seeds

and stalks from these different weeds. Then we put these stalks, these plants in jars that we had collected from Paris flea markets, and filled the jars with vinegar. To complete the project we went around EuroDisney and planted the collected seeds, with each weed corresponding to a particular attraction in the park.

For example, with Snow White's castle, we filled the jar with thistle and then took thistle seed and planted it around the castle. If we had followed through it would have been nice to go back to see if any weeds had grown.

IB: Could you talk about the transactions made with the farmers for the *Feed and Seed* projects? Do you think of all those projects as one continuum: is it a series?

MZ: It is a series, but each farm's name is indicated individually. It is called *Feed and Seed* but then it will say, for example, Heisey Farm or Gelsinger Farm as well.

IB: Where were those farms?

MZ: They were all in Pennsylvania. We took an ad out in the *Lancaster Farming Journal*. The ad said something about collecting empty seed bags in exchange for some money as an art project.

IB: And those seed bags are normally just trash for the farmers, right?

MZ: Right, they burn them. There were about thirty responses to that ad, so we did preliminary interviews over the phone. We asked the people at each farm what they were planting, how many acres, when did they plant it, what is it used for, and so on. What they were growing was important to us; we liked it more if it was a dairy farm versus a beef cattle farm. We wanted the seed we were subsidizing to be for something other than growing feed used for fattening an animal to be killed. It was part of the project that the plants would go directly to create milk or food for people.

Eventually we narrowed it down to seven participants. Kate and I drove to each one of the farms and sat down and talked to the farmers, explaining who we were and what we were trying to

do. We had simple contracts that said if they showed us the cost of the seed we would give them ten percent right up front when we came to collect the bags and then if the bags sold in the gallery we would give them the rest of the money for their seed. So if a farmer spent three thousand dollars on his seed for that particular year and we got all the bags, then we would give him three hundred dollars up front and twenty-seven hundred dollars if we sold it. I think we only sold two or so; it wasn't like it was lucrative for most of the farmers.

IB: What was their response?

MZ: Well, there is always a kind of skepticism, but in the end they had nothing to lose, because we were going to give them their ten percent no matter what, just for stacking up the bags. If we never showed up it wouldn't have mattered, they would have just burnt them as usual. But most people actually were pretty nice. And it was easy for me to gain their trust because I could say I grew up on a dairy farm and now I make art, that was a little bit of a way in.

IB: What was the information that was sandblasted on the front of the Plexiglas that sandwiched the bags together?

MZ: It is the name of the farm, how many acres were sown from the bags, and whatever crop it was. We bundled them together because we wanted to package them like commodity art objects, playing off the idea of the marketplace of the art object and then going back to pay the farmers for the seed. So that was part of it, and you know, it is funny, because those things really look like art from the eighties.

IB: In the eighties there was a more active discussion about public art—what do you think has changed in public art now?

MZ: I'm not sure there is less discussion now, it is just different. There is still the design team approach but we aren't talking about it so much. It has been codified as the way of working in most art in public places programs around the country. In the mainstream of public or socially conscious work, artists like Rirkrit Tiravanija just did things, just went out and made food and

served it. It was a different approach. I think that our approach was more related to looking at a specific site and responding to that site. There was a real physicality to it; even though it involved a social interaction, there was still a physicality to it.

IB: It wasn't invisible art.

MZ: It wasn't just an event. Even when we got close to the notion of the event like in *Loaded Text* or *Half Monument, Half History* we still had a physical products even if it was temporary. However, had Kate lived who knows how our work may have evolved. We have drawings from the early nineties that say things like "Have milk and cookies with someone." I think the large-scale physicality still exists within the institution and institutionally sponsored exhibitions, but on the other hand it seems that a lot of artists are now working behind the scenes. They find their own opportunities to do things that are much more subtle and may affect a lot less people; they are still effective, but within a smaller group. You see less of the somewhat megalomaniac large-scale public art projects that used to be popular; the work is much more direct now.

IB: But there was still a directness to your work, even in the eighties. For instance, work and labor are a big part of your history.

MZ: Yes, and I would like to think that Kate and my work was a large influence on much of this new way of working in the social space. We, too, found our own situations to produce work and we too didn't care if it only affected a localized audience. This work I speak of was done fifteen or twenty years earlier than the current work that relates to a similar way of producing. We were heavy into the lecture circuit. Kate and I spoke at many educational institutions for much of our career together.

IB: Right from the beginning you used tractor-trailers, pallets, farming implements, gardening tools—the stuff of workers. Were those materials comfortable for you, or did you decide that these were going to be symbolic materials for you?

MZ: I think it was both, but perhaps it has more to do with com-

fort. I don't think we can ever escape our backgrounds and part of that, for me anyway, came out of being from a family of farmers.

For me, the most satisfaction came from the physical labor. You can have this moment of walking around and looking and thinking about things, but what was really satisfying was that actual writing on the sidewalk or...

IB: ...painting a house.

MZ: It seemed that the harder I had to work the more gratifying it was. It goes back to the idea of art-making—what is the value of the production of art versus the production of anything else? We began to look at those things and think about where our work can relate to the production of labor.

IB: It was a way to connect these two audiences of people.

MZ: Yeah, it was a form that related to what people knew. When we first went into a situation we would always be clear about the fact that we were artists; we never tried to hide that. We are artists, this is what we do, but we see ourselves working side by side with whoever you are, plumbers, carpenters, electricians, and so on. To us it was just a language that seemed commonplace, a way of infiltrating that system. It was not an elitist project, but instead we tried to make the information more attainable.

IB: Did your family view what you were doing as "honest" work, equivalent to what they were doing for work?

MZ: I don't think they completely understood what we were doing, but when Kate and I would go home to my family my brothers would have conversations with me about what we did. My brothers do very physical things: one is a mechanic, one is an auctioneer, a couple of them run bulldozers. They would always say, "I am making art, I am dynamiting," or, "I am digging a pond, that is my art." I would agree with them, and that was their way of understanding and relating to what we did. I always wanted to work with them on something, work with my brother and his bulldozers, work with my brother as an auctioneer—I always thought that would be interesting. I still do. I still would love to do that. Kate's

background was very different—her father was in advertising.

IB: So she knew about manipulating messages?

MZ: Yeah, and I think that played into our work extremely well. Kate was very witty with a great sense of humor and could appreciate subtlties. Her father was responsible for naming such products as "Lasso" and "Round-Up," which basically became one of the biggest selling herbicides in the world. It was more the name than anything else, and I think that really influenced our interest in paint names or tourist slogans. Her mom was a former model. She was also the Dial soap woman when Kate was a young girl. I think those influences surfaced in our work in various ways through out our career.

IB: In the beginning, what did you find lacking in institutions? Why does an institution need to be pushed into the public, why not engage in these dialogues from within an institution?

MZ: As young idealists we really had an attitude about that. We wanted the work to be out there, to create a dialogue with a much broader social audience. But eventually we saw that the gallery could be a place that might help us frame the rest of the work we wanted to do. I don't think we were so negative toward the institution. What we wanted was to find a public somewhere else. One of our earliest frustrations was that institutions weren't really willing to do that; now they are, but they weren't in the eighties, or they simply didn't have to.

IB: Do you think work like yours had a part in changing that?

MZ: I think it has. One of the things that made it difficult for us to sometimes get exhibitions was that no one knew what they were going to get. So often we would say, well we don't want to work in here, we want to do this. What happened at Artists Space is the perfect example. They had never done anything outside, and all I wanted to do was put something outside on the street in front of the building, but they had no clue how to do it. It was 1985, and they had never done that before. The project almost didn't happen because they had no way to get formal permits and insurance and

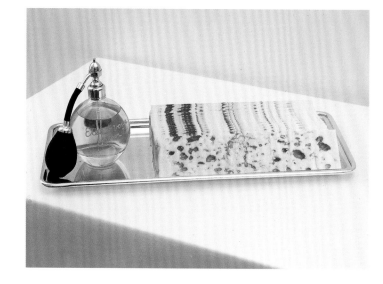

Êtes-Vous Servi?
1992
Perfume, atomizer, bookmarks
printed with images of French
cheese, silver tray
Scent matched to the smell of the
French National Archives

all of that. But instead we went to another institution to help: the Lower Manhattan Culture Council, which had a history of doing things in unordinary spaces. They could do it for us, so we collaborated with them to produce it. When we were in the Whitney Biennial in 1989 we didn't want to just put objects in the Whitney. We initially proposed growing corn, harvesting it, parking the harvesting equipment in front of the Whitney and serving the corn in the restaurant as corn bread, but that was way too complicated for them and so it didn't happen. We were actually told that they just wanted to hang things on the wall. But now they have a whole public art component to the Biennial that is off-site.

IB: Did you feel when you made objects that were for galleries and museums that they were in some way a compromise?

MZ: No, never. It was a learning experience for us to make works for the gallery. We treated it just as we would treat any other context. What we did for those galleries was slightly different from some of the other projects, but many times they also grew out of those other projects.

IB: They weren't just souvenirs of those ideas?

MZ: They weren't just souvenirs. They were individual works, and actually we loved seeing a show of these things.

IB: Where did you get your cabinets, and was it important where they came from?

MZ: All of them were American. They were somewhat primitive, mainly because that showed their histories as objects and their uses more readily. It wasn't necessarily done to be overtly decorative. Most of them were late nineteenth century. For us, that was a time period that becomes collectible. It always has to do with something that is just beyond your grandparents, those things you really want to collect because they are things you can't have. You long for these things that you don't know, and that particular sort of late nineteenth-century furniture represented that to Kate and me. It was one step removed from what we could actually have or what we grew up with.

We had a certain kind of aesthetic. We knew we wanted a pie safe for *The Smell and Taste of Things Remain* (1992), but it could have come from anywhere, as long as it had the right aesthetic and the right number and arrangement of shelves.

IB: Do you feel like history is misused?

MZ: I think history itself is problematic because it is written from a particular sort of ideology, so in that sense it always needs to be questioned. That is the basis of a lot of our work. Then, also, history over the years has become modified in a way that everything else has been modified. A city might get a grant to make its downtown over, but that ends up kind of falsifying it, almost over dignifying it, so that history becomes fake, or reconstructed in a way that is no longer meaningful.

IB: It's a stage set.

MZ: It's a stage set, yes. I go back and forth as to whether we should just bulldoze everything that has history and start over. Of course, that was the mentality of the sixties and seventies and it didn't work. Our work was a way of engaging a particular place, because every place has history. You go through and you look for things that have been reported, or preserved, or presented as a way of looking at that place historically, but you suddenly realize only certain things have been represented, or kept, or glorified.

IB: There are details that are left out.

MZ: Kate and I were always looking for the details that were left out and how we could then use those details to make our work. It is a nice juxtaposition to the work of someone like Fred Wilson, who looks at these issues from a very specific cultural background.

IB: He is looking at collections, and sites, and histories from his personal experience. Your pieces are as autobiographical as his are in a certain way, finding parts of your own past, your own family in these places. Do you ever think about your works as being autobiographical?

MZ: I wouldn't say specifically autobiographical. I think certain

aspects clearly go back to our early histories. When I teach now, I often say, "Find yourself in this, because that will make it important to you and carry you through, because if it is not something you are personally invested in, it is not going to interest anyone else." You have to have some love for what you are engaged with. There are ideas of history and details that always interested both of us, both Kate and me.

IB: Is finding yourself in a piece harder when you are working as a collaborative team?

MZ: No. I think it is harder now.

IB: You came from different backgrounds and you had different interests. Did you ever disagree and just abandon a project because you couldn't find a compromise? Did you ever see it happening one way while she saw it happening another way, and not be able to come together on it?

MZ: We wouldn't abandon something because we couldn't agree. That was just part of the process.

IB: Are there places that you always wanted to work that you didn't get a chance to?

MZ: Before Kate got sick we started having a lot of discussions about where our work was going and how we were making projects. We felt we were being pawned, that we were being manipulated by the art system, the curatorial system. We were being asked to do shows or coerced into theme shows that we weren't necessarily interested in. It is hard to say no to opportunities, and we needed money, but I think we wanted more of what we had back in our early career. What we did then was different because they were self-initiated projects. This goes back to thinking about that very early influence from Christo and Jeanne-Claude: this idea that you decide, and then you just go out and make it happen. Kate and I both admired that about them. But it was through our successes that we got into the whole system. We were constantly producing, but not always doing the kinds of things or working in the places in which we wanted to work.

I think one of the biggest projects that never happened for us—and one that I really wish would have happened—was one for which we applied for a grant from the Guggenheim Foundation but never got it. We wanted to rent a Winnebago and drive for a year, going into small towns and, in a way, repeating what we did for the Durham project by doing civic improvements. The idea was to go to coffee shops and diners and talk to people, and find out what needed to be done in the town, but then make an artwork out of doing that work. We would stay there a couple of weeks and than move on to the next place and start all over again. If there was anything we wished we could have done, I think that was it. Right about that time we were thinking about how we were tired of going from one institution to the next and just putting stuff up. We wanted to produce something more engaging and down to earth.

IB: You had been getting farther away from your audience.

MZ: Yeah, we were getting farther away from what we really started out to do, which can easily happen because success allows that—there are time pressures and deadlines. We were also trying to look at what the next part of our career would be like. We were asking ourselves if we were going to continue this way or try to shake it up a little more, change it.

IB: You were doing so many projects during those ten years working with Kate that you didn't have time to revisit many project sites after. Is that something you would have liked to do? How do you evaluate the impact of your work?

MZ: I don't think there is a measure. You just trust that somewhere along the line it has an effect. What is important is that there is an immediacy to the actual project, but that there is also a memory. You don't have to move hundreds and hundreds or thousands and thousands of people to actually be effective. If you affect a few people, then you are doing the job.

This interview took place over two conversations, January 11, 2005 at the Tang Museum, Saratoga Springs, New York, and June 28, 2005 at Mel Ziegler's studio, Austin, Texas.

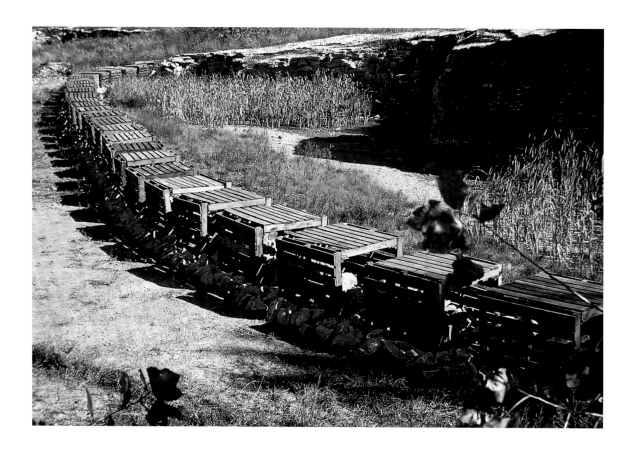

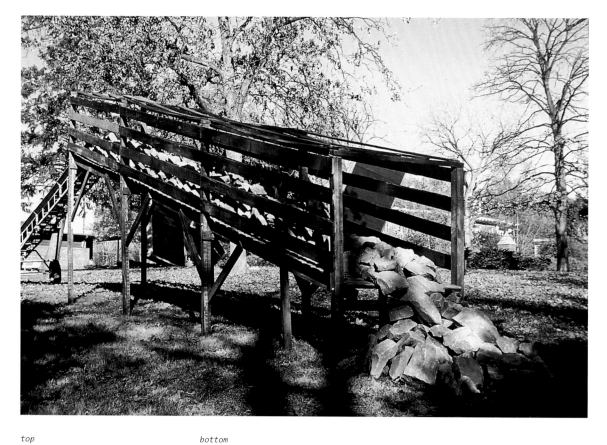

right and bottom right
Kate Ericson
Rock Extension
1980
Artist-initiated project,
Houston, Texas

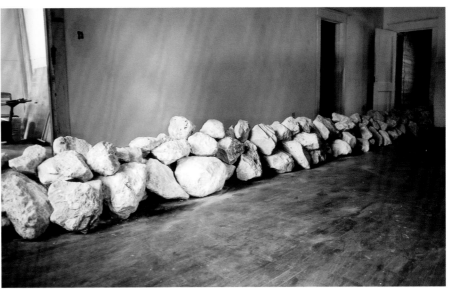

Kate Ericson and Mel Ziegler
Coal Chutes and Wall Piece
1978
Artist-initiated project, Kansas
City Art Institute, Kansas City,
Missouri

The artists' first collaboration.

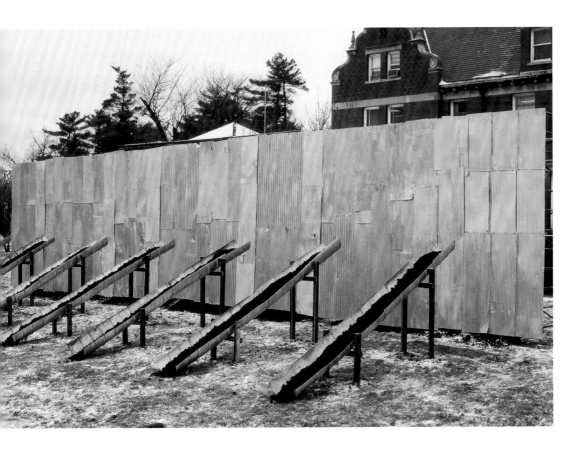

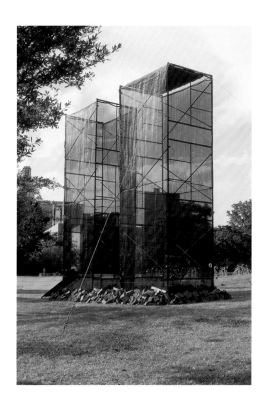

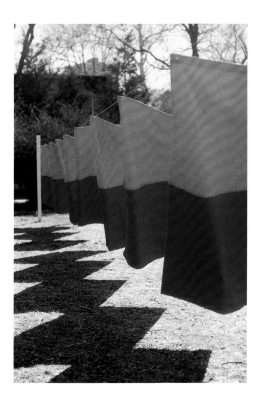

far left
Kate Ericson
Twin Towers
1979
Artist-initiated project,
University of Texas, Austin,
Austin, Texas

left
Kate Ericson
Red Line/Green Line
1977
Artist-initiated project, Kansas
City Art Institute, Kansas City,
Missouri

Kate Ericson
San Jacinto Stone Project
1979
Artist-initiated project,
Houston, Texas

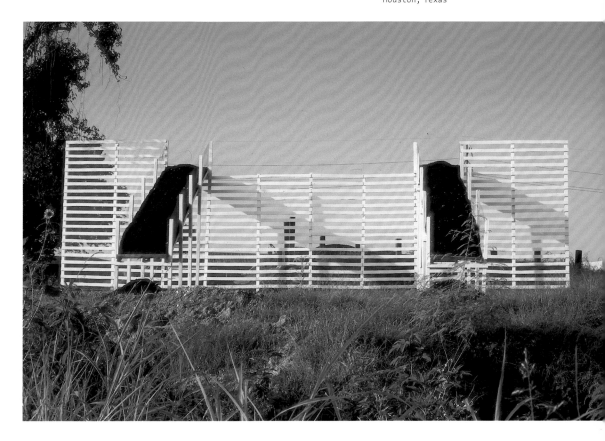

opposite
Kate Ericson
Suspended Brick Wall
1979
Artist-initiated project,
University of Texas at Austin,
Austin, Texas

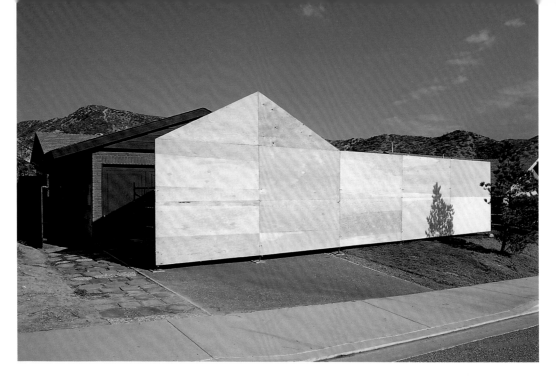

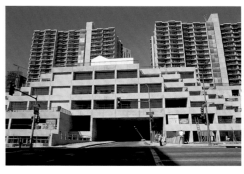

top and right
Kate Ericson
House Sign
1981
Artist-initiated project in two
versions: on the suburban property
of a private homeowner in Val Verde,
California, and on the roof of
a parking garage next to a high
rise building in Angeles Plaza, Los
Angeles, California

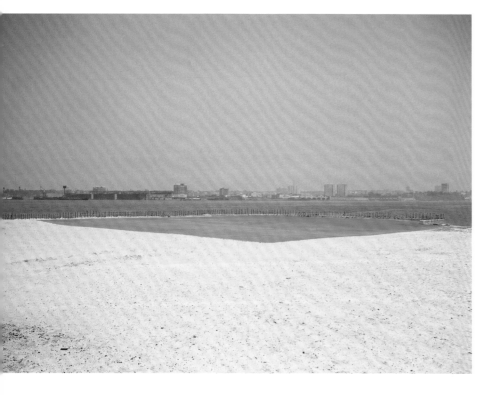

left and above
Kate Ericson
The Happy Hour
1984
Project for *Art on the Beach 1984*,
Battery Park City Landfill, New
York, New York (In collaboration
with Juergen Reihm and Ellen
Fisher)

opposite
Kate Ericson
Tombstone
1983
Project for *Window on Broadway*, New
Museum, New York, New York

THE KANSAS CITY STAR

VOL. 97, NO. 279 MAIN EDITION ★ ★ KANSAS CITY, THURSDAY EVENING, JUNE 23, 1977 — 32 PAGES Sports, 671-3821—News, Business Office, 421-1200 Want Ads, 221-6000—Circulation, 221-6200 15c

Mel Ziegler
The Front Page
1977
Proposal for blank front page of
the newspaper, *Kansas City Star*,
Kansas City, Missouri

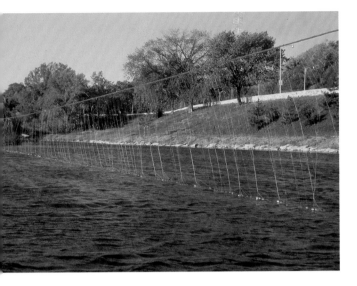

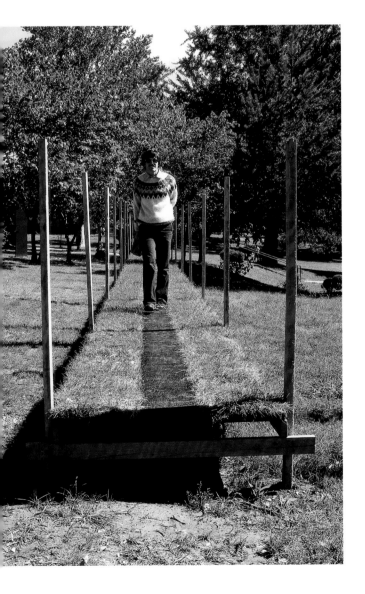

top left
Mel Ziegler
1,000 Bobbers
1977
Artist-initiated project,
Kansas City, Missouri

bottom left
Mel Ziegler
Asphalt Path
1977
Artist-initiated project, Kansas
City Art Institute, Kansas City,
Missouri

Mel Ziegler
Winter Wheat
1977
Artist-initiated project, Kansas
City Art Institute, Kansas City,
Missouri

Mel Ziegler
Red House
1979
Artist-initiated project with
Jhan Lampkin and King Cox,
homeowners, Houston, Texas

Mel Ziegler
Under Construction
1979
Artist-initiated project with
private homeowner, Houston,
Texas

Mel Ziegler
Demolishment
1980
Artist-initiated project with
demolition company, Houston,
Texas

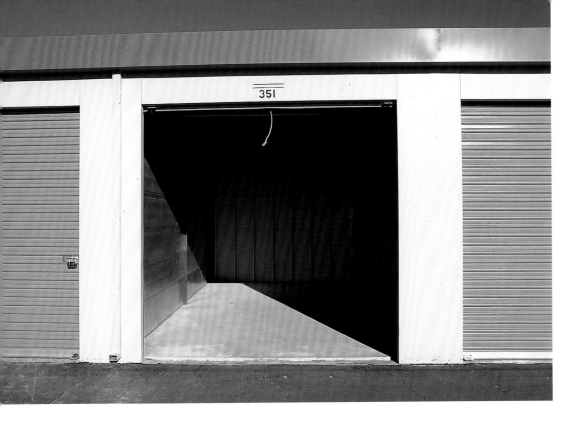

Mel Ziegler
CalArts Project
1980
Valencia, California

Mel Ziegler
Front Lawn
1981
Artist-initiated project with
private homeowner, Los Angeles,
California

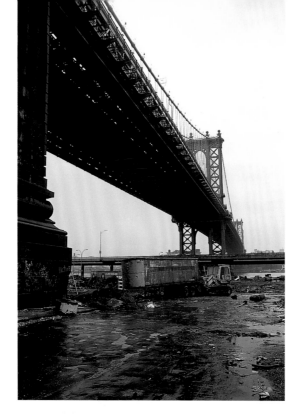

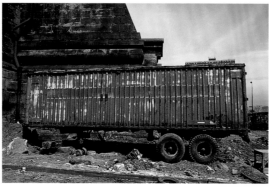

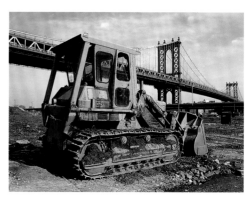

Mel Ziegler
**Yellow Bulldozer, Red Trailer,
Blue Bridge**
1983
Mail art project, New York,
New York

Mel Ziegler
On Broadway
1984
Artist-initiated project,
New York, New York

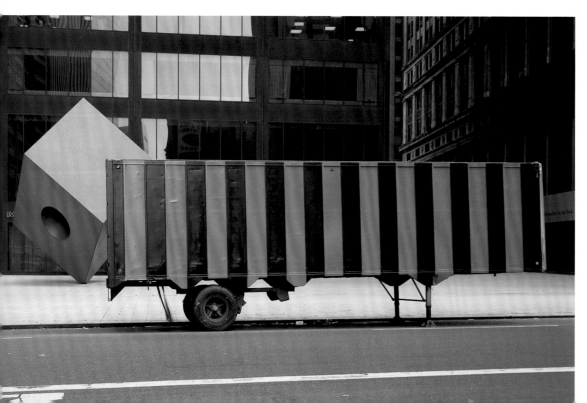

opposite
Mel Ziegler
Pastellus
1984
Artist-initiated project,
New York, New York

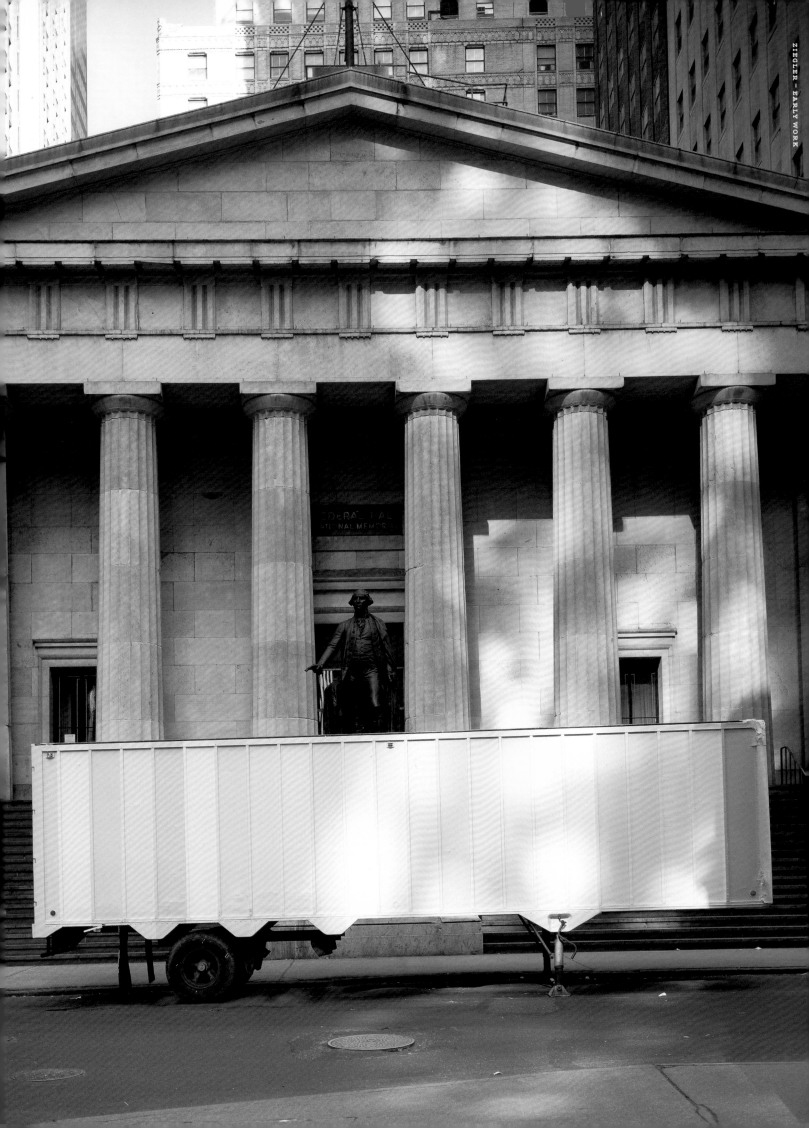

Kate Ericson and Mel Ziegler
Public Cathedral
1980
Project for the Houston
Festival Foundation
Exhibition, Houston Public
Library, Houston, Texas

Kate Ericson and Mel Ziegler
Garden Sculpture
1985
Ward's Island, New York
Sponsored by Artists Representing
Environmental Arts (A.R.E.A.)

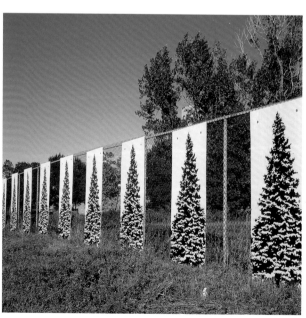

top
Kate Ericson
Oak Floor
1984

bottom
Mel Ziegler
Instant Landscape
1984

Both from *Selections from the Artists File*,
Artists Space, New York,
New York, 1984.

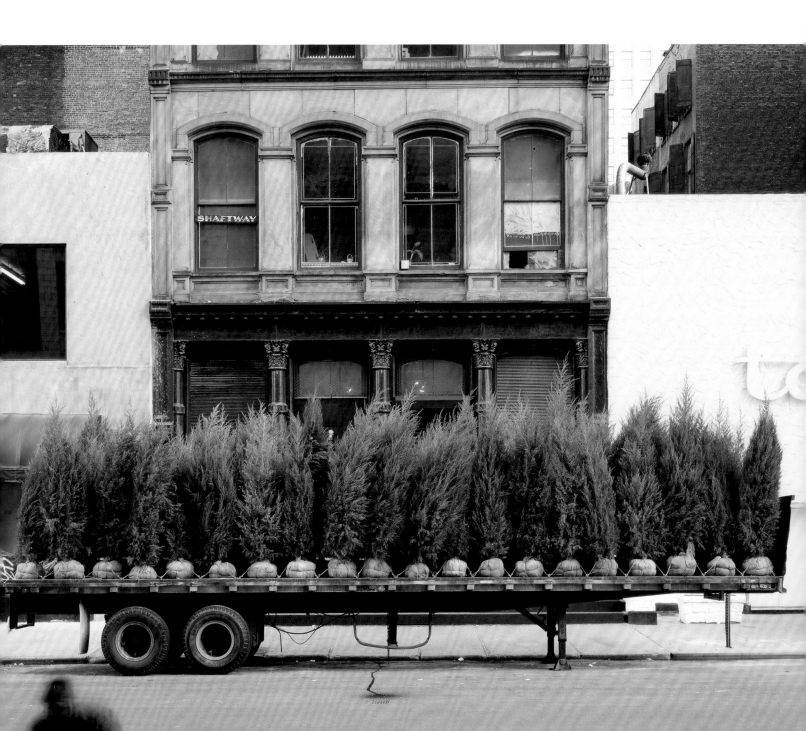

Views of front lawn at
23 Michael Avenue, Bellport,
New York

Unplanted Landscape

1985
Artist-initiated project
with John and Teri Odwazna,
homeowners, Bellport, New
York

The artists provided a
complete set of plants to
landscape a previously
barren front lawn on the
condition that they remain
above ground for one
month. The homeowners helped
select the plants and at
the end of the project they
were planted.

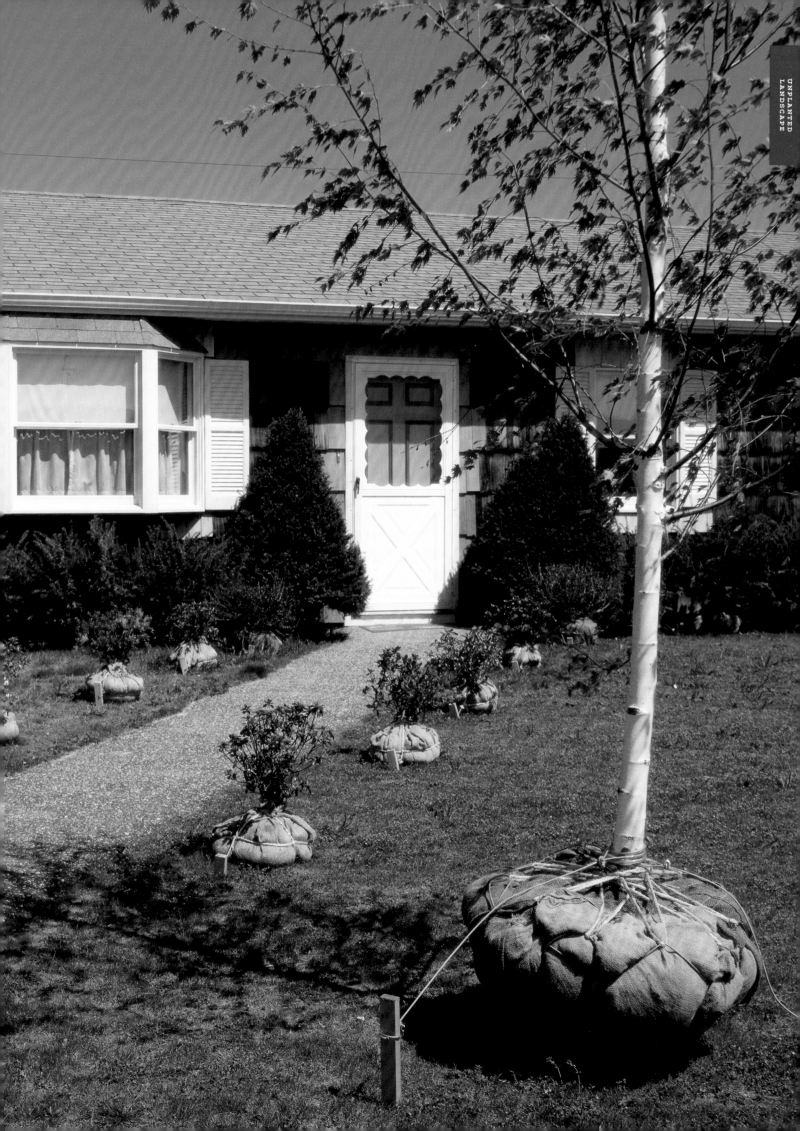

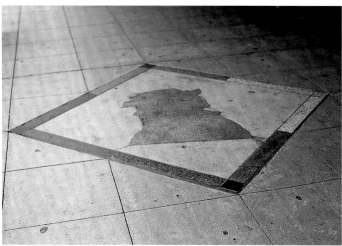

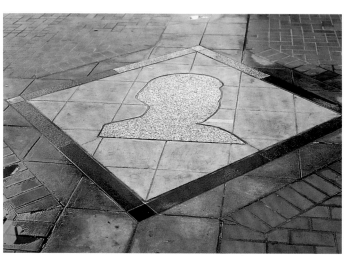

Traveling Stories

- -

1985
Downtown Seattle Transit
Arts Program, Seattle,
Washington

Quotes from Seattle
citizens about movement
were sandblasted on stair
risers throughout the
Seattle transit system.
The citizens' silhouettes
were inlaid into the
sidewalk at the top of each
stairway.

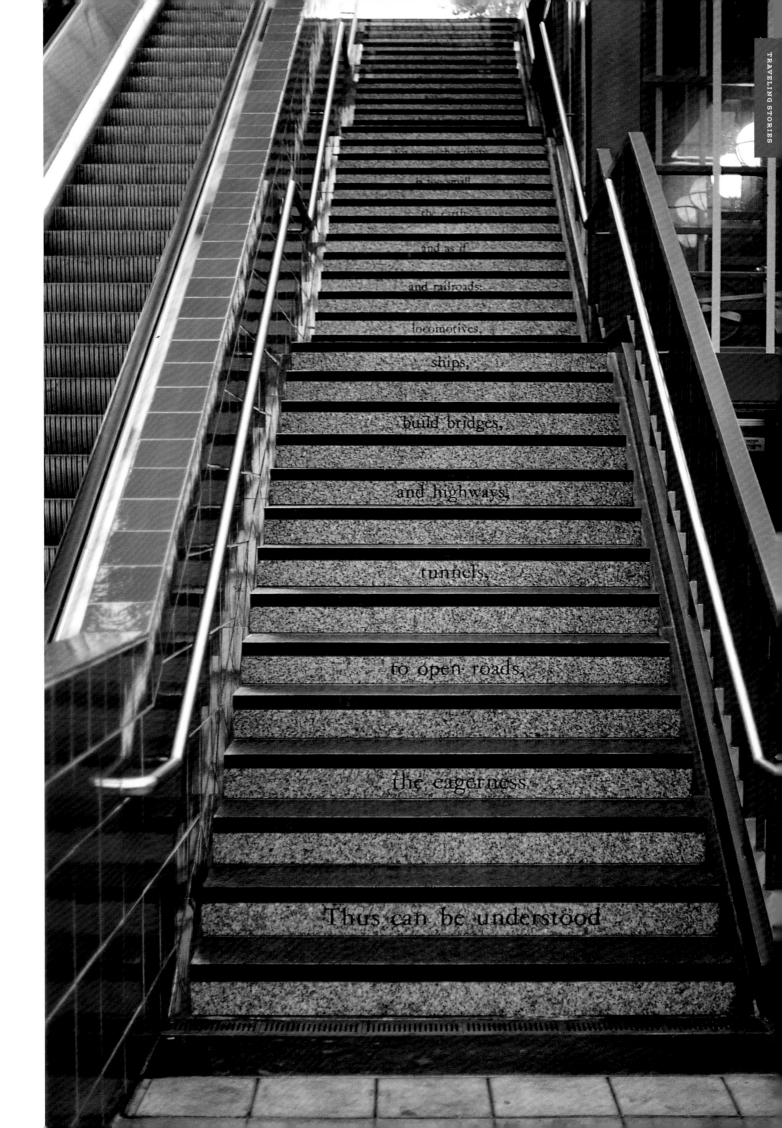

is too small

the earth

and as if

and railroads:

locomotives,

ships,

build bridges,

and highways,

tunnels,

to open roads,

the eagerness

Thus can be understood

House Monument

1986
Los Angeles Institute
of Contemporary Art, Los
Angeles, California

Texts about the idea of house or home were hand written by the artists on a quantity of lumber sufficient to build an average-sized family dwelling. Viewers could read each layer of the stacked wood (approximately 1,300 pieces) like a book. An advertisement was taken out in a local paper offering the lumber for sale to someone interested in building a primary residence. The building materials were sold to a homebuilder at half price. As part of the project all traces of the texts had to be buried in the construction of the house.

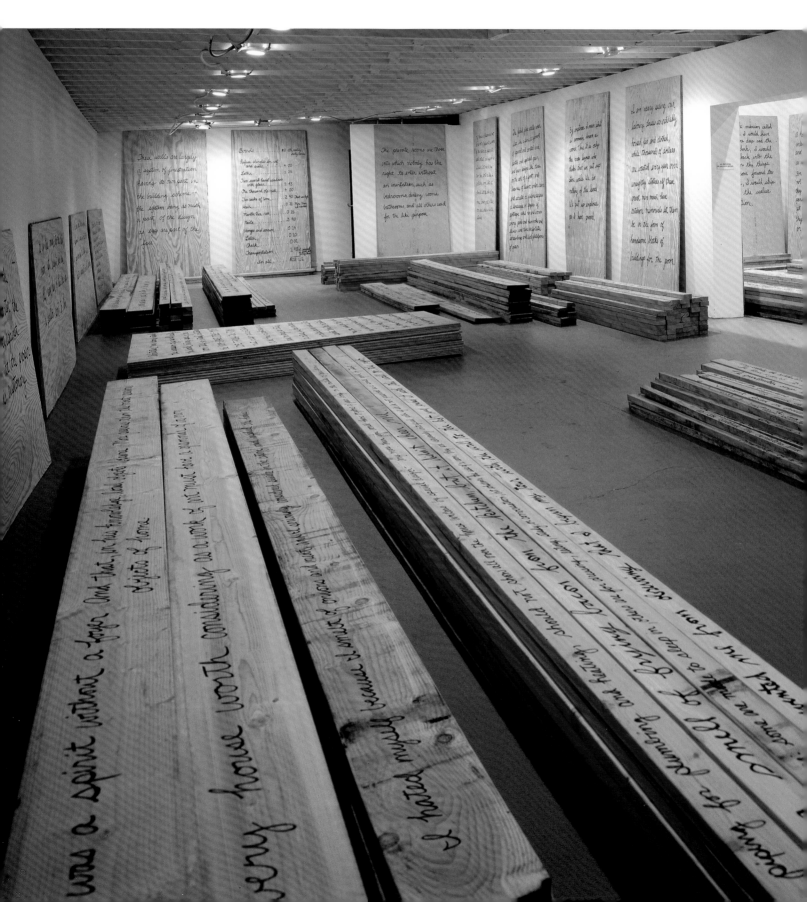

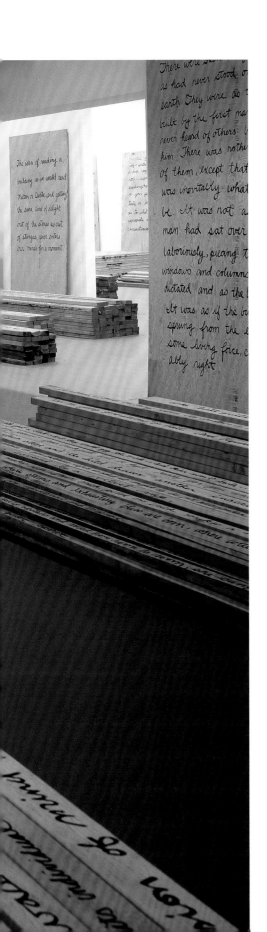

LANE RELYEA

HOUSE MONUMENT

IN ITS INITIAL MANIFESTATION, KATE ERICSON AND MEL Ziegler's *House Monument* (1986), opened as a month-long exhibit in a Los Angeles gallery. The show consisted solely of stacks of plywood and two-by-fours, over thirteen hundred pieces of wood total, all the lumber needed to build a standard two-story house. Inscribed by hand on each piece of wood was a quote about houses and homes, which the artists had gathered from a variety of sources in philosophy, literature, folklore, and beyond. "Up near the roof all our thoughts are clear," read a line from Gaston Bachelard, written in Sharpie marker across the length of a two-by-four; to which Nathaniel Hawthorne replied on a nearby sheet of plywood, "What we call real estate—the solid ground to build a house on—is the broad foundation on which nearly all the guilt of this world rests." Concurrent with the show, the artists ran a newspaper ad and sold the wood at half price to a pair of expectant homeowners. In the second phase of the project, the buyers of the wood erected *House Monument* as a finished residence on a vacant lot in the Southern California suburb of Costa Mesa.

Like much of the best late-1960s conceptual art from which it obviously draws inspiration, *House Monument*

63

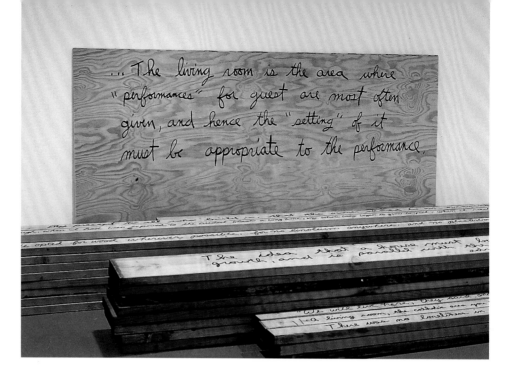

Installation view: LAICA, Los Angeles

lends itself to such straightforward description. The work unfolds with a crisp, task-driven pragmatism; it mobilizes a certain readymade (a common, public-domain house plan) through a set of real-world institutions and arrangements (the library, the lumberyard, the Los Angeles housing market) and in the end accomplishes a concrete task (building a home for a family to live in). And yet *House Monument* cannot be appreciated as so purely literal and functional, especially if its title is taken seriously; it must also be seen as symbolic and representational. Not only does the work tidily summarize the history of post-conceptual art practice, bringing together the archive and the landscape, dematerialized text and real-world processes and spaces, but it also reintroduces a type of sculptural object that long predates the real and the readymade—namely, the public monument.

But how can a private residence in the suburbs be considered public? And how can this one house, even granting its street-oriented frontality and impressive two-story scale, stand out as monumental from all the other nearly-identi-

cal homes in its sprawling neighborhood? It is precisely the split between public and private that *House Monument* resists. Or rather, Ericson and Ziegler's project avoids a destiny common to much modern art, of having its post-exhibition existence divided between, on the one hand, a privately owned object (say, a painting hung over the couch) and, on the other, reaction, opinion and discourse circulating through the public sphere (in the form of conversation, newspaper and magazine reviews, exhibition catalogs, and the like). Here the whole house, its couch as well as the painting, is made into an art object, albeit an object that literally has at its core a public dialogue about its own possible meanings. Reversing the trajectory typically experienced by works of art, *House Monument* starts as a spread of commentary, assuming the form of the library's ordered stacks and categories; only upon leaving the gallery does that spread get forged into a single, integrated entity. The gallery installation offers a wide-ranging discussion, inscribed on the building materials, for private contemplation, while in Costa Mesa a private home assumes the status

of a work of art. And if the final, built house helps focus this discussion by figuring it, granting it a concrete, summarizing form, the discussion in turn expands and generalizes—makes representative and symbolic—the house. *House Monument* ends up as both an anthology and a diary, at once encyclopedic and everyday, archetypal and individual.

Braiding together words and wood, Ericson and Ziegler's project chronicles, duet-like, this passage from the general to the particular, from architectural blueprint to finished construction, plan to elevation. Superimposing the library and lumberyard, *House Monument* starts with raw inventories and their organization and cataloguing, with wood and text fitted to standard lengths and abstract categories. The reigning image here is of a cultural warehouse, a vast archive gathering the conventions of storytelling and carpentry. Moved to the construction site, this material is then taken off the shelf and put to practical use, made to fit specific situations. As wood gets cut, text is edited. At every step, architecture serves as a metaphor for narrative structure and vice versa: rooms and stairways,

Ron and Diane Khatablou, homeowners,
Costa Mesa, California, 1986

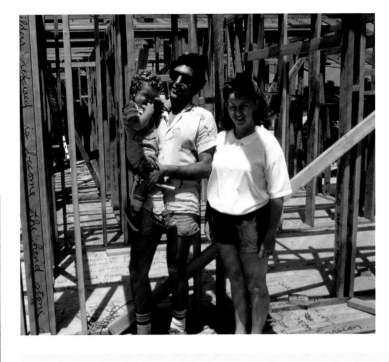

Newspaper ad: *House Monument*

doors and windows speak of beginnings and ends, transitions and retreats.

If such metaphors account for the work's expansiveness—for how it opens up associations and meanings beyond the mere givens of wood, quoted language, even the house itself—these same metaphors also keep *House Monument* from becoming *too* monumental. The play of textuality leads to endless misrecognitions: while the quoted literature insists on a figurative reading of the house, the actual wooden structure reads that figure too literally. All the appropriating, cross-referencing and jigsawing of standard units of timber and discourse brings to mind Roland Barthes's famous description of the text as "dilatory...structured but off-center, without closure...a serial movement of disconnections, overlappings, variations...a fabric woven entirely with citations, references, echoes."[1] But *House Monument* can't be said to yield entirely to textual dispersion and drift; a secure home does get built, and even in the library the artists' research is holistic, cutting across and synthesizing disparate disciplines (beside Hawthorne and Bachelard, those quoted include

Harry Truman, the surrealist poet Joe Bousquet, the nineteenth-century Scottish songwriter Caroline Nairne, and the amateur anthropologist Lord Raglan). Neither decentered archive nor uniquely authored work, *House Monument* approximates more closely the intersection where saying and doing come together in actual utterances and everyday speech. Its words belong not just to the bookshelf but to "the real language of the woodcutter," to quote an earlier, more labor-minded Barthes from the 1950s: its "language is operational...a language thanks to which I '*act the object*.'"[2]

Being a product of collective labor, both mental and manual, is how *House Monument* rises to the level of public symbol and earns its name. But this same labor also keeps Ericson and Ziegler's monument from overly rigidifying, becoming statuesque, authoritarian. Fluid temporal process and fixed sculptural representation simultaneously support and overturn one another; in the end it's impossible to distinguish the completed house from all the operations involved in conceptually and materially piecing it together, all the researching, bartering,

writing, and nailing (not to mention the anticipated remodeling and redecorating of the house by each subsequent owner). While Ericson and Ziegler dedicate their project to housing as a public issue and social ideal, somewhat in the manner of earlier moderns like Le Corbusier and Rietveld, it's an ideal left open to debate, contested by myriad voices, a work forever in progress. Embodied here is not some static, eternal Truth but dialectical process itself. From the gallery where cultural enthusiasts dig through piles of lumber, to the construction site where carpenters read poetry and philosophy— and, as they saw and hammer, re-write it, too—*House Monument* embroiders not just text and lumber but action and reflection, theory and practice, absorbing thinking into making as making, in turn, gives concrete expression to thought.

NOTES

1. Roland Barthes, "From Work to Text," *Image-Music-Text*, trans. Stephen Heath (New York: Noonday Press, 1977), 157–60.
2. Roland Barthes, *Mythologies*, trans. Annette Lavers (New York: Hill and Wang, 1972), 145–46.

Construction views: *House Monument*

Boards, $8 03½, mostly
 shanty boards

Refuse shingles for roof
 and sides, 4 00

Laths, 1 25

Two second-hand windows
 with glass, 2 43

One thousand old brick, . . . 4 00

Two casks of lime, 2 40 That was high

. 0 31 More than
Hair, I needed.

Mantle-tree iron, 0 15

Nails, 3 90

Hinges and screws, 0 14

Latch, 0 10

Chalk, 0 01

Transportation, 1 40

 In all,

Completed house, Costa Mesa,
California

If You Would See The Monument, Look Around

1986
Sponsored by Creative Time Inc. and Central Park Summer Stage in cooperation with New York City Department of Parks and Recreation and Central Park Conservancy, Central Park, New York, New York, August 3–September 14

Tools were collected from the crews that maintain Central Park. The tools were coated with bronze paint and returned to the park workers for use. The event was publicized with a postcard that could be found in kiosks around the park. In trying to see the tools in use, viewers would experience the park as a work of art itself.

Postcard distributed in park

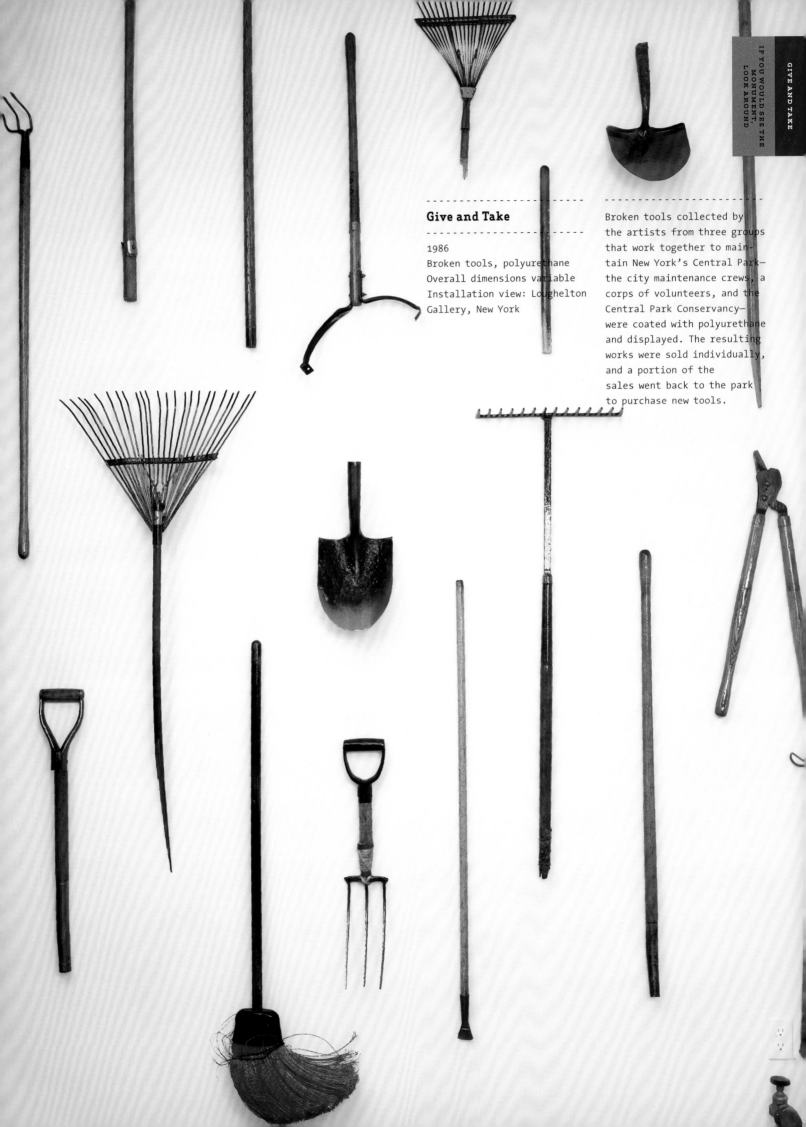

Give and Take

1986
Broken tools, polyurethane
Overall dimensions variable
Installation view: Loughelton
Gallery, New York

Broken tools collected by the artists from three groups that work together to maintain New York's Central Park—the city maintenance crews, a corps of volunteers, and the Central Park Conservancy—were coated with polyurethane and displayed. The resulting works were sold individually, and a portion of the sales went back to the park to purchase new tools.

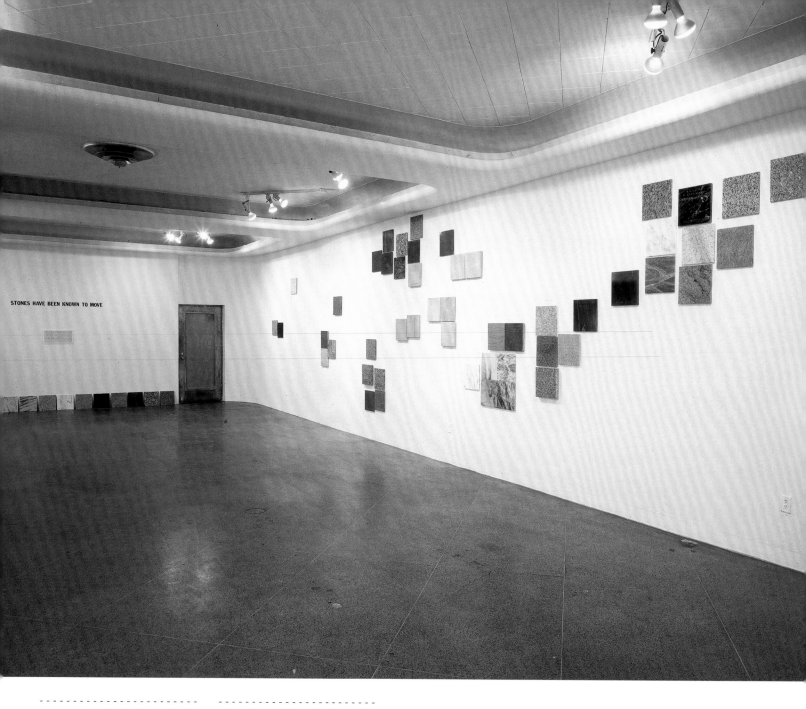

STONES HAVE BEEN KNOWN TO MOVE

Stones Have Been Known to Move

1986
Sandblasted stone samples,
metal brackets, vinyl text
74 stones: 12 x 12 inches
each
Overall dimensions variable
Courtesy of Mel Ziegler,
Austin, Texas
Installation view: White
Columns, New York

The artists collected
promotional samples of
American marble, granite,
limestone, and travertine
from various stone
distributors to produce
this piece. Each stone is
sandblasted with the latitude
and longitude of the quarry
from which it was mined
and the name and location of
a known example of its
use. The stones are hung on
the wall according to the
coordinates of the quarries,
forming a large-scale map
of the United States.

BILL ARNING

STONES HAVE BEEN KNOWN TO MOVE

THE ROLE OF FIRST-PERSON NARRATIVES IN CONJURING up Ericson and Ziegler's work remains crucial, and it is with that in mind that I share my own adventures with the pair many years ago, an endeavor that proved to be a challenging growth experience for me. I became the director of White Columns in 1985, an alternative arts space then located near the Hudson River, west of SoHo, after having worked there for little over a year. Thomas Solomon, the previous director, had generously handed me a half dozen of his recent discoveries to ease my transition into the job, and among them were Kate Ericson and Mel Ziegler. They had previously participated as separate artists in an exhibition at Artists Space, but now presented their works to me as a collaborative team.

Their first proposal for White Columns was a nearly invisible work: installing wainscoting on the gallery wall. This decorative interior finishing, used to protect walls and conjure the stately aura of Victorian homes, would look inappropriate in any contemporary art gallery space that since the 1960s had progressively been stripped of its remaining salon details. Ericson and Ziegler's version would have looked even more strange, since they proposed

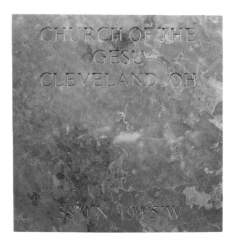

to mount it not at its usual floor-to-waist height, but from belly-level up to eye-level, and to paint it the same white as the gallery wall. It would produce a very subtle effect, with the immediate visual impact being that of a large, empty gallery. Perhaps from youthful inexperience, I felt uncomfortable with presenting such a rigorously reductive work in my first season as director, especially because other art spaces were presenting bright, aggressive paintings by emerging artists. Despite my independent spirit, generational peer pressure discouraged me from promoting a near-empty exhibition along the lines of Yves Klein's *La Vide* (1958)—and without the French mystic's blue cocktails! If I had bothered to commune with the spirit of sculptor Gordon Matta-Clark, one of the cadre of Soho denizens who had founded White Columns a decade before, I might have had the vision to proceed. Instead, I looked for excuses not to install that project.

We soon realized that installing wainscoting in White Columns' west Spring Street location (an elegant, Art Deco former bank lobby with recessed bay lighting) would entail severe logistical problems. With all of the walls curved, commercially available wainscoting would be difficult to install. The piece was abandoned. I am ashamed to admit it, but at the time I was relieved.

I was much more enthused over their second proposal, a brash and more visual piece, but as a neophyte arts administrator I had no idea how to make it happen. Near White Columns stood the Ear Inn, a celebrated bar and restaurant frequented by artists and musicians. Stories about the name vary: either the owners could not afford a new sign, or the landmarks law affecting this very old structure forbade any additions, so with a little black paint the owners covered the ends of the neon B, transforming the name from "BAR" into "EAR."

Ericson and Ziegler noted the surreal quality of a building sprouting an appendage reading "EAR," which flapped ear-like off the edifice. The building that housed White Columns, 325 Spring Street, belonged to the Port Authority of New York and offered subsidized rent to not-for-profit arts groups. It had a highly anthropomorphic appearance, topped with a head-like structure. Ericson and Ziegler proposed installing a sign on it identical to the "EAR" sign but saying "NOSE," making the architectural anthropomorphism explicit.

The artists already had a good deal of experience with commercial manufacturers and the authorities who grant the permits needed to actualize such a piece. Yet when the Port Authority gave me the list of required insurance waivers and permissions, I gave up. All that exists of today of this proposal is the artists' handmade photographic mock-up.

Ericson and Ziegler's method required working with institutions and individual curators to develop projects over time, presenting proposals that sometimes appeared unfeasible and must be vetted through discussion. Yet from my discussions with curators who also worked with them, almost no work reached an "ultimatum moment." Through a combination of Ericson and Ziegler's patient temperament and generous logic, their work usually managed to avoid the critical impasse point where artists must walk away from commis-

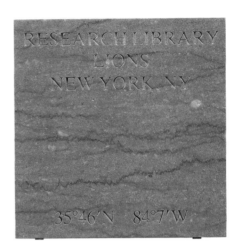

sions in defense of the integrity of their art. Many of Ericson and Ziegler's proposed projects were not realized for logistical reasons, and some unpleasant situations arose. But because their work required negotiation merely to come into existence, they always expected to engage in open-ended dialogue. My failure to bring into being either the wainscoting project or NOSE into being did not stop White Columns from mounting the first Ericson and Ziegler collaborative exhibition in a New York gallery space.

The work that resulted, *Stones Have Been Known to Move*, put White Columns' expansive curving wall to great use and required no outside permissions. Ericson and Ziegler collected marble, granite, limestone, and travertine samples from dozens of dealers. As part of their business, stone dealers send out these samples to impress potential clients with the stones' beauty. Their sales pitches also include examples of celebrated uses of the stones. Despite the luxuriousness of these building materials, their use in tawdry settings, such as bathroom stalls, was just as common as classier examples, such as Boston's Four Seasons Hotel or the Supreme Court in Washington, D.C. The artists considered it crucial that these lovely stone squares already existed as promotional materials for the stone dealers, rather than as a medium crafted by the artists.

Each stone was sandblasted with the name and city of its exemplary use, along with the longitude and latitude of the quarry where it was taken from the ground. The artists then mounted the samples on the wall using the guidelines of the longitudinal and latitudinal coordinates, a system that resulted in a sketchy but unmistakable map of the United States. The diagonal upward thrust of the right unmistakably indicated the Northeast, while the West Coast appeared significantly more amorphous. Once viewers recognized they were looking at a map, they soon understood that the words on the stones detailed a location different from that of a conventional map. Squares designated as belonging in New York, Boston and Washington, D.C. were instead clustered somewhere in the lower Midwest.

Most people do not know the longitude and latitude of even familiar locations, so this map seemed very strange indeed. The work made apparent a massive shifting of the skin of the earth from one place to another in order to construct, cover, and decorate buildings. From the viewer's position above this map one could see the whole country as a text in constant flux that could be read as both information and poetry.

Winter Cellar

1986
Canned goods from Pennsylvania
Dutch country, sandblasted
glass jars, metal shelf
Dimensions variable
Private Collection
Installation view: Loughelton
Gallery, New York

Project collaborators:
Claire Drescher, Ruth
Drescher, Ada Sensenig, Anna
May Stouffer, Josephine
Wise, Carol Ziegler, Esther
Ziegler, Jesse Ziegler.

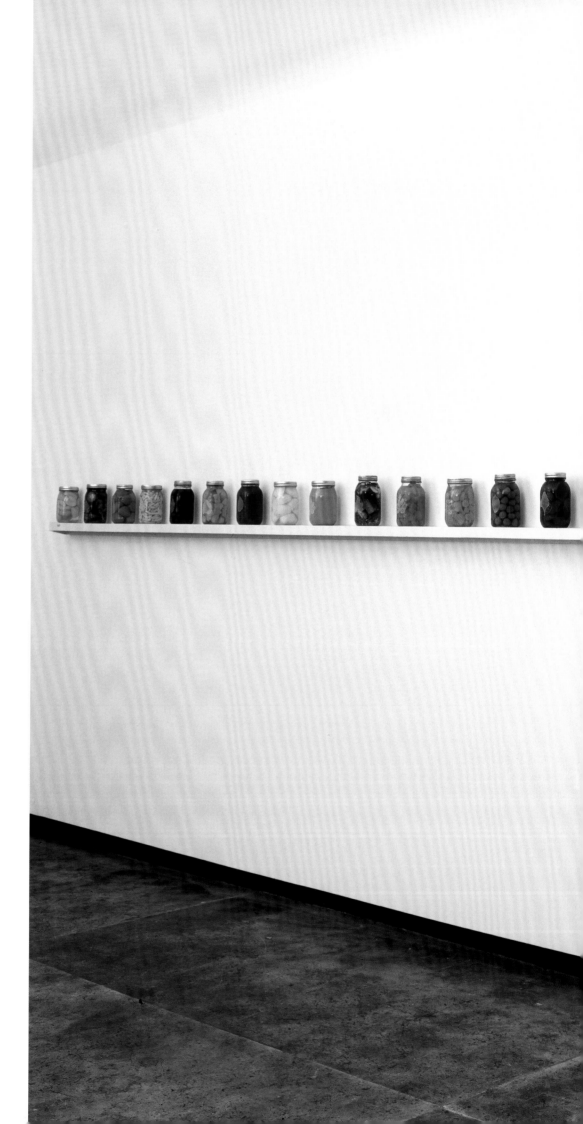

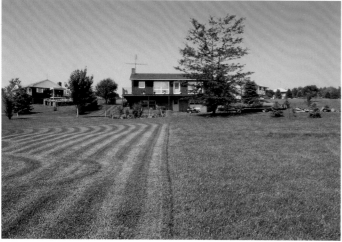

above
George and Maria Palmer

- -
Half Slave, Half Free
- -

1987
Artist-initiated project
with private homeowner,
Hawley, Pennsylvania

- -

A homeowner was compensated
to not mow half his lawn for
a two-month period.

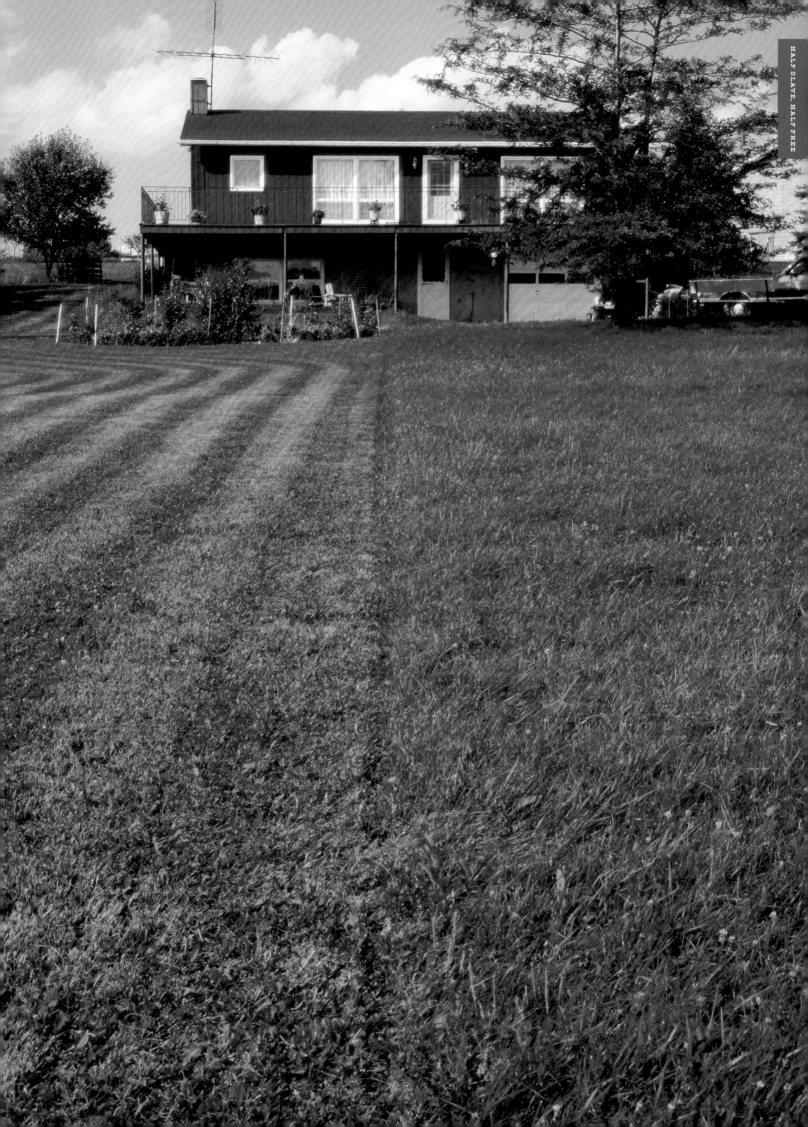

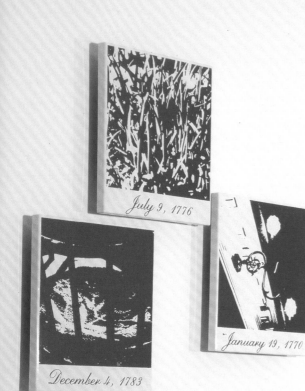

July 9, 1776

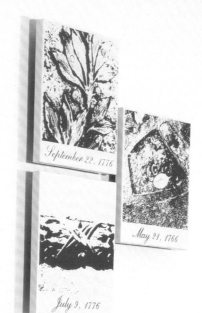

September 22, 1776

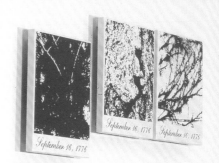

May 21, 1766

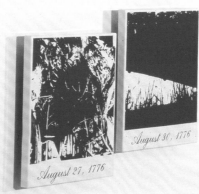

July 9, 1776

January 19, 1770

December 4, 1783

September 16, 1776

September 16, 1776

September 16, 1776

September 15, 1776

August 27, 1776

August 30, 1776

Time the Destoyer Is Time the Preserver

1987
Porcelain enamel on metal
16 panels, each 14½ x
12½ x 2 inches, overall
dimensions variable
Courtesy of Mel Ziegler,
Austin, Texas
Installation view: Loughelton
Gallery, New York

Markers were created to commemorate events that occurred in and around Manhattan relating to the American Revolution. On the markers, the dates of the events were combined with evocative images photographed at each site by the artists. The resulting panels were mappped on a wall according to the locations in New York where the events took place.

September 15, 1776

January 19, 1770

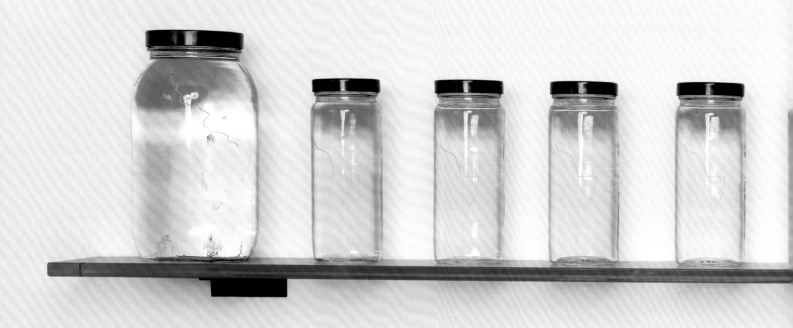

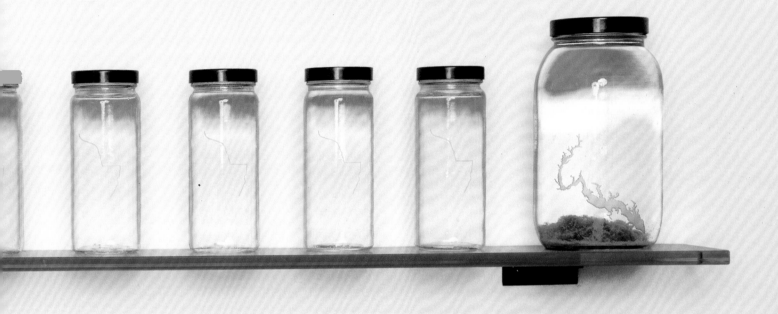

Where the Water Goes

- -

1987
Water, sandblasted glass
jars, shelf
11½ x 56½ x 5¼ inches
Courtesy of Mel Ziegler,
Austin, Texas

The artists collected fresh
water from three sites in the
Washington, D.C. metropolitan
area: the Upper Potomac River
north of the aqueduct that
supplies the city with water,
each of the nine sinks in the
public restrooms of the
United States Supreme Court,
and the Lower Potomac River
downstream from the city's

primary wastewater treatment
facility. Eleven jars
correspond to each of the
collection points and are
sandblasted with the water's
path, making visual the
relationship of the natural
world to the architectural
and institutional realms.

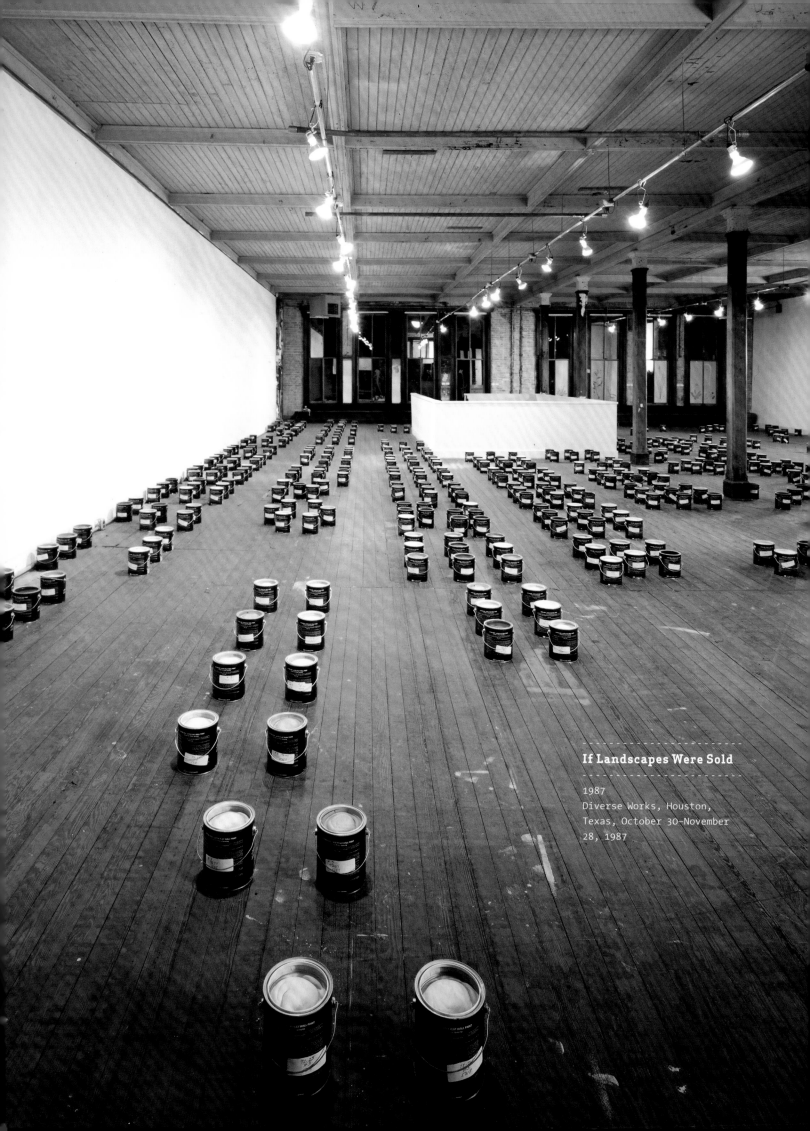

If Landscapes Were Sold

1987
Diverse Works, Houston,
Texas, October 30-November
28, 1987

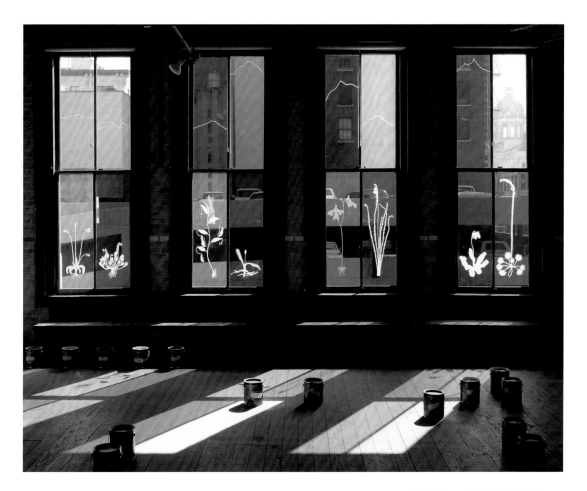

All the buildings from downtown Houston's central business district were color matched by the artists. Open cans of paint corresponding to those colors were arranged on the gallery floor based on the location of the buildings. The windows of the gallery were replaced with the same type of tinted glass found in the high-rise buildings of downtown. These panes were sandblasted with images of mountain peaks and poisonous plants. At the end of the project the paint was donated to a nearby community organization for residents to use on their homes.

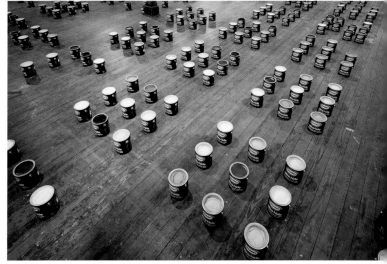

Dark On That Whiteness

1988
173 jars: 3¾ x 3½ x 3½ inches each
147 x 192 x 3¼ inches overall
Courtesy of Mel Ziegler, Austin, Texas

The artists color matched the exterior walls of the federal buildings and national monuments surrounding the National Mall in Washington, D.C. Glass jars were filled with latex paint matched to those colors from an American paint manufacturer's color chart. The jars were sandblasted with the corresponding commercial paint name and mapped on a wall according to the location of the buildings and monuments.

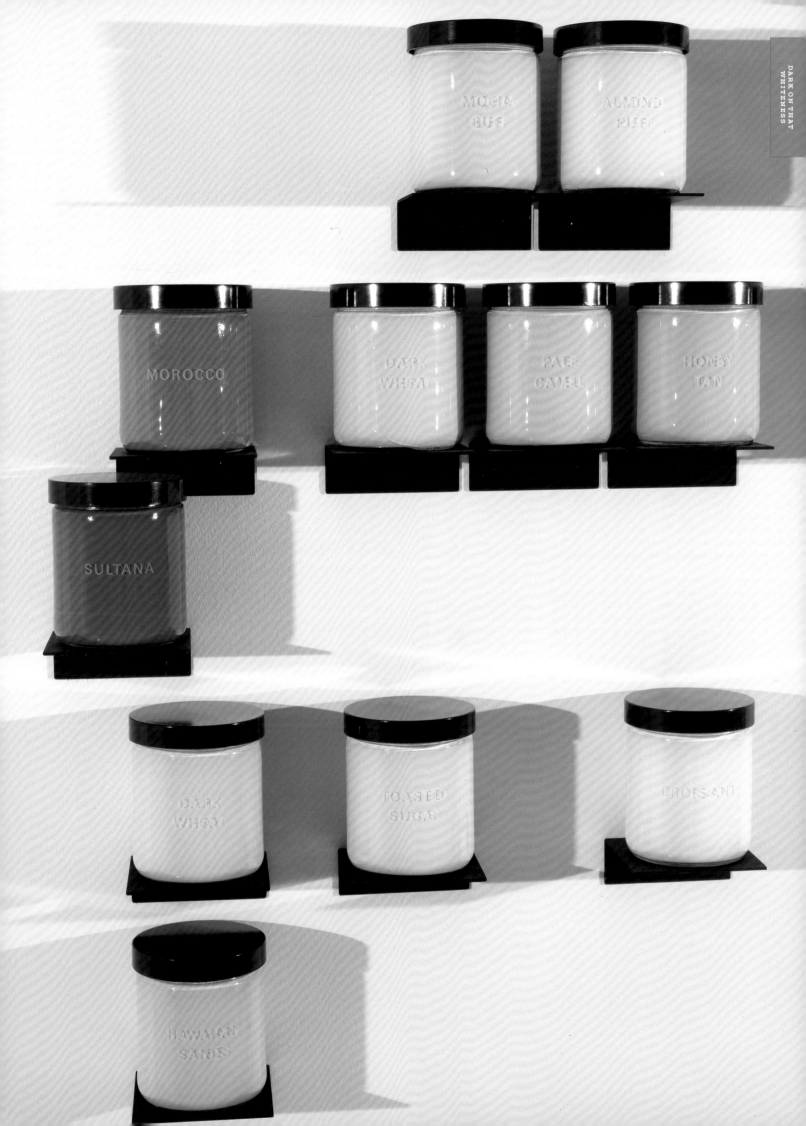

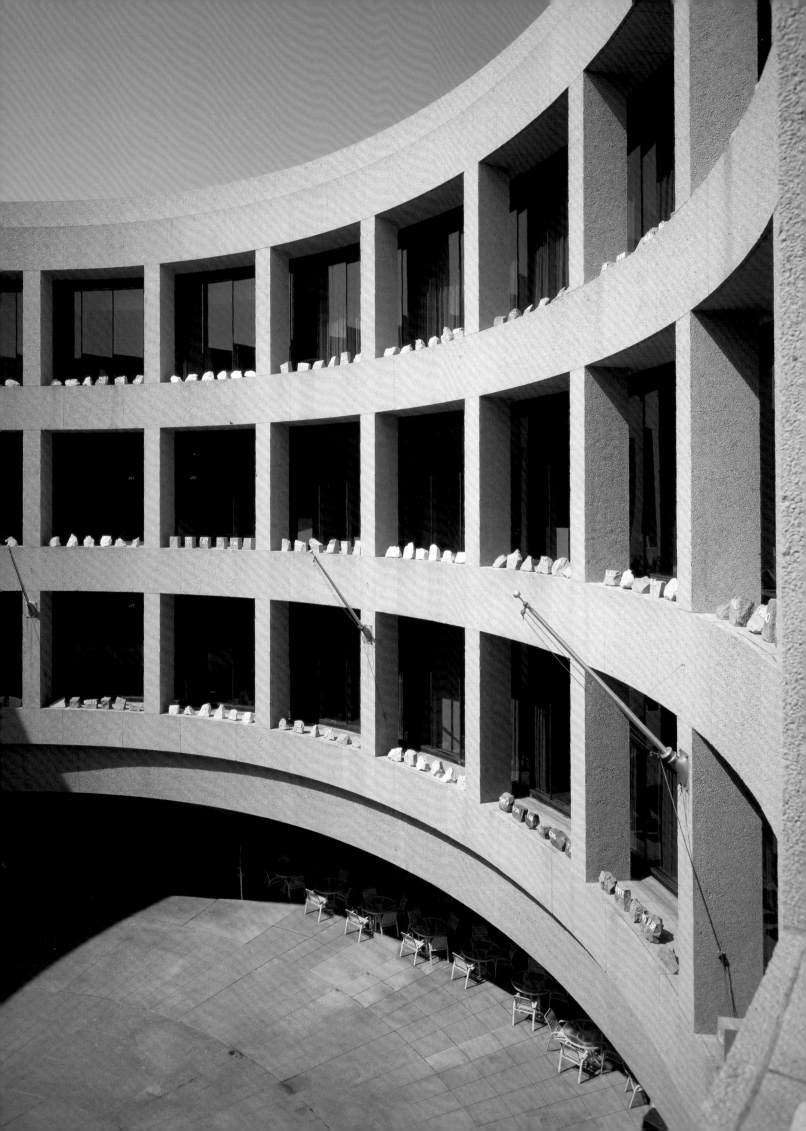

The Conscious Stone

- -

1988
Hirshhorn Museum and
Sculpture Garden, Smithsonian
Institution, Washington,
D.C., March 9–May 30, 1988

- -

Spalls from quarries that
provided stone used to build
well-known Washington D.C.
structures were displayed on
the inward facing window
ledges of the Hirshhorn
Museum. Letters attached to
the stones spelled out the
names of those structures.
At the end of the project the
stones were ground up and
used as gravel for the making
of asphalt to repair roads
in the area.

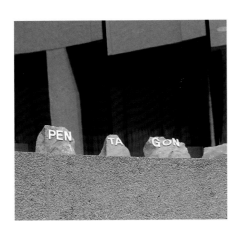

NED RIFKIN

THE MUSEUM ROCKS

I FIRST MET KATE ERICSON AND MEL ZIEGLER IN NEW York in the early 1980s while I was a curator and the Assistant Director at The New Museum of Contemporary Art. Our mutual artist-friend John Baldessari, who had taught Kate and Mel at CalArts, had highly recommended them to Marcia Tucker, the founder and Director of our upstart organization dedicated to contemporary artists and their art. I recall making a studio visit to their modest space in Manhattan and immediately enjoyed their individual presentations as well as the slides of their collaborative works. An outcome of this time together was inviting Kate to create the very first installation in The New Museum's window space on lower Broadway. She proposed and produced a wall of bricks that mirrored the arched windows at the front of the museum and appeared to be a remnant of an older space, mystifying visitors—from the outside at least—who expected to find a "new" museum ready to be open.

I got to know Kate and Mel better thereafter and was delighted by their projects in New York and elsewhere. When I left The New Museum in the fall of 1984 to become the Curator of Contemporary Art for the Corcoran Gallery of Art in Washington, D.C., I brought with me many rich

89

Wayne Field and the rigging crew
from the Office of Plant Services,
Smithsonian Institution

experiences of working with emerging artists from around the United States. Those experiences proved influential as I became the Chief Curator at the Hirshhorn Museum and Sculpture Garden a few years later. It was my thought that people understood contemporary art in the somewhat conventional ways that they tended to regard historic works of art (e.g., traditional paintings and sculptures, and photographs, drawings, prints or mixed media on paper). In response to this, a program entitled Hirshhorn WORKS was introduced to allow artists to intervene at the Hirshhorn and to work on-site in ways that enabled visitors to understand that contemporary art was evolving from something object-specific into something centered on the experience of an object or an installation or an action. The plan for WORKS, which we managed to follow and implement for about three years, was that each participating artist would be given a budget to create a temporary, site-specific work that would be exhibited at the Hirshhorn for three months.

Reflecting the ephemeral nature of the work commissioned by the Hirsh-

horn, we decided against publishing a traditional catalogue for the artists, and instead produced two different WORKS publications: a published interview with the artist conducted by the curator in charge of the project, and, at the end of the year, an interpretative essay in a WORKS "yearbook" that would document the creation and implementation of the WORKS project, as well as offer bibliographical and biographical information on each of the artists.

When it came time to schedule slots for the first year of WORKS, Kate Ericson and Mel Ziegler were very much on my mind. Following Sol LeWitt's beautiful launch of this new program in December 1987, it seemed a good idea to bring in relatively unknown artists who took a very different approach to site-specific intervention. Whereas Sol was very well established—even revered by many artists—Kate and Mel were young artists who had never had a major museum exhibition. Their work was even more conceptually based on research and "mapping" ideas that concerned various aspects of the land or cityscapes they observed. Despite the fact that they

were hardly known at all, I believed they would create something quite uncanny and—for me at least—entirely indelible.

We arranged for Ericson and Ziegler to exhibit in the second of the Hirshhorn's WORKS series. Kate and Mel, in their typical thoughtfulness, spent some time just touring around Washington, D.C., looking for inspiration. I recall them coming into my office to tell me about what they were thinking of undertaking for their piece. In thinking about Washington, D.C.'s dominant characteristic—its role as the nation's capital—the artists noted that a major aspect of this was the distinctive (and very conservative) architecture of the city. They proposed that they would trace the source of stones for a variety of buildings, some famous and immediately associated with the "official" Washington, D.C., and others relatively unknown or perhaps known only by those who lived there. In other words, Kate and Mel rather characteristically wanted to map the itinerary of the stones that had been quarried for these "rich and famous" buildings, while at the same time carrying out the same process for a number of "ordinary"

The Conscious Stone, detail
during installation

or "everyday" buildings.

They found the source quarries and traveled to the sites by truck, requesting spalls: the scraps of stone that are left after shaping rocks for a specific design. After gathering six such fragments from each quarry, Kate and Mel brought them to the nation's capital, where they were put on view along the Hirshhorn's cylindrical inner façade, set on the ledges of the museum's distinctive inner curve of windows as if on a display shelf. The artists identified the building to which these funky forms of rock were related by affixing the names of the buildings in plain, white, hard-plastic letters, grouped by syllables. The letters were large enough for viewers to read them from the Fountain Plaza as much as three stories below. The final touch was a standard museum label in the Museum's sculpture ambulatory for each group of stones positioned on the window ledges. The information on these labels gave a few more details out: the source of the quarry by town and state, the building for which the quarry had been mined, and the year of the building campaign.

The impact of Kate and Mel's piece was phenomenal. The disposition of these relatively small off-cut fragments of stone was, at best, inelegant. They appeared to be odd-shaped teeth coming out of the "gums" of the Hirshhorn's windowsills. They had a slightly grotesque effect, but also humorous in the silliness of these eccentric outgrowths. With the letters on the outside, viewers could note the correspondences between what one saw at the Museum and what one experienced day in and day out as the buildings of D.C.

So, in the end, there was this ignoble stone, for a brief time elevated—by cherry picker and hydraulic lift—to the level of works of art, only to be left outside of the Museum, looking in at the sculptures that populate the ambulatory of the Hirshhorn, the Brancusis, Giacomettis, and Rodins that rest peacefully on pedestals, distanced from the rough surfaces of the aggregate concrete lintel. Most poignant to me was that, following the exhibition at the Museum, these odd pieces of disparate stones, the very same material that corresponded to numerous buildings throughout the national

capital, were destined to be ground up and mixed into an asphalt amalgam used to fill potholes—those vexing cavities that occur in the District of Columbia's roads throughout the winter and into the spring. Yes, the stones that had been known to move in this installation had the performative dimension of experiencing both the heights of epiphany and the universal ritual of interment. The life of the stone, unlike the more properly cut and fitted quarrymates that had made it into the nation's building fabric, was now playing itself out.

Mapping saplings

- -

The Nature of Things
(Robinia pseudoacacia,
Baron Lemot, Mr. Bouyer, and
Mr. Brebion)

- -

1988
Fondation Regional d'Art
Contemporain, Pays de Loire,
Clisson, France

- -

Tools belonging to the
gardener at this rural artist
residency program were
displayed in the gardener's
tool shed on the grounds of
La Garenne Lemot. The hand-
carved handles of the tools
were made from the park's
acacia saplings and were
hung on the wall according to
the actual pattern of acacia
trees growing in the park.
New tools were purchased for
the gardener to use during
the exhibition and at
the close of the project the
original tools were
returned.

Installation views:
The Nature of Things, 1988

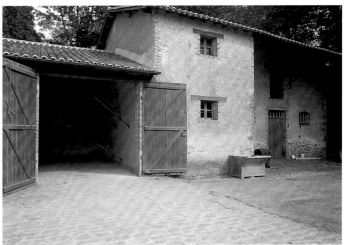

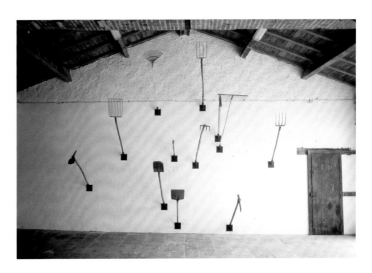

Picture Out of Doors

1988
Sponsored by Santa Barbara
Contemporary Arts Forum,
Santa Barbara, California,
September 10–October 9, 1988

All the doors in the home of
David and Pat Farmer were
removed and stacked by size
in the living room of the
house. During the course of
the exhibition viewers
were invited to look around
the entire house.

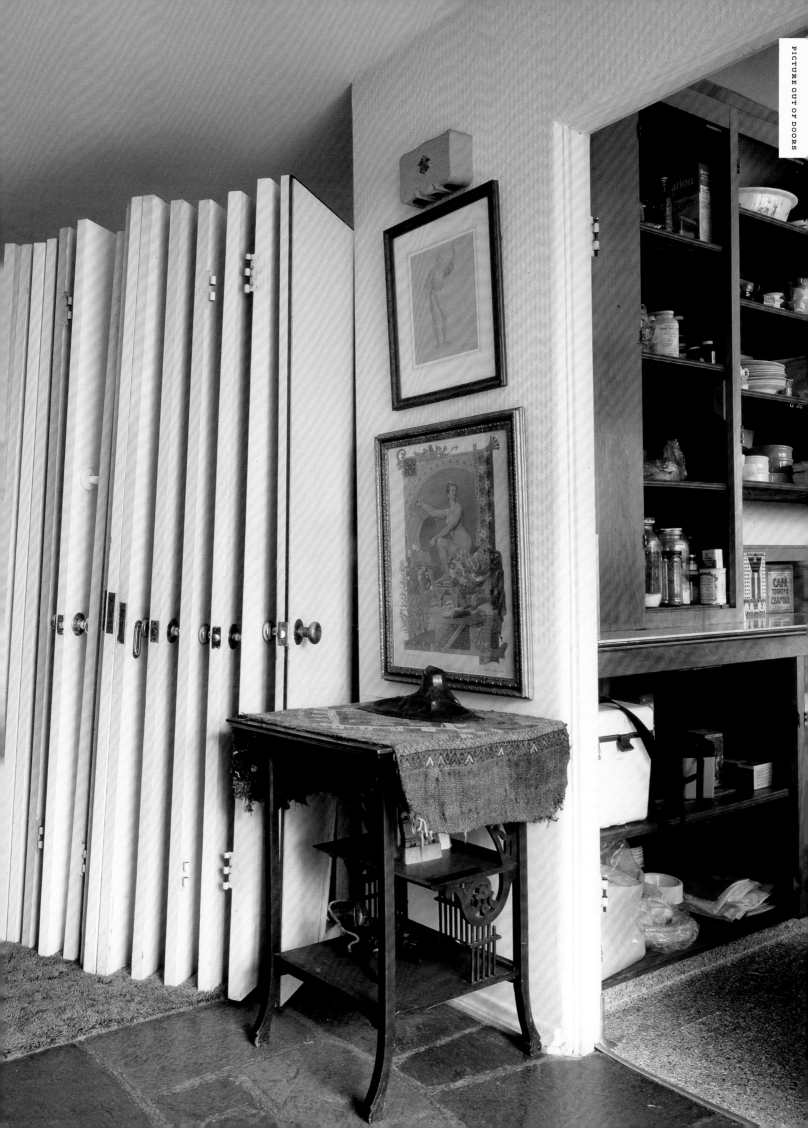

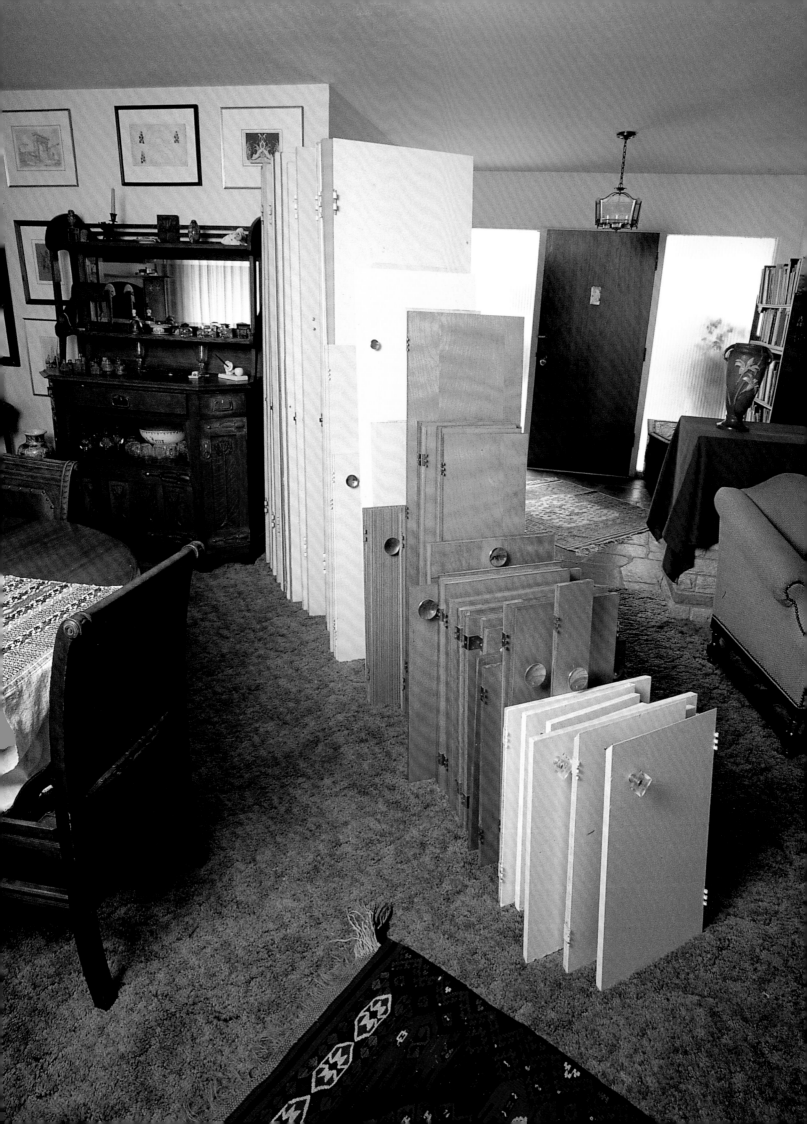

Installation views:
Picture Out of Doors, 1988

America Starts Here

1988
Broken glass and fiberglass panels, sandblasted glass, wood frames, two photographs
105 panes: approx. 21 x 15 inches each; overall dimensions: 125 ½ x 565 inches
Courtesy of Mel Ziegler, Austin, Texas
Installation view: Institute of Contemporary Art, University of Pennsylvania, Philadelphia, Pennsylvania, June 10–July 31, 1988

The artists removed broken windows and fiberglass replacement panels from the former National Licorice Company factory at 1301-19 Washington Avenue, Philadelphia, and replaced them with new windows. All of the broken panels are framed between sheets of glass sandblasted with the paths of well-known trails, canals, rivers, and railroads, or tracings of cracks found in

architectural elements in the former and current national capital cities of Philadelphia, New York, and Washington, D.C. The removed windows are displayed in the configuration found at the factory. Their lines echo the cracked features of two of Philadelphia's most beloved tourist attractions, the Liberty Bell and the broken glass of Marcel Duchamp's *The Bride Stripped Bare by Her Bachelors, Even (The Large Glass)*, 1915–1923.

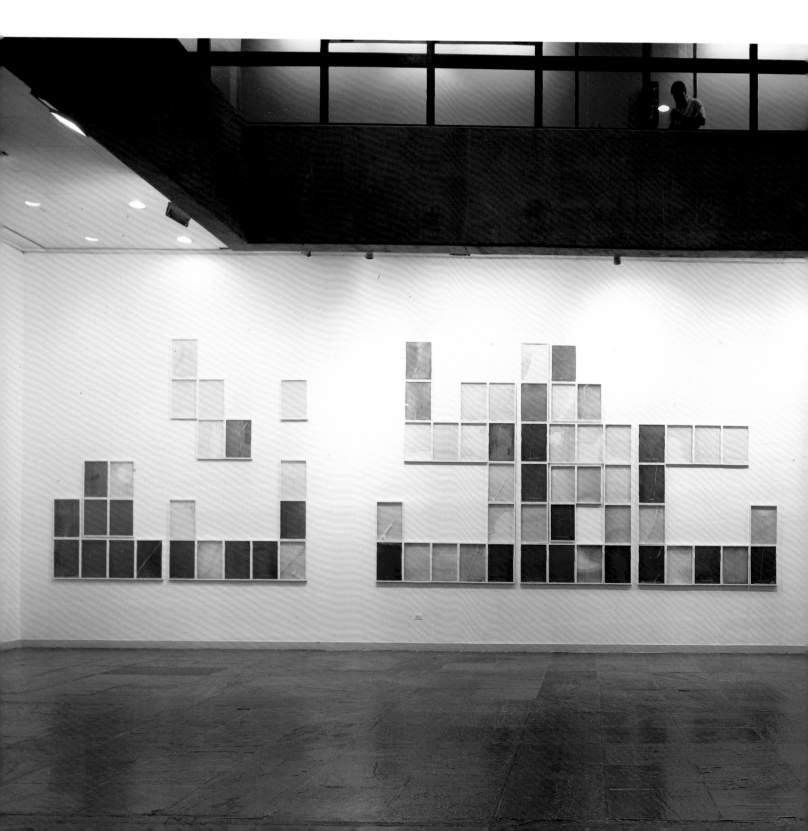

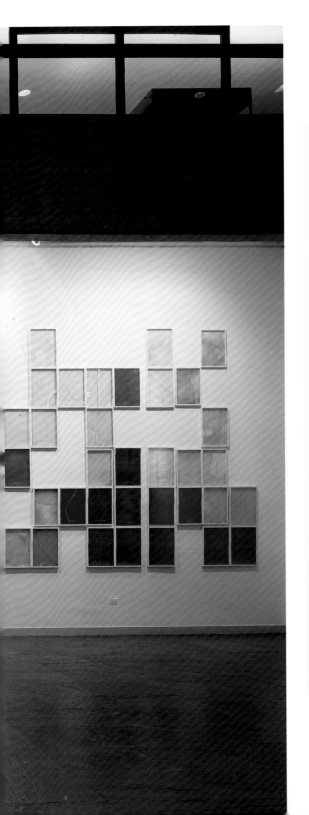

JUDITH TANNENBAUM

REMEMBERING AMERICA STARTS HERE

THE FIRST REQUEST THAT KATE ERICSON AND MEL Ziegler made during their initial visit to Philadelphia for the project that would become *America Starts Here* was to see the site of the Move debacle. Two-and-a-half years earlier, in May 1985, a state police helicopter dropped a bomb on a house occupied by the militant group known as Move in a West Philadelphia residential neighborhood only about two miles from the University of Pennsylvania campus and the Institute of Contemporary Art. The bombing had been ordered by the Philadelphia Police Commissioner in response to years of tension and conflict between the group, its neighbors, and the local authorities. Not only were eleven people in the house killed, including five children, but more than sixty houses were destroyed by the resulting fire, leaving 250 people homeless.[1] This was the first time in American history that the government had bombed its own citizens. I had been shocked and horrified by the Move events, but I had never taken the initiative to visit the site. Kate, Mel, and I drove out to 62nd Street and Osage Avenue to see the middle-class African-American neighborhood and the row houses that had replaced those destroyed. I don't remember the details of our conversa-

Views of the National Licorice Company factory, Philadelphia, before windows were removed and after replacement windows were installed

tion, but I know I was (and am still) grateful to Kate and Mel for reminding me that it is all too easy to sweep horrific events under the rug and write them out of history. The simple act of seeing a site where great devastation took place—whether it be Gettysburg, Auschwitz, the World Trade Center, or Move—makes historic events part of the present and "real" in a way that nothing else can.

More than fifteen years have passed since I worked with Ericson and Ziegler on *America Starts Here*, a project for the Institute of Contemporary Art's "Investigations" series.[2] I don't remember how I met Kate and Mel or what my first experience of their work was, but I recall being impressed and moved by the way they injected specific historic, anthropological, geographic, architectural, and linguistic content into the abstract, modular, aesthetic vocabulary of minimalism. My invitation to the artists to create a new piece for the ICA in Philadelphia was open-ended. I had no idea what they would propose or what the work might look like, nor was I able to anticipate any of the logistical challenges that lay ahead. The resulting project developed

over the next few months, growing out of the couple's previous work, but also drawing on their direct experience of and research about Philadelphia. In the end, Move did not play an overt role in Here, but for me the visit epitomized Ericson and Ziegler's working process as well as the scope and depth of their study about "place." The Move bombing may have particular relevance for Philadelphia and Philadelphians, but the more critical question it raises is simply, "How could something like that happen in America?" It made such all-encompassing issues as race, class, economic equality, and justice painfully concrete and meaningful. What does this event say about our collective past and what is its significance for our future—as individuals and as a "civilization"? Complex and potent questions such as these underpin Ericson and Ziegler's work, counteracting the simplicity and elegance of their minimalist forms.

Before too long, Ericson and Ziegler focused their attention on the abandoned factory buildings that exist in many sections of Philadelphia and are particularly visible when you approach

the city on trains coming from points north. These buildings are typically box-like rectangular structures, several stories high, made of brick with vertical concrete piers. They feature large windows, many of them with numerous panes of broken glass. Again, Kate and Mel heightened my consciousness—making me look with new eyes at my everyday surroundings. I now see buildings like this in every American city I go to, and I cannot imagine how I was once able to screen them out. Together with Bernd and Hilla Becher's photographs, I credit Ericson and Ziegler for making me aware of the grandeur of industrial architecture and of domestic buildings. Their work transformed structures that previously seemed generic and anonymous into something distinct, worthy of recognition, even beautiful.

America Starts Here, named after the official tourist slogan of Pennsylvania, connected the white cube of the ICA gallery directly with the cityscape of urban Philadelphia. After exploring a number of possible locations, we got permission to use the National Licorice Company building at South 13th Street and Washington Avenue, not far from South Philadelphia's vibrant Italian community and the school and rehearsal studios of the Pennsylvania Ballet. Despite the proximity to a vital downtown center, the area was strikingly neglected and run down. Ericson and Ziegler's plan was to remove a large number of broken windowpanes and green plastic replacement panels from the second story facade, and replace them all with new clear glass. The 105 panes they took from the derelict building were chosen from a fifty-foot-long section that corresponded to the size of the wall inside the ICA. Each window fragment was sandwiched between two pieces of glass and framed before it was hung on the gallery wall in the location that corresponded to its original position on the front of the National Licorice Company building.

From a distance, the framed panels (each twenty-one by fifteen inches) read as a minimalist grid that deviated from its expected symmetry or rational progression by empty spaces left on the wall. The viewer would not know why the panels were arranged in this partic-ular configuration unless he or she consulted a photograph of the factory building that was mounted nearby. Upon closer observation, however, one would notice that the artists had sandblasted the top layer of glass with sinuous tracings—roadways, trails, rivers, and railroad lines that referred to the settling of the United States, as well as the cracks found in government buildings and monuments, each identified by name.

Many of these sandblasted images referred to particular places in the region, alluding to both the site of the exhibition and Philadelphia's singular position during the founding days of the United States of America. Other panels spanned the eastern corridor from New York, which was the first capital of the country (1789 to 1790), to Washington D.C., which became the capital in 1800. (Philadelphia was the second capital—from 1790 to 1800.) Some of the places that Ericson and Ziegler inscribed on the glass are still celebrated while many have lost their significance. Tourists continue to travel to Philadelphia to visit historic sites that highlight the ideals of freedom and democracy—Independence

Hall, the Liberty Bell, Betsy Ross's House, the new Constitution Center, among others—and the city still identifies itself with the events of those early days and the achievements of the patriots who shaped the republic.

By displacing the broken windowpanes and superimposing linear elements and text on them, Ericson and Ziegler created a new kind of mapping that works on both a metaphorical and material level. In *America Starts Here*, "The result is a lexicon of America's political and physical growth superimposed on a symbolic fragment that represents urban decay and the shifting economies of late twentieth-century America."[3] By embedding glass fragments from the recent past—signifiers of contemporary urban blight—with place names associated with growth and expansion during the colonial and early federal stages of the nation's history, the artists enabled us to see through from one layer to the other. Simultaneously, they reveal the cracks and tensions of the past, which are all too often hidden from view.

The National Licorice Company building is a symbol of capitalistic expansion and prosperity fallen on hard times; it is in a state of decay, but still standing. By bringing physical traces of cultural history into an exhibition space and creating a literal and conceptual framework around such evidence, *America Starts Here* brings a tangible sense of reality to what might otherwise seem abstract or irrelevant (in the same way visiting the Move site intensified my awareness of that event). Ericson and Ziegler brilliantly connect our own everyday environment with layers of cultural history, underscoring how the public arena depends upon and is greatly enriched by personal experience and the details of daily life.

- -

NOTES

1. See William K. Stevens, "Police Drop Bombs on Radicals' Home in Philadelphia," *The New York Times*, May 14, 1985; and "6 Bodies in Ashes of Radicals' Home; Assault Defended," *The New York Times*, May 15, 1985. Also, Alice Walker, "Nobody Was Supposed to Survive," from *Living by the Word*, London: Women's Press (1988), 155–7, 159–60. Mayor Wilson Goode, who was African American, accepted responsibility for the bombing, but no criminal charges were ever filed.

2. America Starts Here was presented at The Institute of Contemporary Art, University of Pensylvania from June 10–July 31, 1988. A brochure with an essay by Patricia C. Phillips was published in 1989. The installation was shown subsequently at the *1989 Biennial Exhibition*, Whitney Museum of American Art, New York (see Biennial catalogue, pp. 48–51).

3. New York: Whitney Museum of American Art, *1989 Biennial Exhibition*, catalogue, p. 49.

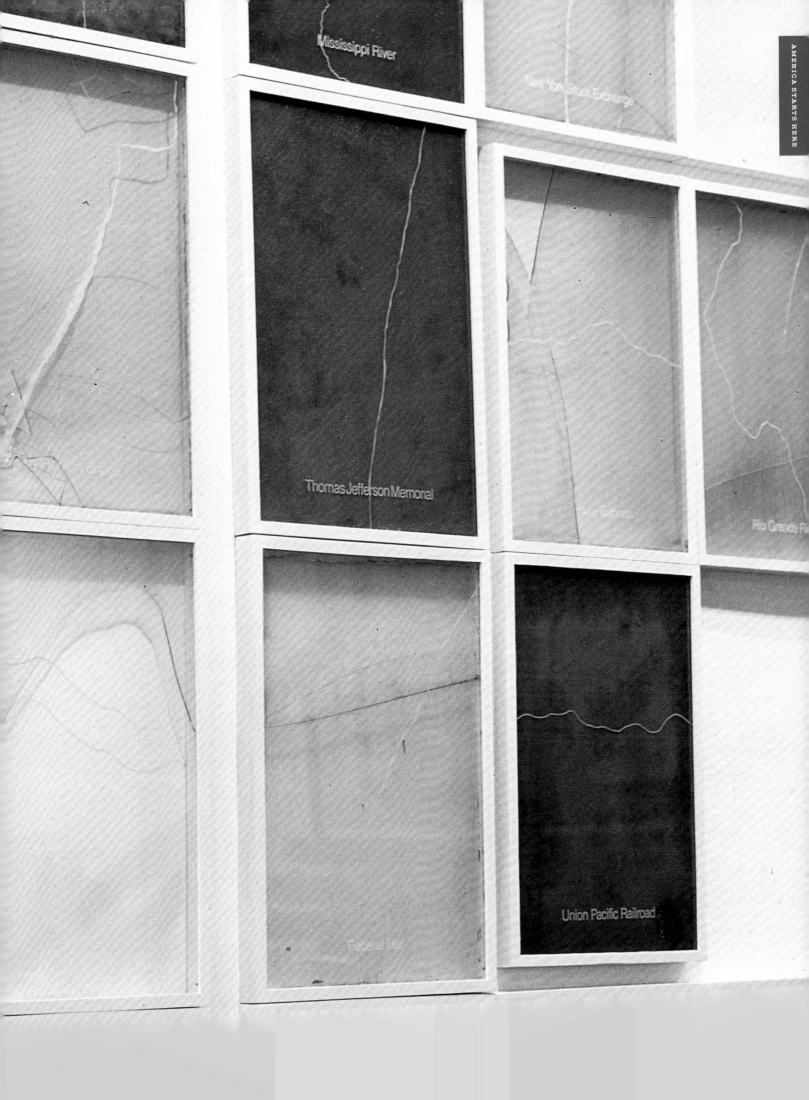

Mississippi River

New York Stock Exchange

Thomas Jefferson Memorial

Rio Grande R

Mississippi River

Union Pacific Railroad

Walls Have Tongues

1989
Paint, sandblasted glass
plaques, hardware
Dimensions variable
Installation view: Wolff
Gallery, New York, 1989

Colors matched to period rooms at New York's Metropolitan Museum of Art and the Brooklyn Museum of Art were transposed into a commercial gallery space. The lower portion of each wall was painted with colors found on the wainscoting of the historic interiors, while the upper portion was painted with colors representing the walls. Each wall segment was painted with a different combination. The original homeowner and type of room were sandblasted onto acrylic panels that were mounted to each wall.

Installation views:
Walls Have Tongues, 1989

Cadwallader Colden, Jr.
parlor

Signature Piece

1988
Museum of Modern Art, New
York, October 22–November 29,
1988

Signatures were installed
throughout the Museum of
Modern Art's Projects gallery,
sculpture garden, and sites
across the street. The forty-
two names were of people who
work in manufacturing plants
and factories that provided
the museum with architectural
elements and fixtures.
Each of the workers chosen
would have physically worked
with their hands in the making
of these elements during
the time they were furnished

for the museum. They were each
paid a small fee for their
participation, which included
signing their name on an index
card. The first names of the
signatures were silkscreened
onto acrylic panels, which
were then mounted around the
museum on the respective
products. A brochure was pub-
lished with the participants'
full name and products they
were responsible for.

Robert

projects: kate ericson
mel ziegler

BRONZE GLASS	WILLIAM E. ABERNATHY
DOOR HANDLE	CLARIN BACOTE
MOONLIGHT	BERNAT BERMAN
LIGHTING FIXTURE	HANK BRUER
LIGHTING TRACK	DIANE BUTZ
LIGHTING SHIELD	JAKE CAMBI
MARBLE VENEER	LEON CHASTAIN
GLASS	DIANE CHAVIS
LIGHT BULB	THOMAS I. CHIPLEY
BRICK	C. LOWELL GAHAGEN
THERMOSTAT	KARL-HEINZ HARLAND
EXHAUST VENT	ROBERT HILKER
CHAIR	JIM HILL
ACCENT LIGHT	MARY AMANDA HOOSIER
TREE	CHARLES H. HORNER
EXIT SIGN	LAURA JENSEN
ELECTRICAL BOX	JOCELYNE KELLEY
AWNING COVER	RICHARD C. KUNZ
AIR DIFFUSER	ROY L. LAMB
MOTION DETECTOR	RICHARD J. LINDEMANN
ASH URN	ROBERT MAYEN
SPEAKER	SYLVIANN McGLAUGHLIN
WASTE RECEPTACLE	RON MOORE
DOOR	ARTHUR J. OLIVER
SMOKE DETECTOR	LUZ A. OPSAL
LETTERING	JULIO PAIZ
SEALANT	THEODORE H. POPPE
STANCHION	CURTIS POWELL, JR.
MARBLE FLOORING	ROBERT E. PRATT
PIPE	OWEN M. ROWLANDS
TWINDOW	DALE H. SAYLOR
PAINT	ROBERT E. SHANER
MARBLE PAVEMENT	JEFF SHARROW
WINDOW BLIND	MARION SLATTERY
HOSE	DENVER SMITH
ELECTRICAL OUTLET	RUTHANN SOFFE
BROCHURE BOX	MIACHEL THOMAS
AIR CONDITIONER	SHIRLEY TKADLEC
SHEETROCK	CHRIS TOEPHER
RUBBER ROOFING	ROY ZULLINGER

Brochure, *Signature Piece*, 1988

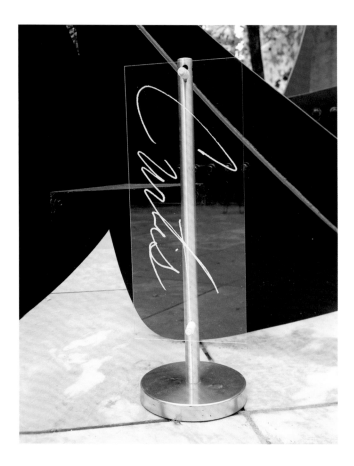

Installation views:
Signature Piece, 1988

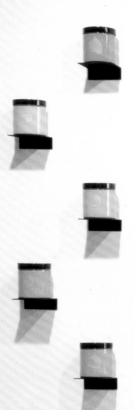
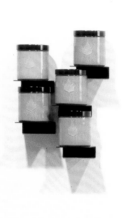

Leaf Peeping

1989
Sandblasted glass jars,
paint, metal shelves
Thirty-one jars: 3¾ x 3½ x
3½ inches each
Overall dimensions variable
Museum of Contemporary Art,
San Diego, California, Museum
purchase, Contemporary
Collectors Fund, 90.9.1-31

Each jar contains paint match-
ing the color of a specific
autumn leaf from a tree in the
Abby Aldrich Rockefeller
Sculpture Garden at New York's
Museum of Modern Art. The
pattern of each color-matched
leaf has been sandblasted
onto its corresponding jar.
The jars have been mapped onto
the wall according to the
positions of the trees as they
were planted in the garden
in the late 1980s.

114

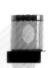
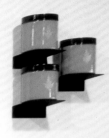
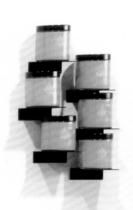
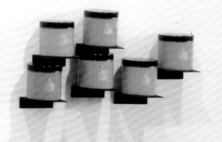

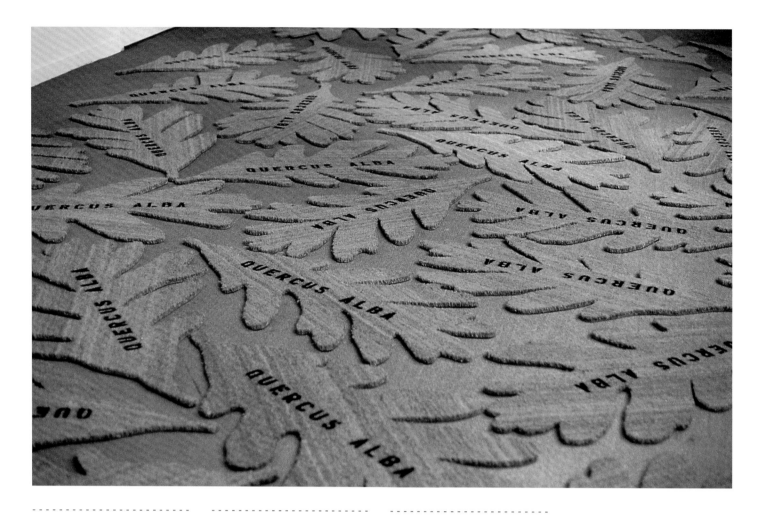

Hollow Oak Our Palace Is

1989
Stenciled cocoa mat
Unlimited edition: approx.
28 x 48 x ½ inches each
Overall dimensions variable
Installation view: Real Art
Ways, Hartford, Connecticut,
1989

This affordable, unlimited
edition of welcome mats
was produced in response to
the imminent displacement of
Real Art Ways—a Hartford,
Connecticut alternative arts
space—by the Oak Leaf
Development Corporation, a
real estate concern. The
leaf-shaped floor mats are
stenciled with the scientific
name of the white oak tree—
quercus alba—and are drawn
from different leaves
taken from the city's Charter
Oak, a fabled ancient tree
in which the state's charter

was hidden from the British
representatives of King
James II, who demanded the
dissolution of the colony in
1687. The funds generated
by selling the mats went to
support Real Art Ways' move.
The title is from a sea shanty,
*A Wet Sheet and a Flowing
Sea*, written by Allan
Cunningham (1784–1842), an
eminent botanist.

Weeds Or Wildflowers

1990
Stenciled cocoa mat
Various sizes, overall
dimensions variable
Installation view: SPACES,
Cleveland, Ohio

Cocoa mat was cut in the shape of leaves taken from different plants found in the Cleveland Flats historic industrial area. The railroad that passed through the area spread seed from a wide range of locales, causing an unusual diversity of plants to grow there. These plants were considered intrusive weeds by local botanists. The artists stenciled the scientific names of the plants onto the mats. Seeds collected from these plants were planted in Ericson and Ziegler's Viaduct Gateway Park project, also in Cleveland.

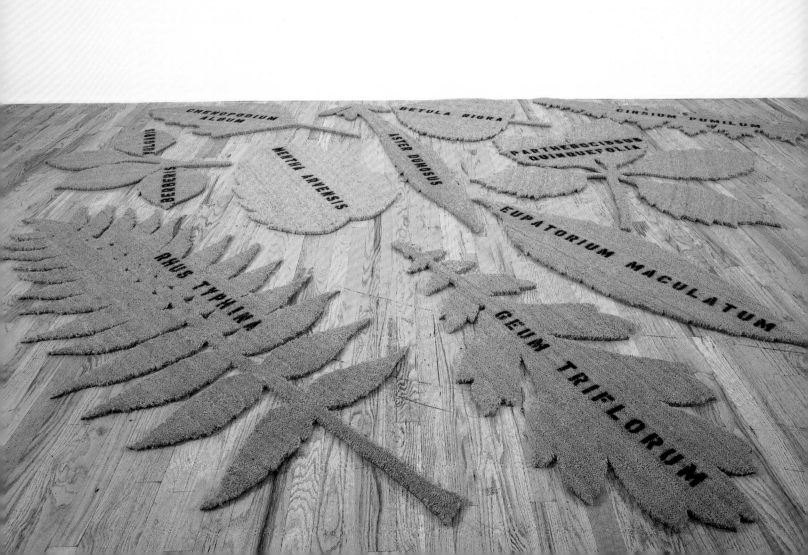

Viaduct Gateway

Subsequently renamed
Viaduct Garden

1990
Commissioned for The Hidden
City Revealed Masterplan,
sponsored by the Committee
for Public Art, Cleveland,
Ohio

Project collaborators:
Patricia Stevens, *landscape
architect*; Michael Bakos and
Elsa Johnson, *environmental
designers*

As part of a design team
working on revitalizing
underused land in downtown
Cleveland as an urban park,
Ericson and Ziegler
researched and displayed
actions and dates that trace
the history of work done on a
specific property over
time. Aluminum signage was
produced in the form of
actions and dates that trace
that history. The words were
handwritten by the person, or
a descendant of the person,
who completed the original
work. The signage was
installed at the locations
where the actions took place.

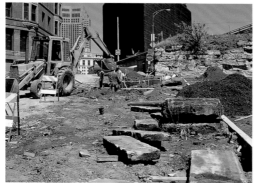

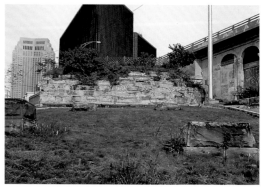

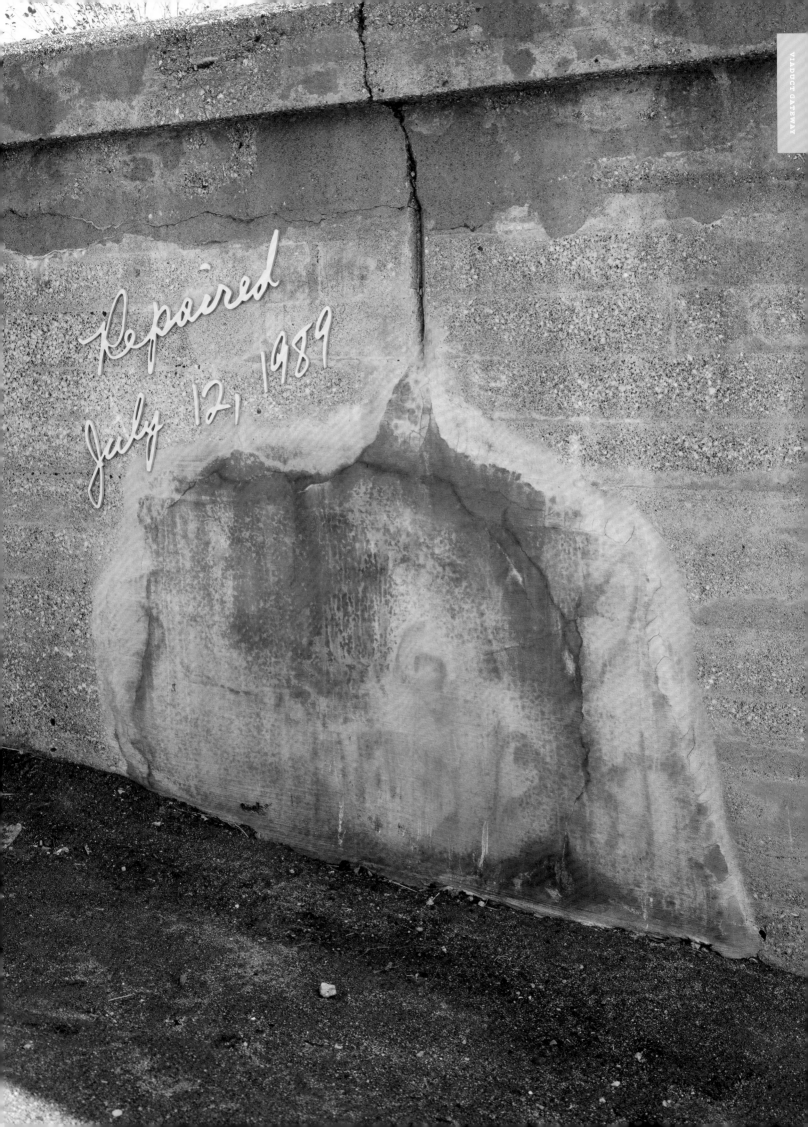

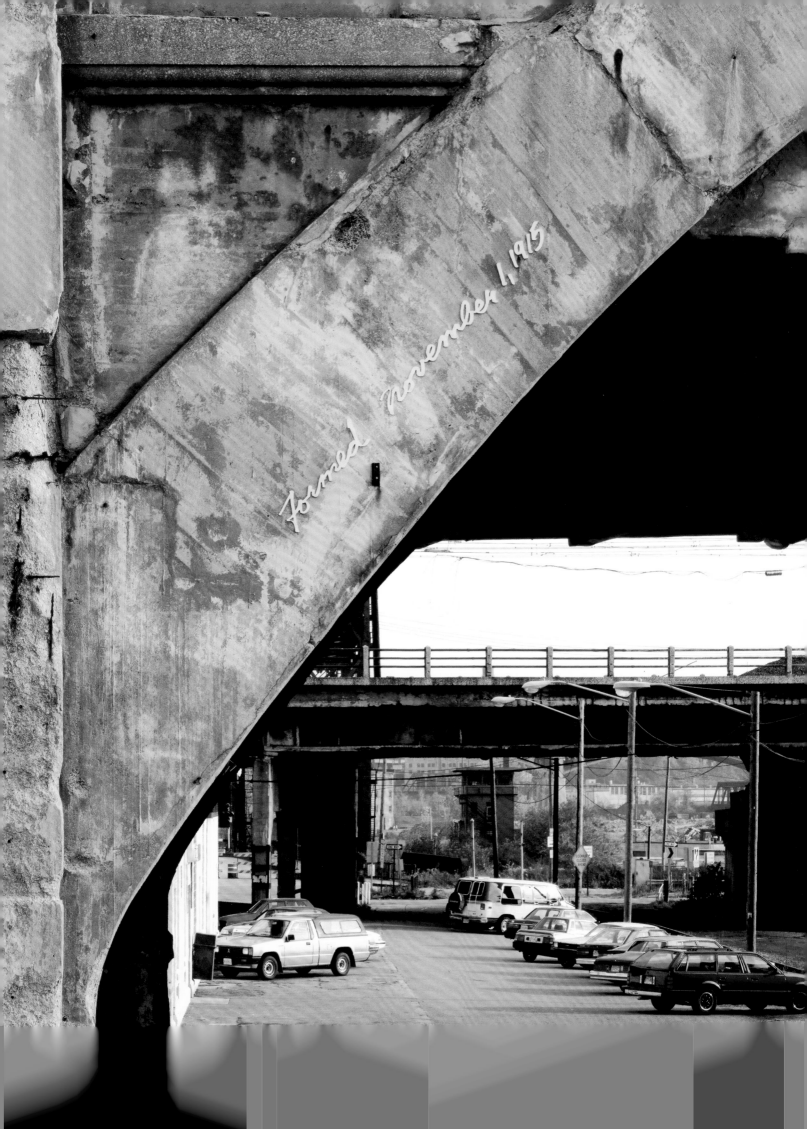

Formed November 1, 1915

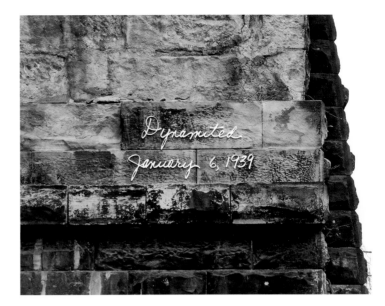

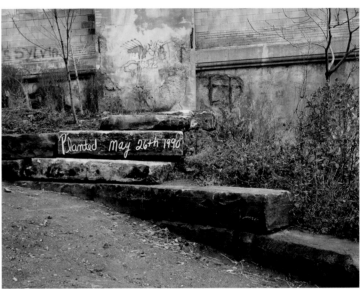

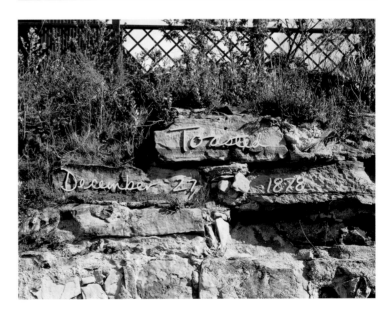

Site views: *Viaduct Gateway*, 1990

121

College Ivory

1989
University Art Gallery,
San Diego State University,
San Diego, California,
April 22–May 24, 1989

Ericson and Ziegler hired a
San Diego State engineering
student to calculate the
cost to build interior and
exterior features of the
university's gallery space.
The figures were displayed
on the features of the
building. Simultaneously, the
current construction costs
of every building on campus
was calculated and displayed
in front of each building.

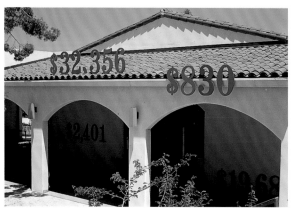

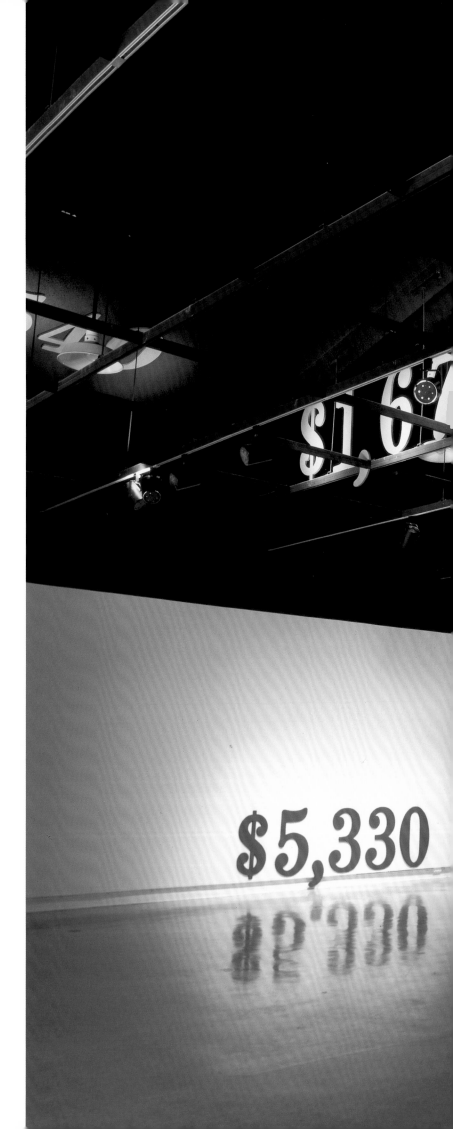

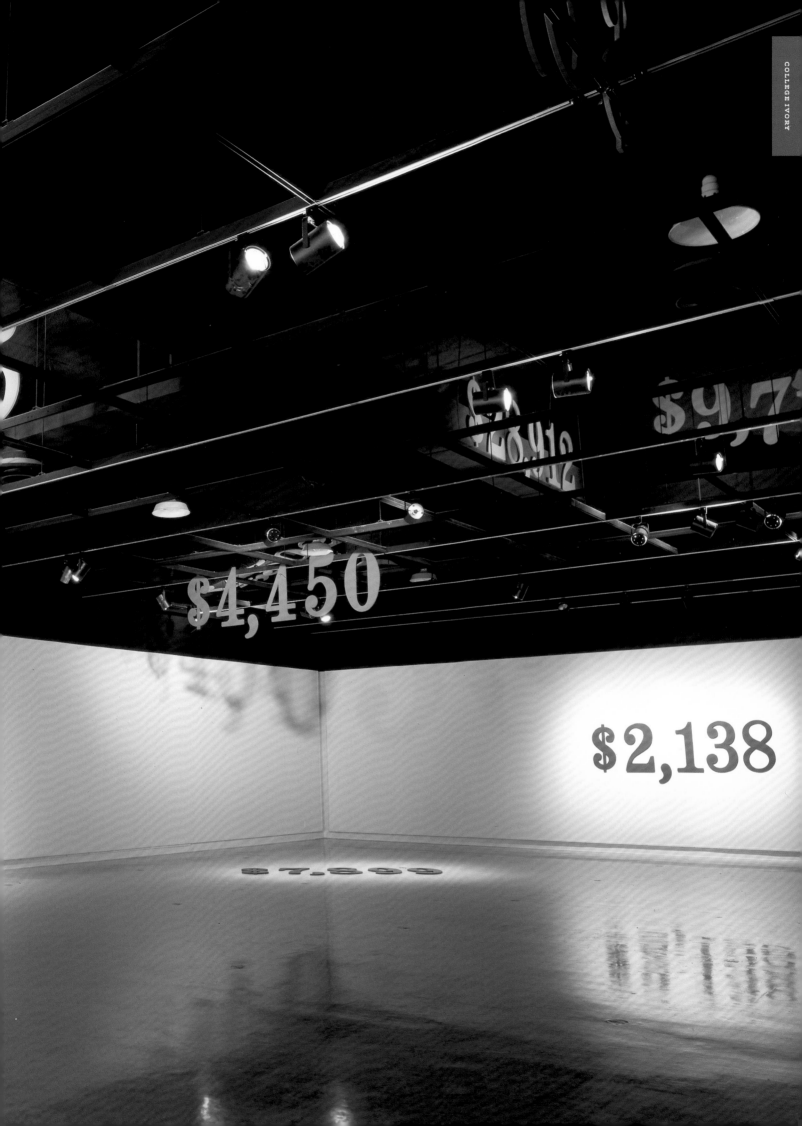

 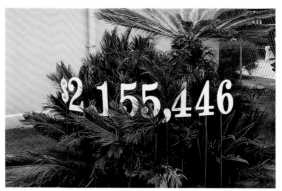

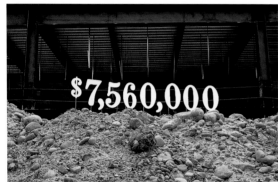 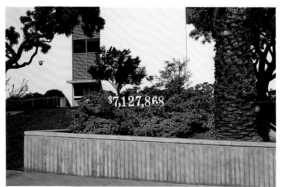

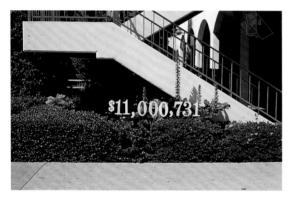 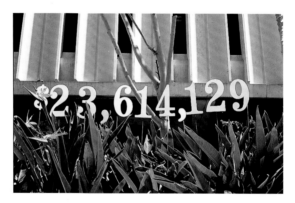

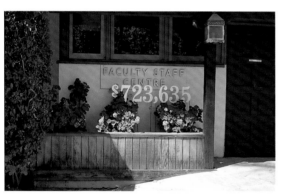 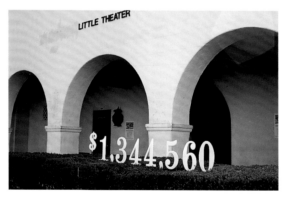

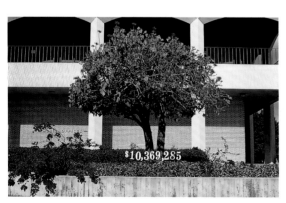

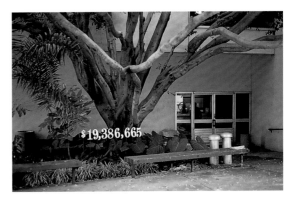

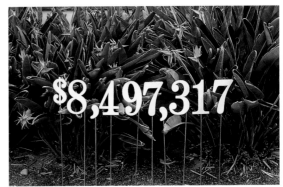

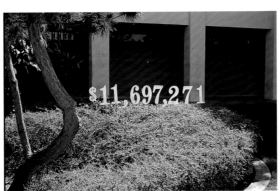

Loaded Text

1989
Durham Arts Council, Durham,
North Carolina

The entire sixty-five-page
text of the Downtown Durham
Revitalization Plan was hand-
written by the artists on
a 150-foot section of side-
walk next to the downtown post
office. The sidewalk was
chosen for its disrepair.
After the display of the text,
a local contractor was hired
to break up the sidewalk

and load the concrete rubble
into three dump trucks.
The trucks were parked in
front of the Durham Arts
Council for a four-day period
coinciding with a public art
conference taking place
inside. At the same time the
contractor installed a new
sidewalk adjacent to the
post office and at the close

of the project the artists
stacked the rubble to form
riprap to prevent erosion at a
site in downtown Durham.

PATRICIA C. PHILLIPS

TWO JUST CAME TOGETHER

LET'S BEGIN WITH SOME QUESTIONS ABOUT PUBLIC ART. In its many forms, contexts, and situations, what can public art achieve? Is it useful—or imperative—to distinguish our hopes and claims for pubic art from what it may be or do? The collaborative works of Kate Ericson and Mel Ziegler, with their characteristic modesty and sophistication, precision and expansiveness, raise and highlight these queries. In their evolving practice, Kate and Mel created scenarios that stimulated challenging, sometimes indirect consequences. The simple elegance of their proposals and projects grew from a deepening conceptual complexity that remains fresh today, while their matter-of-fact aesthetics remain vivid.

I began writing about public art the same time that Kate and Mel began working together exclusively. The exact chronology is elusive, but in the mid-to-late 1980s their shift from individual practices to a cooperative model produced a quietly provocative intellectual partnership. But it is misleading to suggest that the understated, insistent lucidity of their work was inevitable, "naturally" emerging from an entirely harmonious process. Their conceptual interests and affinities did not simply converge,

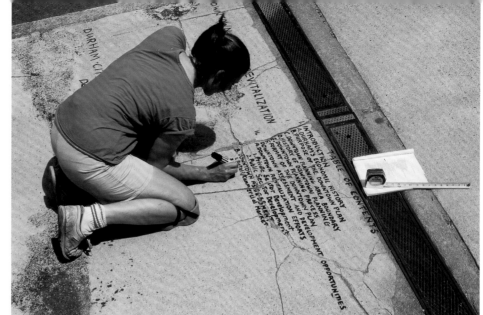

but intricately coupled. Kate and Mel each brought distinctive perspectives to the creation of a more singular vision.

Intervention—where an artist becomes a presence or agent between existing positions—has become a critical subject of contemporary public art. It employs an invasive process to advance an issue, stimulate dialogue, and perhaps alter perceptions within a site or system of public interest. It may not always produce quantifiable social changes, but it makes those involved, both artists and audience, more aware of an interference with or rearticulation of existing social patterns. Kate and Mel's interventionist work was a reflective process of mediation and arbitration. In their most challenging projects, they inserted themselves into the conventional or circumstantial as unallied but immersed participants, practicing interlocution and inter-location—a conversation situated in between the realities and hopes of the communities they worked with. Though aggressive interference was neither their intent nor their method, active public engagement was always the effect.

For a 1989 national public art conference in Durham, North Carolina, Kate and Mel were invited to create an independent public art project. At the time, many working in the field of public art were expressing disappointment with a tenacious form of "plop" artworks with little connection to their surrounding community arbitrarily introduced to a public site. Kate and Mel's honed, open methodology produced an alternative, critical mapping of public art theory and practice. They took several trips to Durham to look around, talk with people, and read the vital signs of the community. They subscribed to the city's daily newspaper, which they read faithfully back in their tiny New York studio. The artists learned that one of the most important (and potentially controversial) issues facing the city was the Downtown Durham Revitalization Plan. Seeking public input, city officials had placed two copies of the substantial document in the public library. The artists puzzled over this insufficient act of public transparency. Realistically, how many people would get to the library to read the

lengthy plan? How many members of the public would fully grasp its scope and content? These issues of planning and public process fortuitously coincided with the public art conference.

The artists also noticed that Durham was replacing decrepit downtown sidewalks in a first small gesture of urban revitalization. On the one hand, there was the massive planning document, and on the other, disintegrating sidewalks. In a recent telephone conversation about the genesis of *Loaded Text*, Mel said, "The two just came together." To raise public inquiry through direct action, Kate and Mel copied the entire sixty-five-page text of the Revitalization Plan onto the cracked, dangerous sidewalk adjacent to the main post office of Durham. Kneeling side-by-side for several days, the artists wrote one page on each section of sidewalk. As they labored in the heat and humidity, they were assailed and encouraged for this arduous demonstration of public access and action. The Plan remained on the sidewalk for several days, until a contractor jack-hammered and removed the old sidewalk, loaded the

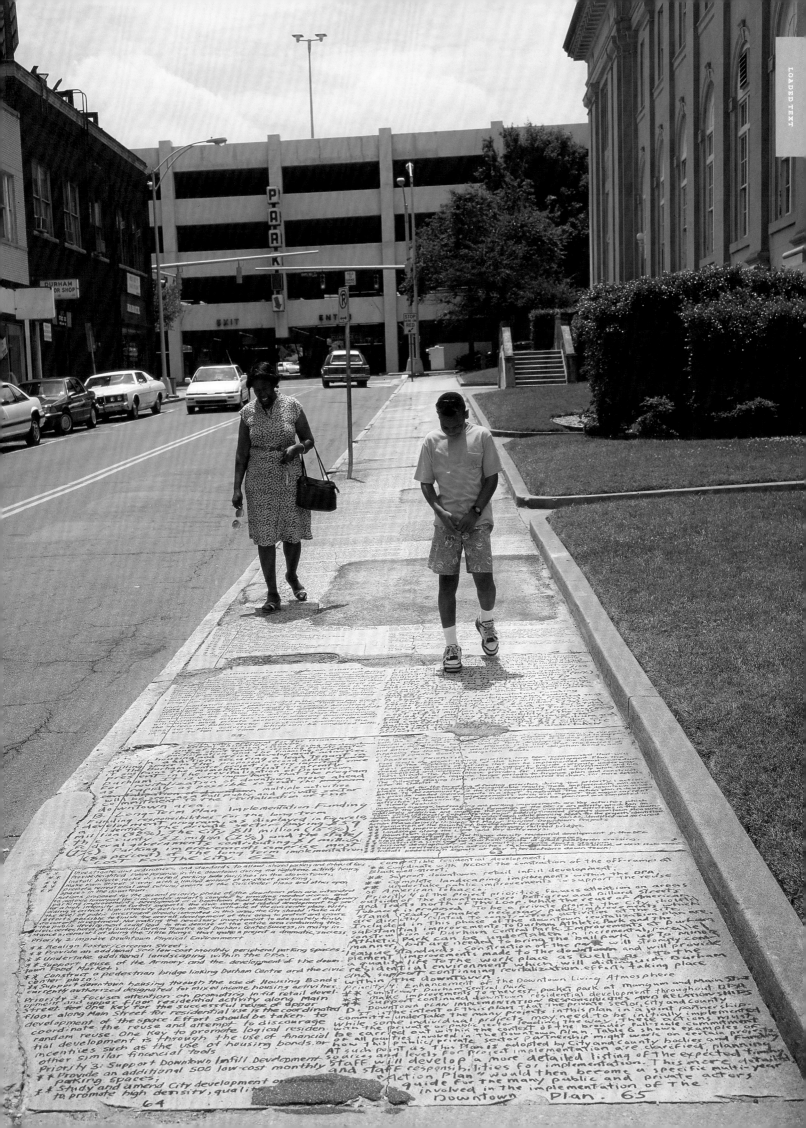

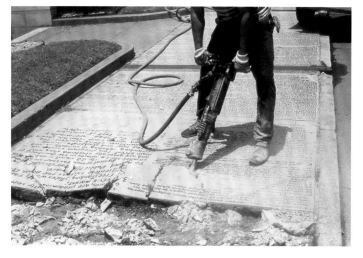
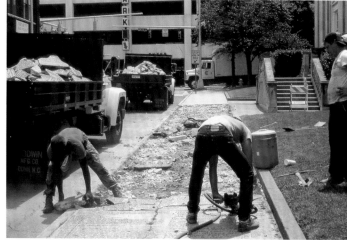

Sidewalk being broken up and loaded
into trucks

concrete pieces, each with its fragment
of text, into three dump trucks, and
drove them to the Durham Arts Council
Building to sit on display—and in wit-
ness—for four days. Completing the
task, the contractor replaced the side-
walk with a new, pristine concrete path
as the trucks deposited the inscribed
concrete pieces at a local stream as
riprap to control erosion.

Kate and Mel hired the contractor
with their art project budget, their own
small but tangible contribution to the
city's revitalization. Unsurprisingly, a
controversy erupted around their
unorthodox project. Where's the art?
What's to show for it? Who's paying for
it? Some members of the local press
characterized Kate and Mel as New York
artists who conned the people of
Durham. They were accused of abdicat-
ing their artistic responsibility and
being profligate with public art funds.
The artists had "performed" a writing of
the Revitalization Plan, but what did
this have to do with art? At the nearby
stream, fragments of text-covered side-
walk now stabilized the banks, and next
to the post office there was a new side-

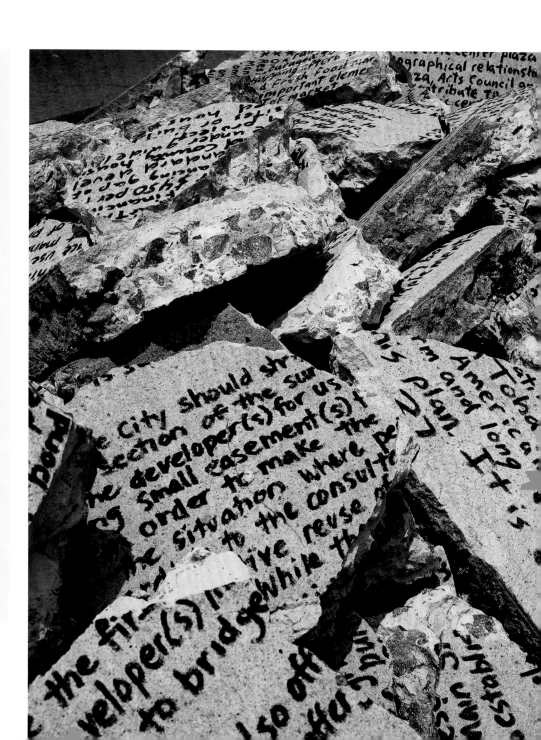

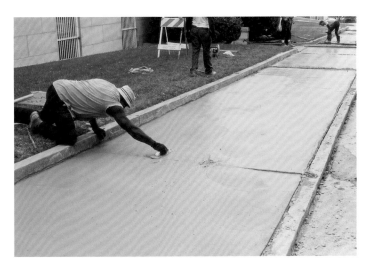

Installing a new sidewalk

walk, but almost no one accepted or appreciated these results as public art. In some respects, the detractors were right. As with so many of their projects, meaning was strategically situated around the physical evidence; the art was entirely contextual.

In public art, the line between success and failure is often fine and unpredictable. Conventional forms of public art can create complicated and contradictory expectations, conditions, and criteria, and time itself can change perceptions of failure and success. In retrospect, Mel feels that talking more with the community and media about the plans and objectives for *Loaded Text* might have deferred or diminished, or helped both the artists and the community anticipate the controversy. With ephemeral, aesthetically progressive work, the relationship between seeing, believing, and knowing is invariably imprecise. Kate and Mel entered a complex alchemy of systems and circumstances at a particular moment in Durham, using the opportunity to create public art about public process. Their work functioned as a

prompt or summons without over-determining what people might do or think. A risky methodology? A successful methodology that produced a failed project? Or a problematic project that now seems remarkably prescient and relevant in a world of increasing opacity and indirection?

Looking back, what have we learned from *Loaded Text*? The project, with its conceptual precision and public process, changed the conversation on public art, and Kate and Mel's invaluable dialogic process stimulated new ways of thinking about art and life. I am moved and inspired by the humble image of Kate and Mel kneeling side-by-side on a sidewalk of Durham, writing, working, and making art in the pursuit of openness. Exacting intelligence and open curiosity. Art and public. Kate and Mel. Two just come together.

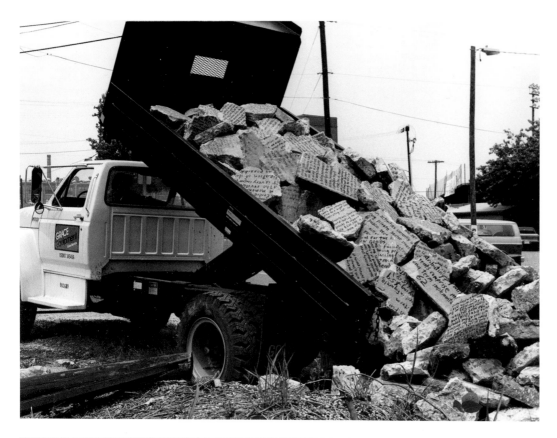

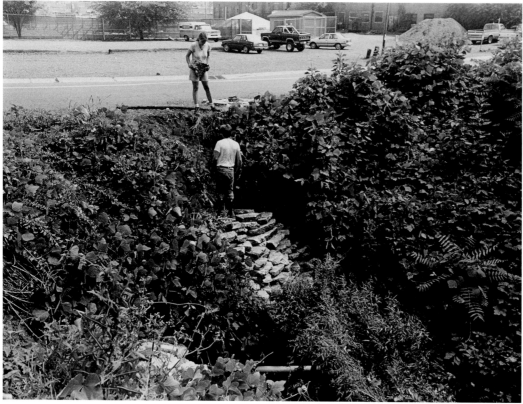

Kate Ericson and Mel Ziegler
stacking concrete pieces as riprap,
Durham, North Carolina

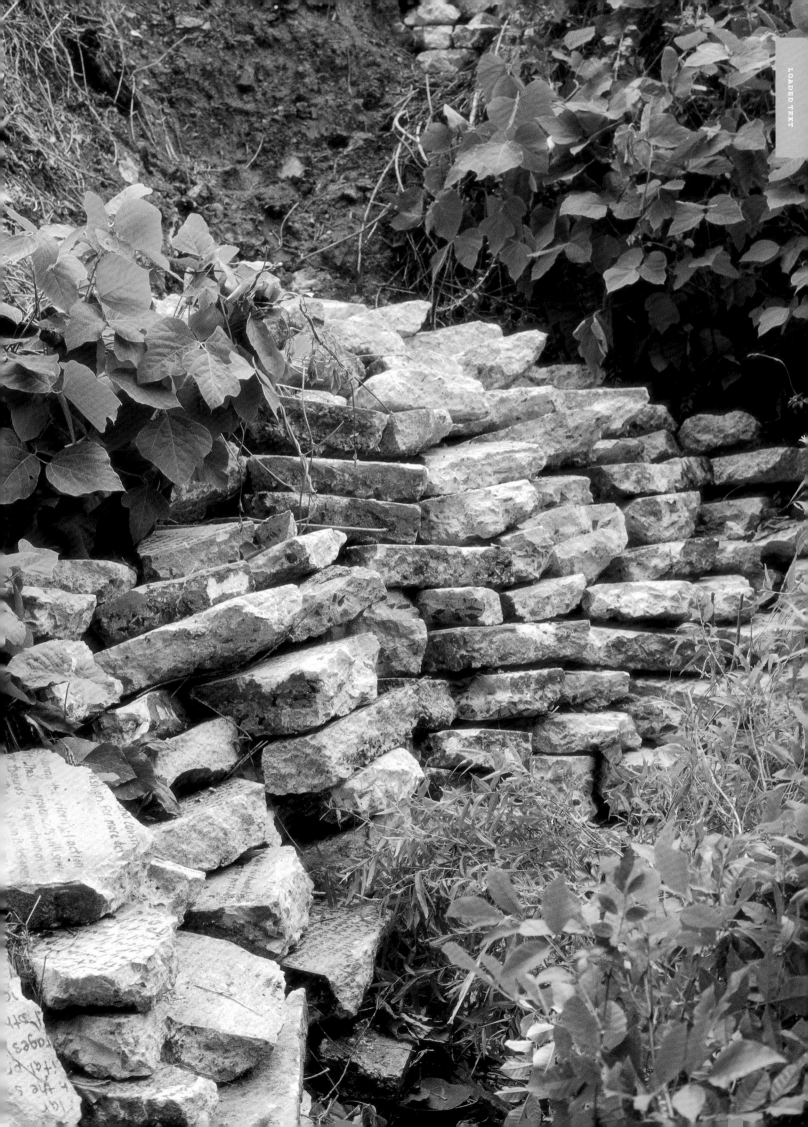

The Wellesley Method

1990
Wellesley College Museum,
Wellesley, Massachusetts,
April 6–June 11, 1990

"The Wellesley Method", developed in the late nineteenth century at Wellesley College, combined traditional art history with the study of original art objects. Ericson and Ziegler solicited old eyeglasses from Wellesley community members, and recorded the heights, addresses, and professions of the donors. The artists annagrammed the letters in the words "The Wellesley Method" into pairs of words, letting their donors pick the words that described them. These words were then sandblasted on their lenses. The glasses were hung according to the donors' eye heights and mapped according to their home addresses.

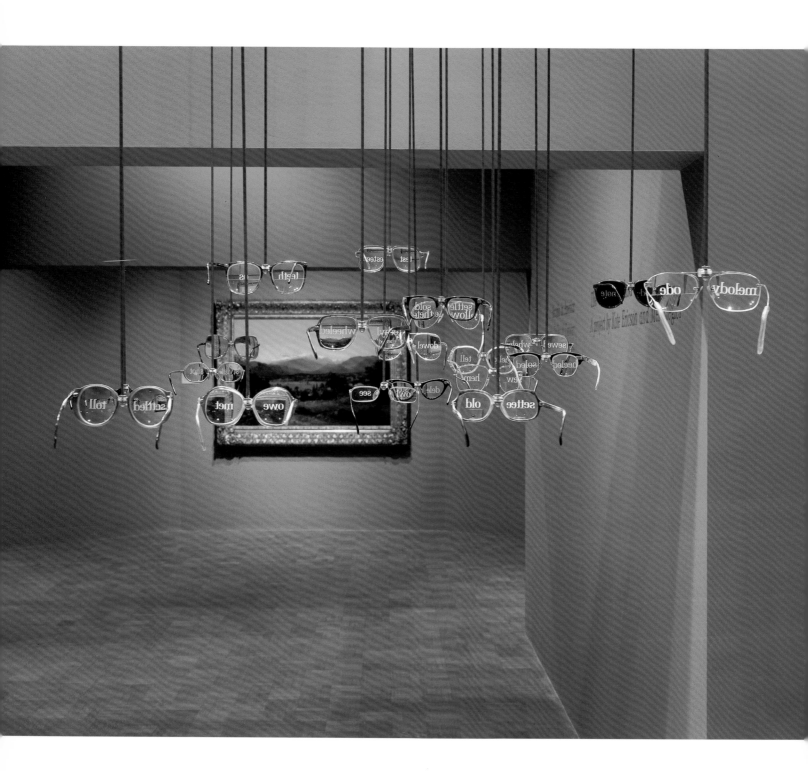

Project participants: Bill Archibald, *painting contractor*; Emma Jean Butler, *administrative assistant*; Maurice Chapnik, *tailor*; William C. Daisley III, *accountant*; Salvatore DeFazio III, *printer*; Ralph DeGiandomenico, *builder and maintenance person*; Peter Dehman, *service technician*; Noel Demers, *computer operations manager*; Ginni DeMilia, *missionary*; Kevin Gordon, *architect*; Nancy Green, *accounts payable clerk*; Connie Hanlon, *antique dealer*; Lewis Kimball Jr., *educational administrator*; Gerald A. Kindness, *optician*; Prudence Landers, *beautician*; Bruce Mansfield, *tennis professional*; Shirley Pepper, *secretary*; Leo Perito, *shoe servicer*; Janet Roberts, *cashier*; Emily Ryan, *patient account manager*; Joanne Slodden, *surgical technician*; Josephine M. Smith, *realtor*; Kathryn Smith, *preschool teacher*; Dr. Daniel Snyder, *orthopedic surgeon*; Dr. Anne Tavel, *clinical psychologist*; Dr. Richard W. Ulbrich, *orthodontist*; Judy Weil, *human resources consultant*; Anne Wellington, *landscape designer*; Paul Wiggin, *singer*; Phyllis Wiggin, *reference librarian*; Michael Woloshyn, *upholsterer*; Wes Worley, *store manager*.

JUDITH HOOS FOX

THE WELLESLEY METHOD

TO CELEBRATE WELLESLEY COLLEGE MUSEUM'S CENTENnial in 1989, the curators decided to focus attention on the museum's permanent collection. We invited noted scholars, when possible Wellesley alumnae, to organize small, focused, investigatory exhibitions on selected objects, each demonstrating a different methodological point of view that would elucidate some heretofore unseen side of the masterpiece in question. The year-long program of exhibitions and related events would acknowledge the fine works in the museum and the inventive scholarship of the college's alumnae and own faculty and staff. Very Wellesley. But we also aimed to counteract the self-admiring nature of this enterprise by inviting Kate Ericson and Mel Ziegler to participate. As curator, I wanted to commission a work that would state emphatically that it is the future that is to be celebrated and plunged into. I was eager to work with Kate and Mel, as I knew they would somehow reveal the essence of the place, as they had done at New York's Museum of Modern Art. But I had no way of knowing how original and inspired their response to the occasion would be.

Kate Ericson and Mel Ziegler came to campus several times in late 1988 and again in early 1989. They switched accommodations from the College Club, with its convent-like

ambience and tiny twin beds, to the Monticello, a motel in a nearby strip mall that both spread their budget further, allowing them more time on site, and ensured that their stay would be more comfortable. During January and February 1990 they distributed some two hundred flyers to local merchants, civic employees, and our museum docents; they mailed 150 more to names gleaned from the Chamber of Commerce Business Directory and the Wellesley Hills Junior Women's Club phone book. The flyer asked for volunteers to give their current or recently discarded corrective lenses to the artists in exchange for a $75 gift certificate at the optician's office of their choice. The project budget enabled them to collect thirty-two pairs of eyeglasses from the townspeople of this affluent suburb west of Boston. When they picked up the glasses, they measured the height of the donor's eyes and noted his or her profession and address, while, in their usual way, interacting warmly with this community of reserved New Englanders. Often they received more than one pair of glasses. Those not used went to New Eyes for the Needy, an organization that sponsors the collection and distribution of discarded glasses in Third World countries.

Interested in the role of language in constructing and communicating meaning, the artists took the phrase "The Wellesley Method"—an epithet for the innovative, object-based teaching of art history that Wellesley introduced in the late nineteenth century—and anagrammed the phrase's letters into as many groupings and combinations as possible. They used sandblasting to imprint these 365 words onto a glass plaque. From the list, they selected pairs of words that would describe each of the eyeglass donors—"tot heed" for the preschool teacher; "teeth os" for the orthodontist; "old settee" for the upholsterer; "eye mote" for the optician. Suspended from the ceiling of the museum at the respective eye heights of the participants and spaced according to their locations in the town of Wellesley, the glasses installation created a synecdoche of the community in the museum, permitting the town to inhabit the institution, something our membership and public relations offices had been unable to do with much success. Situated facing the museum's great John Frederick Kensett painting of the White Mountains in New Hampshire, Kate Ericson and Mel Ziegler's piece made the point that art needs an audience. The exchange that Kate and Mel effected with community members parallels the necessary exchange between art object and viewer.

During their visits to campus, Kate and Mel met with students, all of whom wanted to be Kate and many of whom fell in love with Mel. We brought the artists back to campus in the mid-1990s to meet a new generation of students when we reinstalled the piece in the new Davis Museum and Cultural Center. On that trip they gave wonderful tandem lectures at Harvard and Wellesley. Kate, already sick but with her long-term memory still sharp, spoke about the older work, while Mel talked about recent projects.

The process undertaken for this project brought a new community into the museum. We used this group of citizens in our audience research when we set up a series of focus groups to learn more about the role of the museum in our region and the kinds of amenities needed in the new facility. Whenever we reinstalled the piece we notified the participants and invited them to the opening, a practice

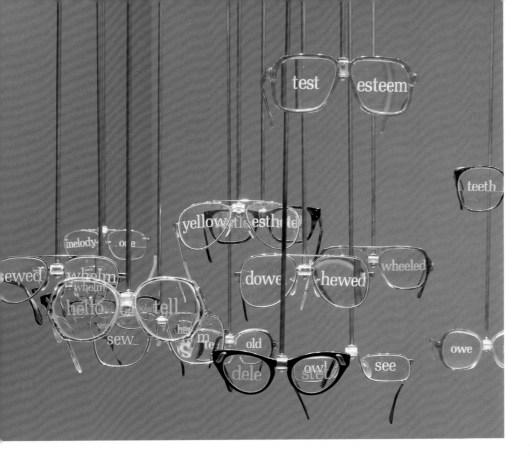

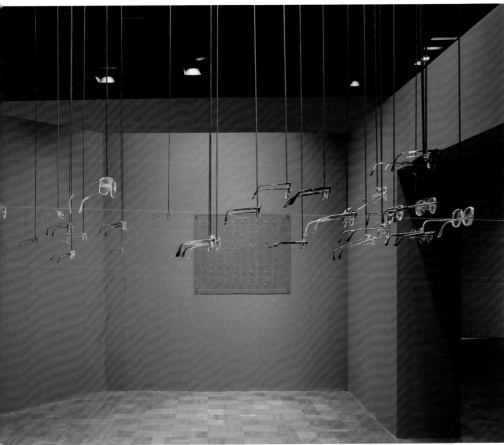

Installation views:
The Wellesley Method, 1990

that I hope continues.

During the planning, fabrication, and installation of the piece we all got very friendly and had a lot of fun together – we had a great staff that included several spirited young alumnae. Kate and Mel asked us each to bring in a recently discarded pair of glasses and to select two words for ourselves. Naturally the choice became an obsession with us. My co-curator, a precise and elegant writer and editor who meticulously crafts language, selected "delete tosh." As my role for the year was making seven shows happen, I selected "hello yes." My architect husband chose "home style," and our daughter, who had just outgrown her first pair of tiny pink glasses, "sweet dolly."

Directly engaging the community, giving them a role in the art-making process, creating a fresh version of Marcel Duchamp's readymade and Joseph Beuys's actions, and helping us to see and think about the role of museums and art in society, the work of Kate Ericson and Mel Ziegler brings together their theoretical approach with our personal experience, an institutional project with individual repercussions.

Feed and Seed (Heisey Farm)

1990
Seed bags, sandblasted
acrylic, hardware
Sixteen bundles of bags: 34 x
18½ x 2 inches each; overall
dimensions, 71 x 169 x 2 inches
Courtesy of Mel Ziegler,
Austin, Texas

Feed and Seed (Heisey Farm) is
part of a series of seven
collaborations with farmers
in which the artists provided
ten percent of the farmers'
annual seed cost in exchange
for the empty seed bags that
had been subsidized. The
farms where chosen after they
responded to an ad placed by
the artists in a Pennsylvania

farming journal. The bundled
bags were then framed under
acrylic sandblasted with
the type of crop and the number
of acres sown with seed
from the bag. When galleries
sold the work the remaining
ninety percent of the cost
of the seed was given to the
participating farmers.

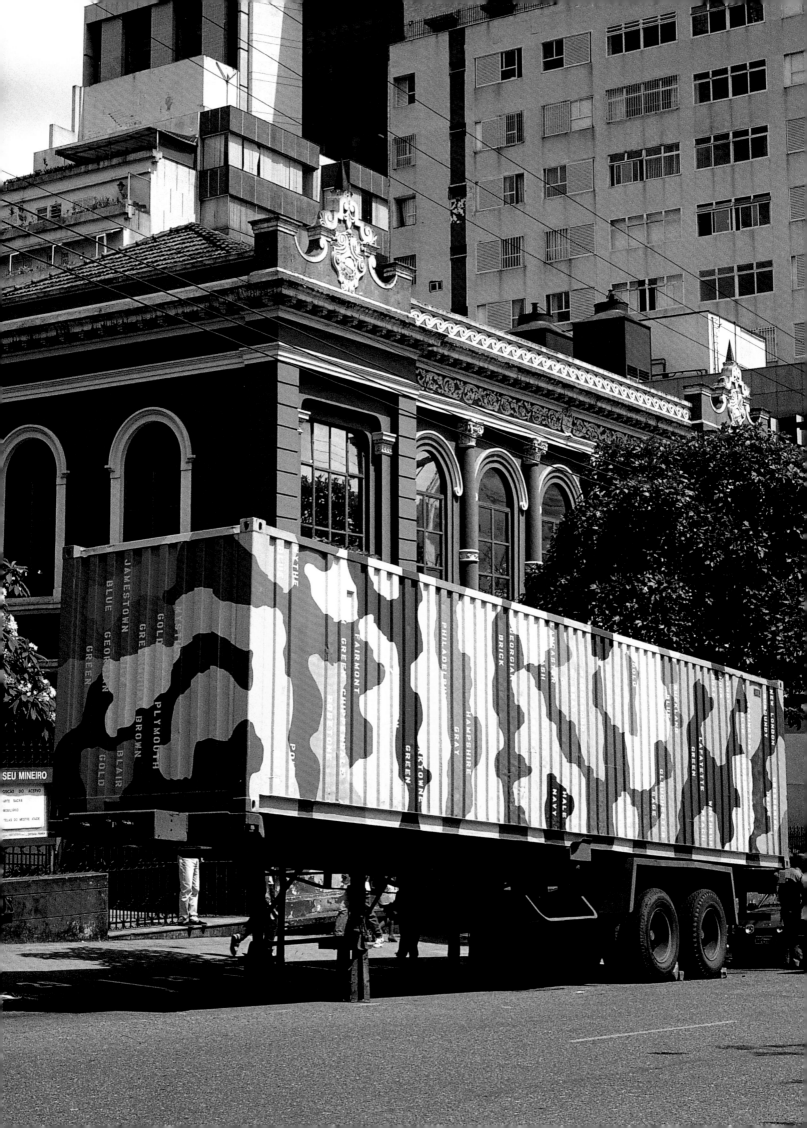

Exported Pallet

1991
Sponsored by United States
Information Agency, Cultural
Fundição Progresso Rio de
Janeiro, Brazil. Traveled to
Museu Mineiro, Belo Horizonte,
Brazil.

This project consisted of a
sea container with four hundred
wooden shipping pallets.
The pallets and container were
painted with eighty colors
that came from Benjamin
Moore's American Historic
Colors paint chart and
stenciled with the commercial
paint names. The pattern used
on the container was from
the skin pattern of an American
"false" chameleon, or green
anole. The project was first
installed at the Fundição
Progresso in Rio de Janeiro
where the truck was parked
outside the space and
the pallets were laid out in
the configuration of the paint
chart. The second installa-
tion was in Belo Horizonte at
the Museu Mineiro, where
the truck was parked outside
the museum and the pallets
were integrated in relation to
the museum's permanent
collection.

KATHLEEN GONCHAROV

EXPORTED PALLET

I FIRST MET KATE ERICSON IN 1984 WHEN SHE COVERED A corner of the sandy landfill that eventually became Battery Park City with green indoor/outdoor carpet. Creative Time's annual summer program "Art on the Beach" was a venue for experimentation and collaboration in public art, and its site was particularly challenging. Everything presented there had to compete visually with the backdrop of the Hudson River and the looming World Trade Center towers. To add to the difficulty, each project also needed to serve as a performance site, in this case for a dance choreographed by Ellen Fisher. Kate's solution was very smart, simple, practical, and elegant, and the bright green carpet became a magnet for all types of summer social activities and a highlight of that year's program.

Three years later, Creative Time again confronted another perplexing problem when asked to organize an art and performance series for Central Park's first "Summer Stage" program. The challenge was to commission a visual artwork that would accommodate the Park Department's strict rules about the placement of physical objects and that could survive in such an exposed environment. We again turned to Kate and her partner Mel Ziegler, who proposed a

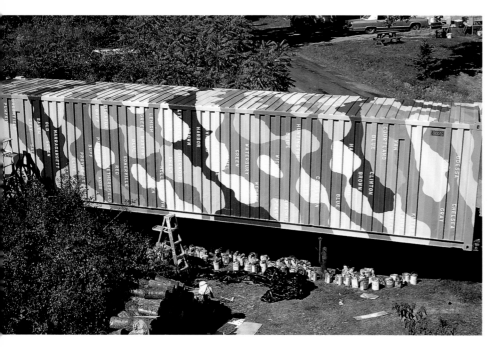

project they titled *If You Would See the Monument, Look Around*, after a quote by seventeenth-century architect Sir Christopher Wren, referring to his design for St. Paul's Cathedral and over fifty other London buildings. The oblique reference was to the many bronze monuments scattered throughout Central Park, but their project did not commemorate historical figures. Instead, it posed the question of what a monument could be by celebrating the unsung heroes responsible for preserving the park. After meeting and getting to know the maintenance crews employed by the Parks Department, the artists decided to bronze the tool handles of the workers, whom visitors would "see if they only looked around."

I greatly admired Kate and Mel for their unorthodox approach to the materials and practice of public art, so when I was invited by the Arts America Program of the United States Information Agency to conceive of project-based works to represent American culture around the world, I immediately thought of them. To me they epitomized the very best of the United States: highly intelli-

gent, inventive, and practical problem-solvers who brought fresh new ideas and a can-do attitude to their work. They were well-versed in American history and ideas and could use that information wisely to critical ends. Most importantly they were completely dedicated to the democratic ideal of actively involving their audience and bringing their art into the lives of a wide variety of people.

When I invited Kate and Mel in 1991 to create a project that would travel around Brazil, I knew they would bring this knowledge and experience with them and do the research that would enable them to create not only an engaging artwork, but also one that would benefit our hosts. I also knew that they were adventurous and open enough to cope with the unpredictable problems that inevitably crop up when working with government agencies and in foreign situations. I was proved correct, and Kate and Mel's sense of adventure was a delight, whether during the actual work or when we were immersed in the local culture. We had many adventures traveling around the country, to São Paulo

for the Bienal, the colonial towns of Minas Gerais and Petrópolis, and Brasilia, the bizarre, futuristic capital laid out in the shape of a jet airplane, where all addresses are mathematical coordinates. We enjoyed many caipirinhas and were special guests at a rare evening of performances by many of Brazil's best musicians held in honor of Cartola, the recently deceased samba singer-songwriter.

Mel and Kate's project conceived for Brazil was entitled *Exported Pallet*, which they defined on the waybill as an "imported cultural package," an ironic reference questioning the exportability of culture. The artists obtained a forty-foot cargo container, the vehicle commonly used to import and export goods overseas between the United States and Latin America, and completely filled it with 400 empty pallets, the wooden platforms used for storing and shipping goods. The word also plays on the term "palate," meaning taste in the aesthetic sense, as well as the artist's "palette," further critiquing the wisdom and effectiveness of exporting culture.

Kate and Mel painted these pallets

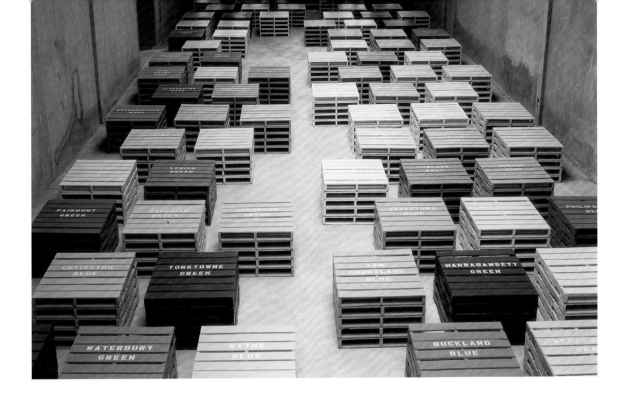

with eighty colors from a collection of interior paints modeled after "significant colors from the eighteenth and nineteenth centuries" and produced by Benjamin Moore. The paints' names were stenciled on the pallets, names like Jamestown Blue, Hawthorne Yellow, Woodstock Bronze, Adams Gold, and so on, that were each associated in some way with United States history and referring to the names of historic persons or places. Of course, these colors were a complete invention on the part of the manufacturer and reflected the Anglo-American ethnocentric nature of their creation. They painted the outer surface of the cargo container with the same eighty colors in a pattern found on the skin of the *Anolis carolinenis*, commonly known as the American chameleon, a lizard found primarily in the Carolinas. This chameleon was a metaphor for artists and other cultural ambassadors who need flexibility and adaptability to understand and survive in a foreign environment.

The cargo container with the pallets was driven on the back of a flat bed truck to venues around Brazil, beginning with a new combined cultural and shopping center in downtown Rio de Janeiro, a venture on the part of the city government to transform an area known for its high crime rate. The container was displayed outside, and the painted pallets were arranged inside in the found configuration of the Benjamin Moore paint chart. Kate and Mel worked closely with and befriended the construction workers from the local community who were still building the site, becoming acutely aware of their hazardous working conditions, long hours, and low wages. From our daily lives in New York City, we were well aware of the irony of art's role in the gentrification process, so we were disturbed but not shocked to find it in Rio. Fortunately, the other venue in the town of Belo Horizonte did not present the same difficulties.

The most significant problem came at the end of the tour of *Exported Pallet*. Mel and Kate's intention from the beginning was that the cargo container and pallets remain in Brazil where they would be used for the purpose for which they were intended, transporting mer-chandise around the country. They wanted the multi-colored container with the chameleon pattern to be seen for years to come on the network of highways crisscrossing Brazil. Although this intent was made clear to the consulate staff in Rio de Janeiro, who were charged with working out the details, we ultimately came up against an arcane set of import-export laws that forbade anything exported to Brazil to remain there even if it had no declared commercial value and was a gift to the country. After lengthy negotiations, the container and pallets returned to New York and were given back to the company they were bought from in the hope that they would return to their regular uses.

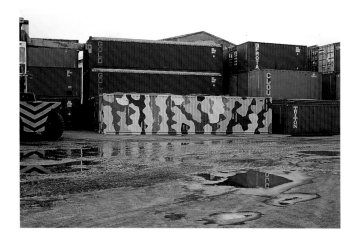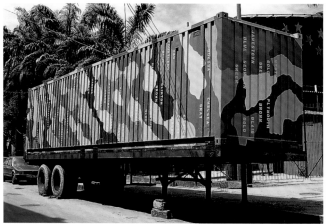

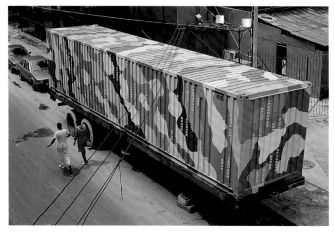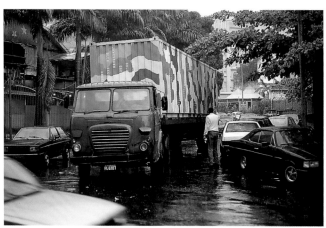

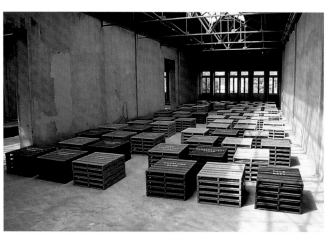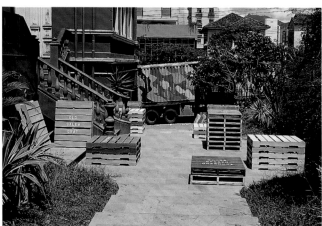

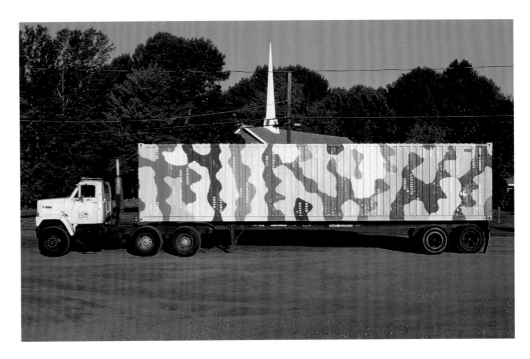

Project views: *Exported Pallet*, 1991

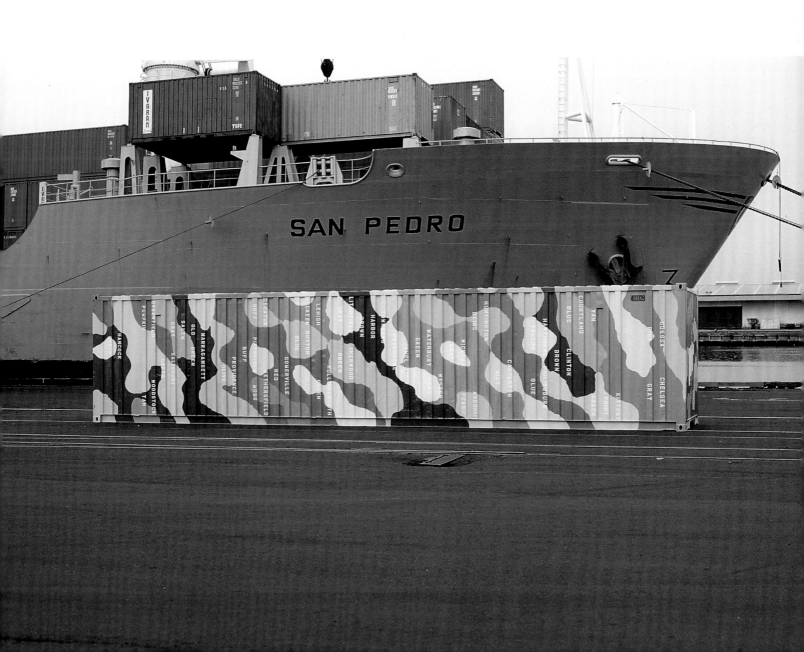

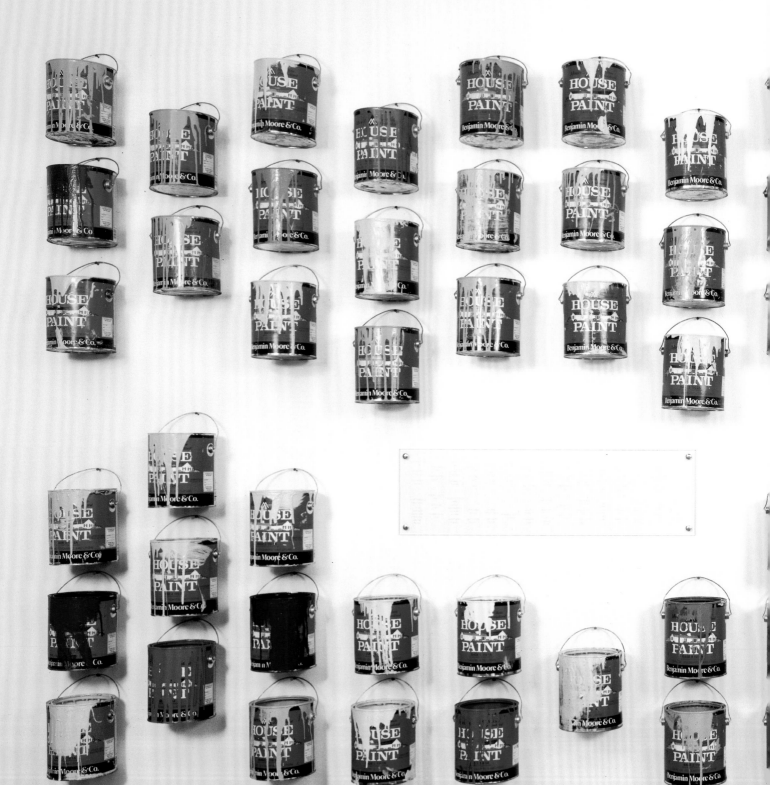

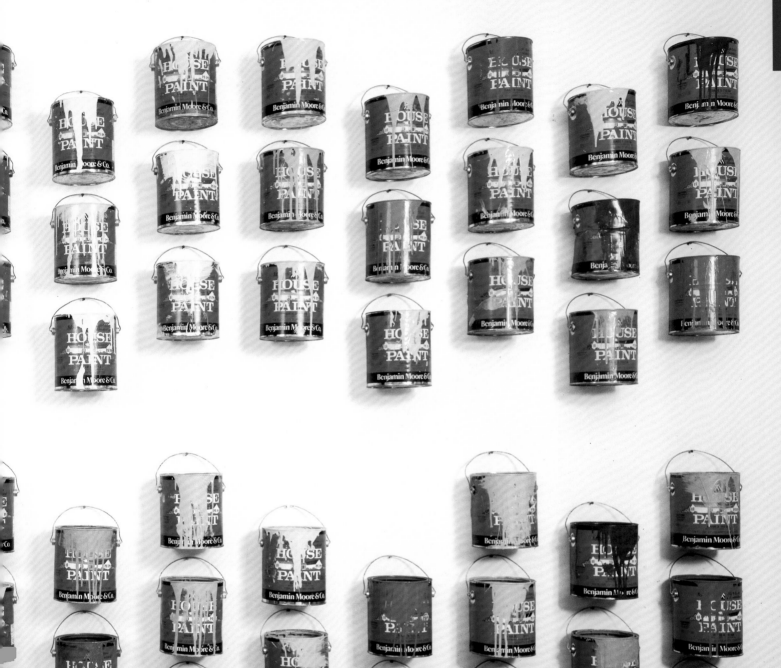

High Gloss

1991
Paint cans, sandblasted glass
plaque, hardware
Overall dimensions: 160 x 74 x 7
inches
Collection of Alice Kosmin

Empty paint cans used to paint
the shipping container and
pallets for the project
Exported Pallet were hung on
a wall according to the
Benjamin Moore Historic
Colors paint chart. The paint
names were sandblasted
onto a glass plaque mounted
on the wall with the cans.

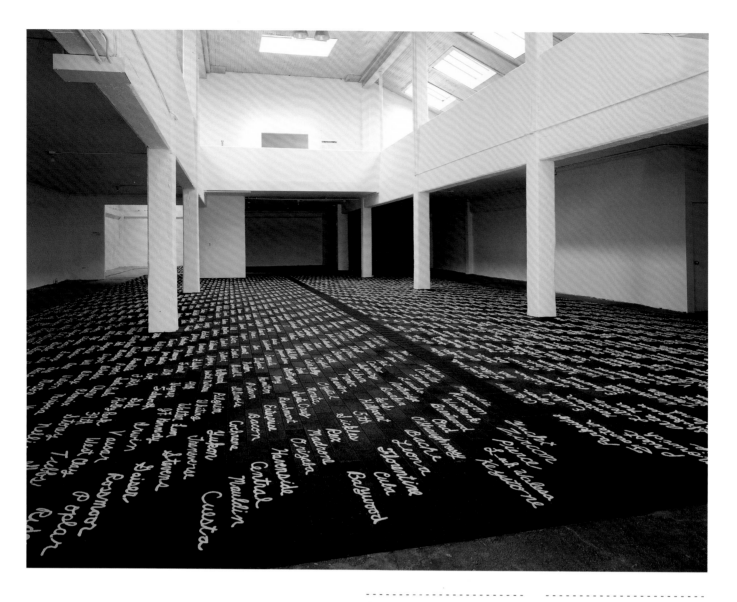

Peaks and Valleys

1991
Capp Street Project, San
Francisco, California,
February 15–March 30, 1991

The artists covered the entire
floor of the Capp Street
space with 2,200 asphalt roof
shingles on which they hand-
wrote the name of every street
in San Francisco. Typical of
the artists' ambition to
create art that raises public
awareness and provokes ideas
about community, *Peaks and
Valleys* stood as a metaphor
for the city of San Francisco—
its unique topography and
economically diverse
neighborhoods. To further
spark dialogue with the
community, the artists later
donated the shingles to a
San Francisco homeowner
in need of a new roof, thereby
placing their work directly
into the public sphere.
Funds allotted to the artists
for their exhibition at Capp
Street paid for the re-
roofing of the house at 1718
Bryant Street in the Mission
District.

Front and rear view of house at
1718 Bryant St., San Francisco,
California

Camouflaged History

1991
Spoleto Festival U.S.A.,
Charleston, South Carolina,
May 24–August 4, 1991

For their contribution to *Places with a Past*, Ericson and Ziegler arranged for a private home just outside the city's designated historic district to receive a much-needed repainting using each of seventy-two commercial paint colors approved by the Charleston Board of Architectural Review for

homes within the district. Army camouflage specialists at Fort Belvoir, Virginia, designed a new, regionally appropriate pattern for the house, and each patch of color was labeled with that paint's official trade name. Names such as "Moorish maroon red" and "Confederate uniform grey" evoked

venerated and at times problematic chapters in the city's history.

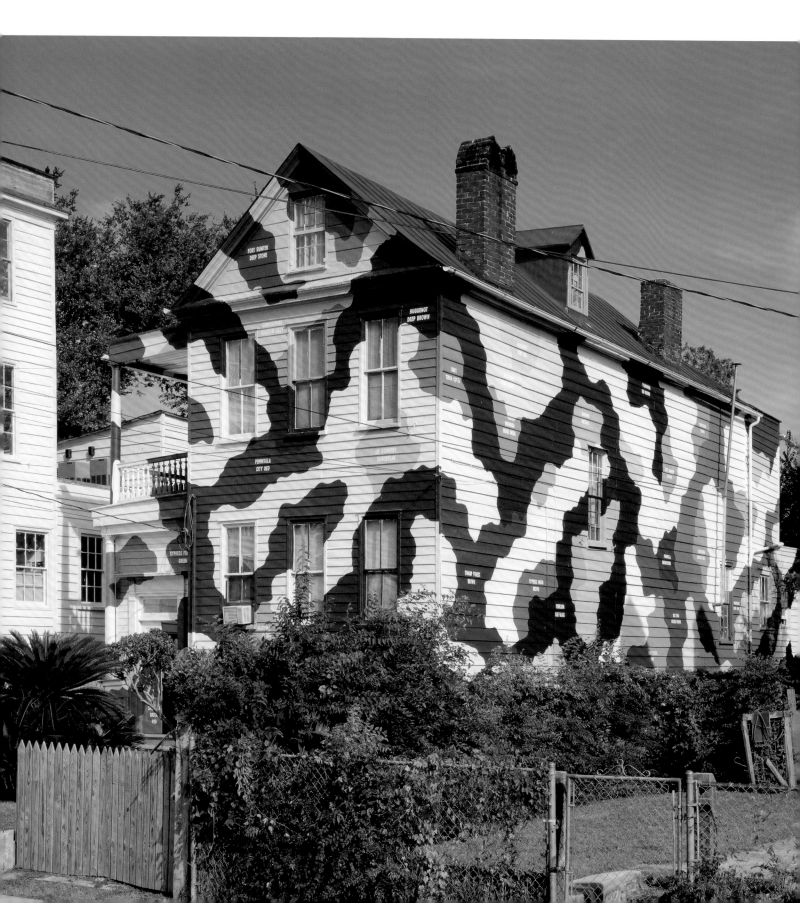

MARY JANE JACOB

CAMOUFLAGED HISTORY

I WORKED WITH KATE ERICSON AND MEL ZIEGLER ON two commissioned projects, both works about the colors with which we live at home: the first, *Camouflaged History* from 1991, employed an existing paint chart to repaint the exterior—the public face—of a nineteenth-century private home; the other, *Eminent Domain* from 1993, led to the design of a new paint chart, imagined for interiors—the private living spaces of the collaborators—but actually demonstrating the personal issues at stake in public housing.[1] The artists' processes for the two works varied accordingly: one involved the negotiation of permission to use private space for public display; the other the negotiation of ideas and issues in the public realm that influence individual lives, a process that required gaining the deep trust of a specific community and creating a true working partnership with its members. In the two short years that separated these projects, consulting and collaborating with the people that artists' projects affect had moved to the forefront of art practice. As a result, contentious debate ensued about authorship, and the relationships between the art world and the everyday world, and between socially elite and economically impoverished audiences. Thus, *Eminent*

Ericson and Ziegler holding the paint
chart used for *Camouflaged History*,
1991

THE AUTHENTIC COLORS
OF HISTORIC CHARLESTON

Reprinted from the sale of this card further the Restoration of Charleston's Historic Treasures

by *Dutch Boy*

Domain became as emblematic of this new emphasis on audience as *Camouflaged History* was iconic of site-specific strategies of installation.

Charleston, South Carolina is a city all about home—planters owned numerous plantations as well as city mansions; Africans were taken from their homes and enslaved here; the Civil War originated here partly as a fight to protect the power rooted in homes. Today thousands have newly made the Low Country region their home, and from this resettlement issues arise that threaten the cultural and ecological sustainability of the land. One of the city's long-time single-family residences provided the site of *Camouflaged History*. Even before Mel and Kate came to town, they knew of Dutch Boy Paints' chart "The Authentic Colors of Historic Charleston" whose seventy-two colors, codified and imposed by the local governing body of the Board of Architectural Review, evoked venerable local stories set against a timeline of American history and architectural styles.

But what hit them upon arriving in Charleston was the frenzy of restoration activity just six months after the disaster of Hurricane Hugo and, in that restoration, the reconstruction of history and the new demarcations between rich and poor, white and black. They wanted to make a project that revealed more. After visits to three neighborhood groups, they focused on the Eastside, still today a troubled, marginal area where family homes change hands as elders pass away or sell because their offspring have moved away, and opportunistic buyers eagerly await the neighborhood's gentrification. There a three-story single house became the location for the project; its site—at a T-shaped intersection marking the southernmost border of the historic district—became a signpost for the differences between the north and south ends of this peninsula city, between the past and the future.

Using exclusively Dutch Boy's "Historic Charleston" palette, Mel and Kate transformed the house with a multi-colored camouflage paint job that, ironically, brought the house attention rather than concealing it. Some people wanted the camouflaged house to stay; others were relieved when the project ended. At the end of the project, the camouflage was painted over in colors chosen by the eighty-year-old reverend who resided there, rendering the house inconspicuous once again.

By contrast, *Eminent Domain* reflected the institutionalized system and big city politics of Chicago, where America's uncomfortable relationship with public housing has played out through one of the system's most infamous histories. Mel and Kate wished to create a paint chart of seemingly infinite variation, a chart that would provoke awareness by telling the history of government-subsidized housing, both suburban and public, color-by-color. Thus *Eminent Domain* was intended as a social treatise, a public information piece that would be available on store shelves, a freely available work of art that aimed to critique certain stereotypes about public housing communities.

As in Charleston, Mel and Kate visited and made presentations at several housing sites. They sought out public housing tenants whose life experience could contribute to the project as collab-

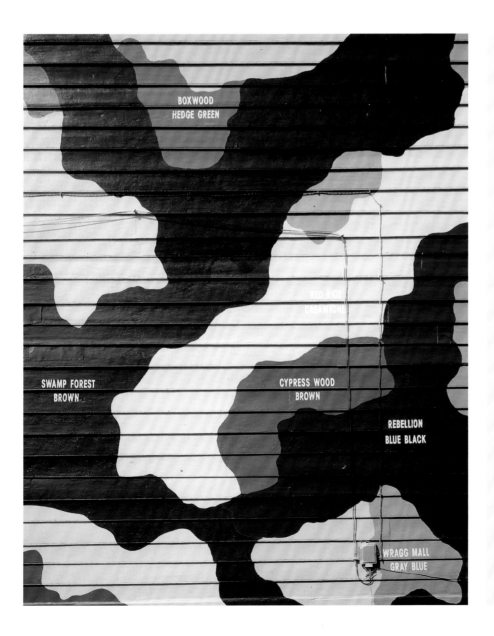

BOXWOOD
HEDGE GREEN

RED RICE
CREAMTONE

SWAMP FOREST
BROWN

CYPRESS WOOD
BROWN

REBELLION
BLUE BLACK

WRAGG MALL
GRAY BLUE

orators. They found the greatest cooperation and interest at Ogden Courts, a 1950 Skidmore, Owings and Merrill high-rise complex, where they met families dealing head-on with social problems. There, too, they met a small group of organized residents struggling to improve conditions in their apartment complex. But the resident leaders, Arrie Martin and Elois Smith, were at first skeptical of the project's relevance to their lives. They were savvy and smart, and they and other tenants interviewed the artists to determine their intentions. "Some of these people were very disillusioned—they'd had 'do-gooders' come in many times before. So what were these two doing? When they first started there was some resistance—it was a very challenging environment. I was very impressed with their humility," recently reflected Rebecca DesMarais, who assisted in implementing Eminent Domain after having worked with the artists in Charleston.

Ultimately it was Kate and Mel's warm personalities and commitment to the project that encouraged the residents to embark on a series of develop-

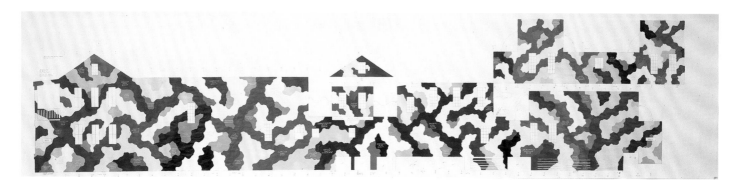

Camouflage plan and initial
tracing onto house at 28 Mary Street,
Charleston, South Carolina.

mental workshops with the artists. Again DesMarais: "Mel and Kate did different kinds of informative sessions. Now whenever I get paper towels that have some of these little homey things on them (houses, hearts, flowers, and so on), I always think of Mel and Kate. They would use such products in these workshops to illustrate and discuss how the idea of house and home is typically depicted and stereotyped from one particular point of view. There were also the pies…." The women of the Ogden Courts Tenants Council would make dinners to earn money for community activities, especially those benefiting the children. Mel and Kate participated by baking pies together. While sharing the artists' belief in effecting change, hoping to better the lives of those in their community with the articulate and powerful message of the paint chart, Ms. Martin and Ms. Smith also wanted some direct educational benefit to come out of this project. In response, the honorarium requested by the artists from the beginning for their *Eminent Domain* community collaborators was used to fund the start of a number of educational pro-

grams for the children of Ogden Court.

After over a year and a half of meetings, discussions, and several major workshops, the chart finally took the form of a U.S. map, its fifty states inspiring fifty color names that told the national story of public housing and housing legislation. Distribution of the chart was proposed and accepted by Tru-Test Manufacturing Company, a Chicago-area-based firm supplying paints for 6,000 True Value Hardware Stores nationwide, with the chart's colors coordinated with the company's stock Tru-Test colors. All the colors, like "Eminent Domain" and "Red Lining," were mixable, and thus would have been available for purchase. However, the manufacture of the chart and its distribution in stores nationwide has not yet come to pass because of lack of sufficient funding. The fact that this important public art piece has remained incomplete, and the community who worked so closely with Kate and Mel ultimately didn't see the project fulfilled, was a disappointment to the artists.

Rebecca sees it differently: "The community participants were affected.

Maybe the project's completion lies in the fact that all those people had some sort of voice in it. I think what constituted completion was to have somebody listening and taking their concerns seriously and to treat them as individuals."

Eminent Domain may one day reach another phase and have a more fully realized outcome but, in my opinion, it achieved actuality by addressing the lived reality of others. Perhaps even more telling is that the effects of Mel and Kate's project are still felt in the art field now, more than a decade later.

- -

NOTES

1. These works were commissioned as part of exhibition programs which I curated: *Places with a Past* for the Spoleto festival USA, Charleston, South Carolina, undertaken 1990–91, and *Culture in Action* for Sculpture Chicago, 1991–1993. The accompanying publications devote a chapter to each of Ericson and Ziegler's projects.

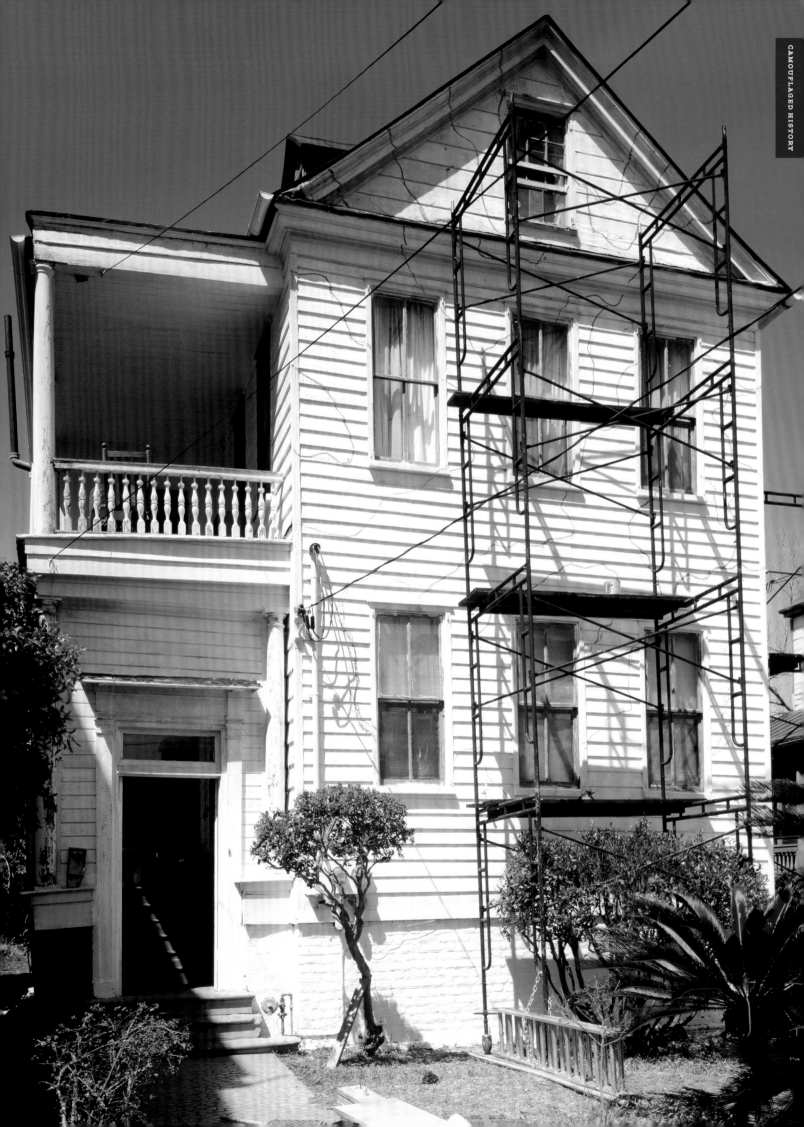

right and below
Images of *Camouflaged History*
during and after painting

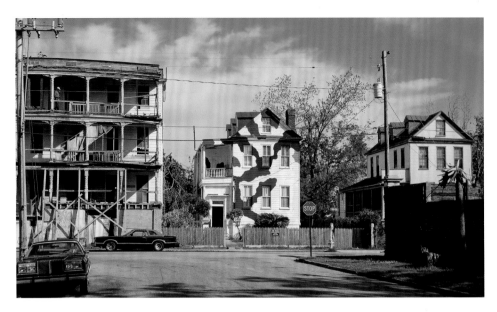

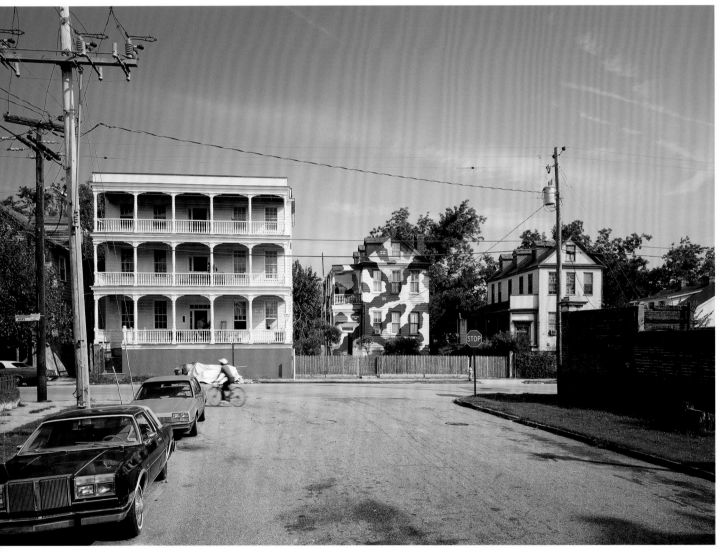

facing
Rear view of house

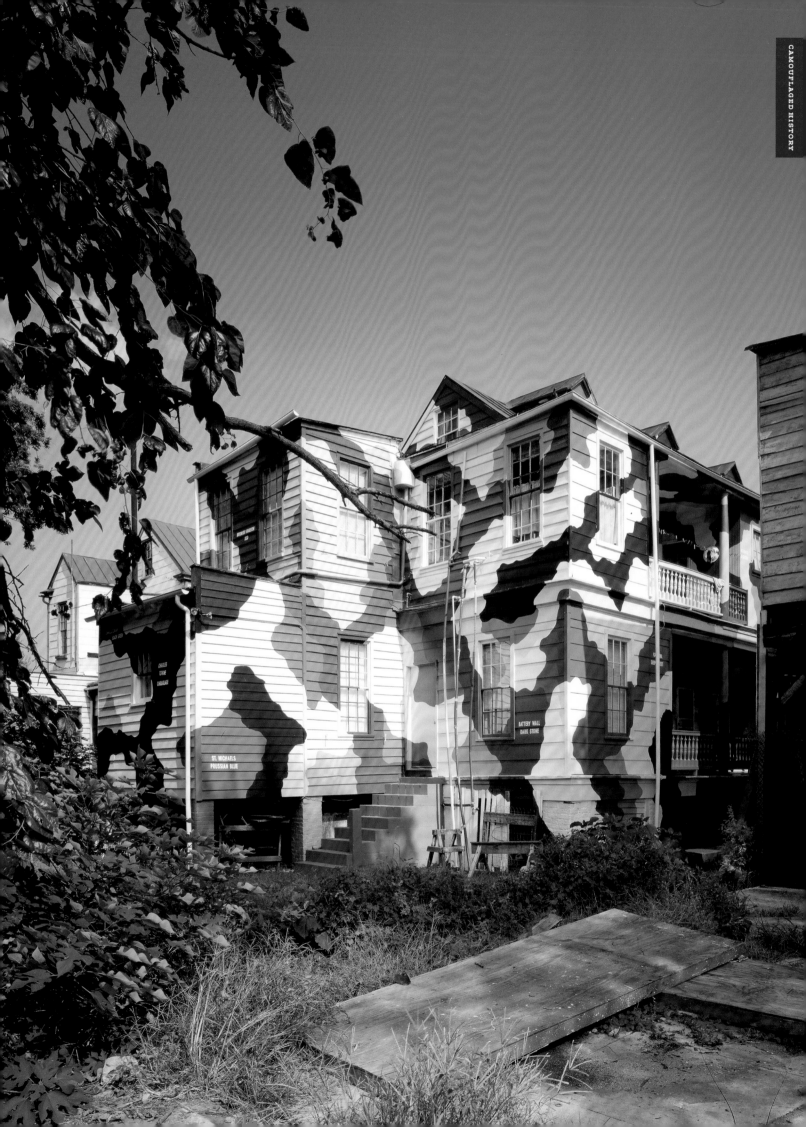

BLACK RED

CHARLES TOWNE CHOCOLATE

ST. MICHAELS
PRUSSIAN BLUE

BATTERY WALL
DARK STONE

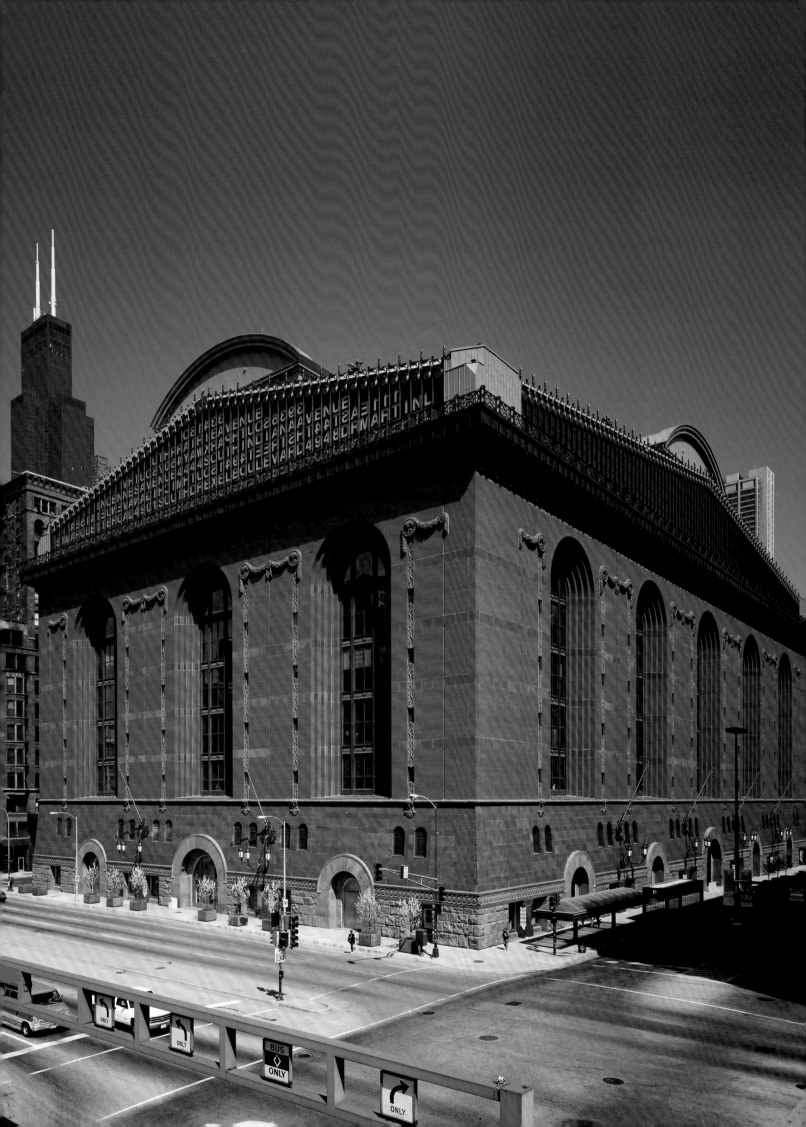

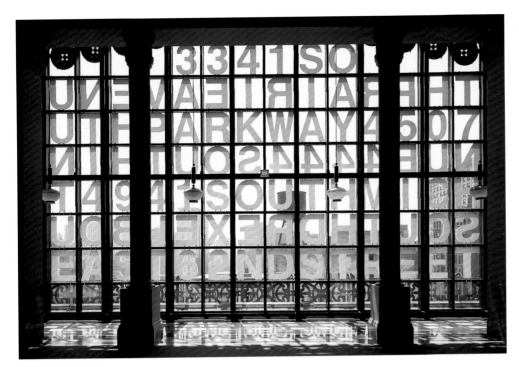

left and below
Interior views: *Wall of Words*,
1992

opposite page
Exterior view, *Wall of Words*,
1992

Wall of Words

- -

1992
Harold Washington Library
Center, Chicago, Illinois

- -

Four-hundred acrylic numbers
and letters were designed
to be interchangeable within
the curtain wall structure on
each side of the Harold
Washington Library Center.
An ongoing program was set up
to select community
participants from various
fields who would design the
arrangements of the letters.
The first installation was
a listing of all the addresses
where Harold Washington,
the first black mayor of the
city, had lived in Chicago.

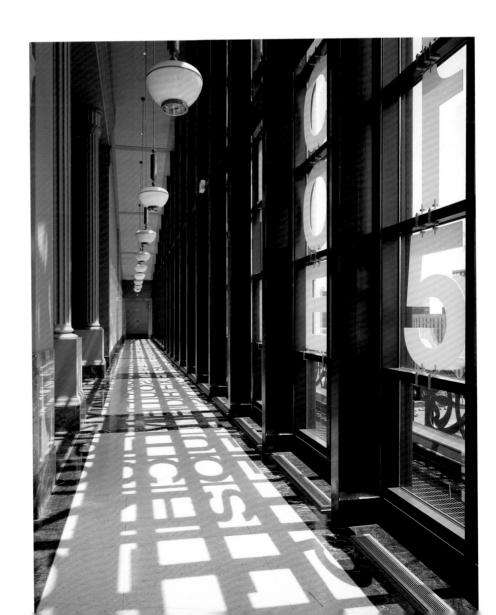

Constitution on Tour

1991
Model train cars and tracks,
sandblasted and painted
marble, metal brackets
28 x 95 x 5 inches
Collection of The Frances
Young Tang Teaching Museum
and Art Gallery at Skidmore
College, Saratoga Springs,
New York, 2005.3

In 1991, Philip Morris
Companies, Inc. sponsored a
high-profile nationwide tour
of an original copy of the
Bill of Rights celebrating
the bicentennial of its
ratification. In response,
Ericson and Ziegler imagined
an alternative approach
to a tour for the document.
The artists sandblasted the
entire United States
Constitution on a sample of
the same marble that covers
the exterior of the Supreme
Court in Washington, D.C.—

the site of the governing
body responsible for
interpreting the Constitu-
tion. This thin slab of
marble was broken and the
shards were placed into ten
Union Pacific model train
cars, chosen for that
company's role in creating
the transcontinental
railroad.

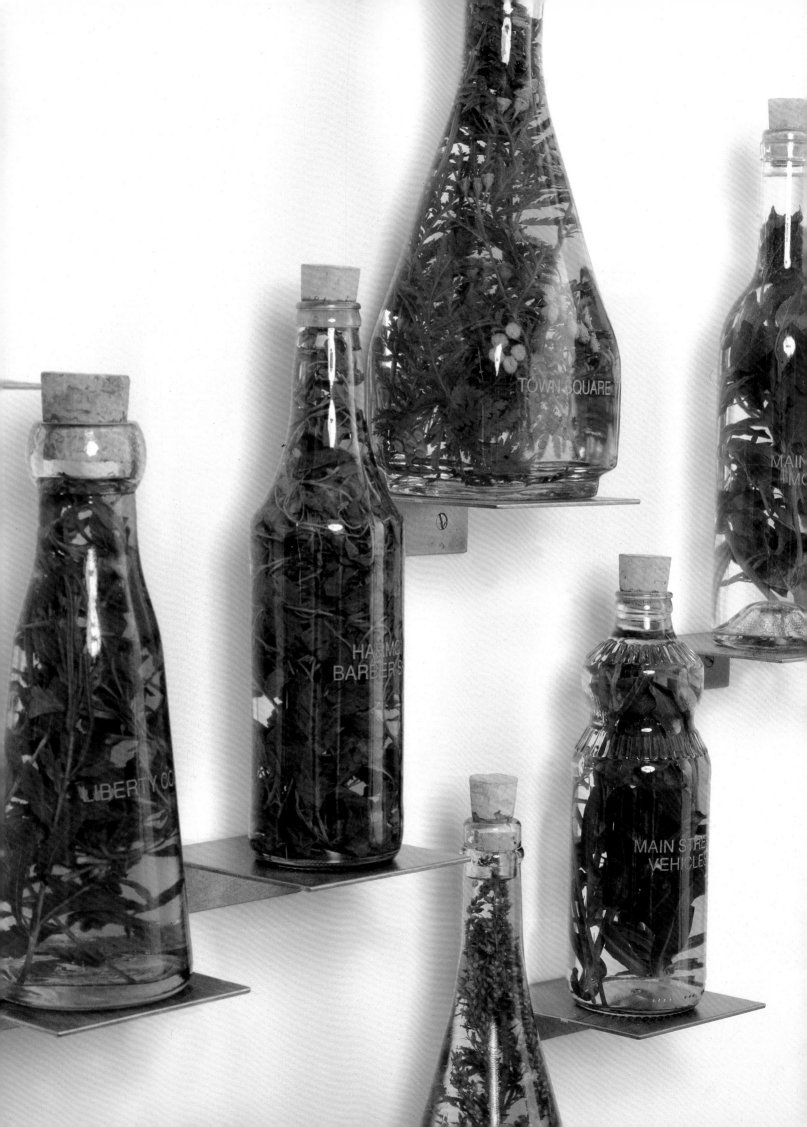

Vinegar of the 48 Weeds

1992
Weeds, sandblasted glass
jars, metal shelves
83 x 92 x 5 inches
Collection of Williams-
Sonoma, San Francisco,
California

Weeds were collected by the
artists from the borders
of EuroDisney and preserved
in glass bottles filled with
vinegar. The bottles were
hung on a wall according to
the locations of EuroDisney
attractions. Each of the
attraction names were sand-
blasted onto the bottles.
Simultaneously, seeds were
collected from the different
weeds and planted at each
of the corresponding sites
inside EuroDisney.

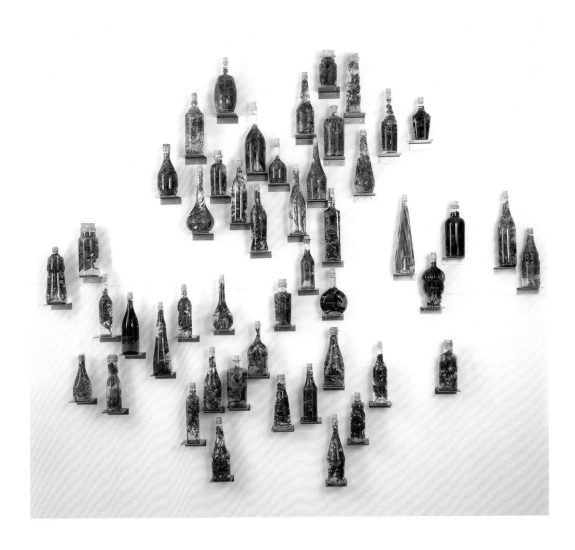

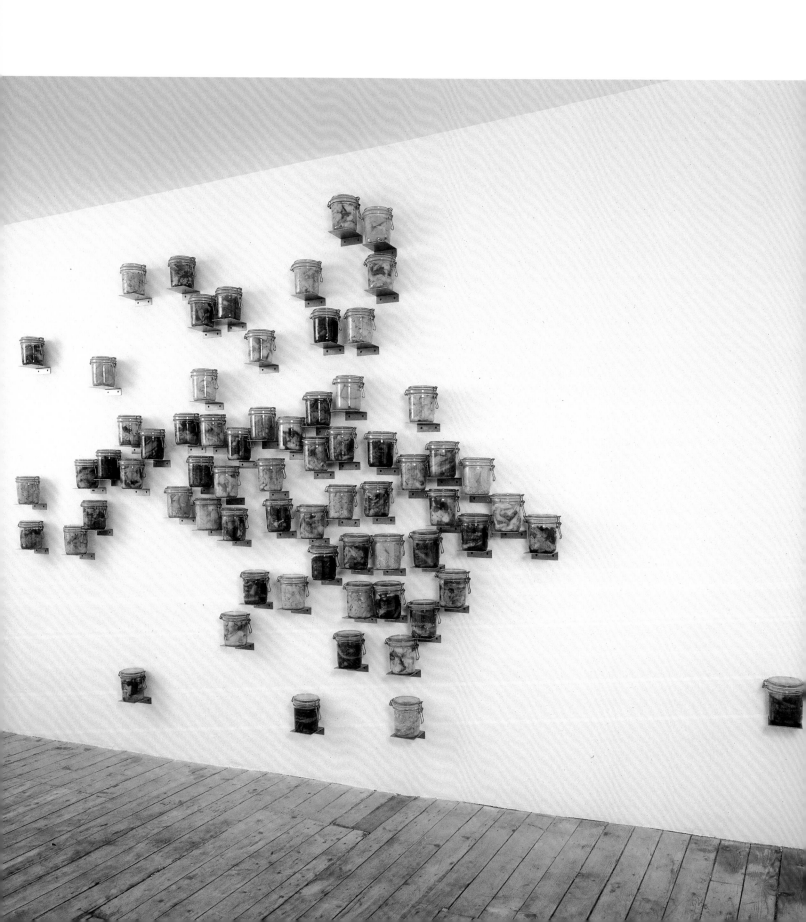

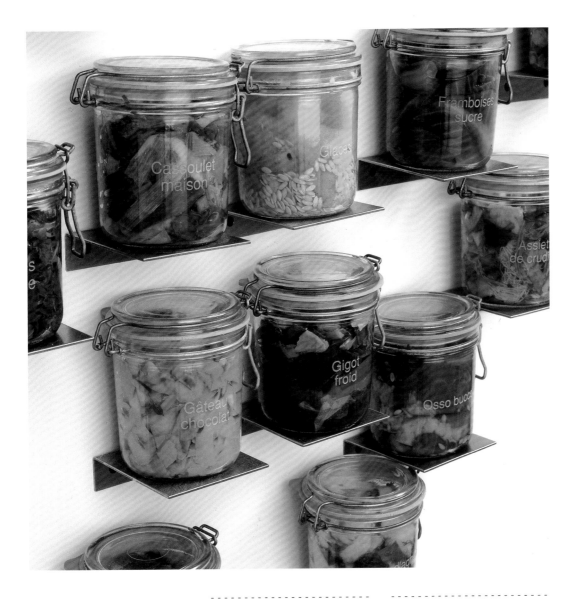

Monumental Menu

1992
Food, sandblasted glass
jars, metal shelves
87 x 138 x 5 inches
Courtesy of Mel Ziegler,
Austin, Texas
Installation view: Ma
Galerie, Paris, France

The artists collected scraps
from the preparation of
food at a Paris bistro. The
scraps were preserved in
glass jars sandblasted with
the name of the item from
the restaurant's menu. The
jars were hung on a wall
according to the location of
Paris monuments.

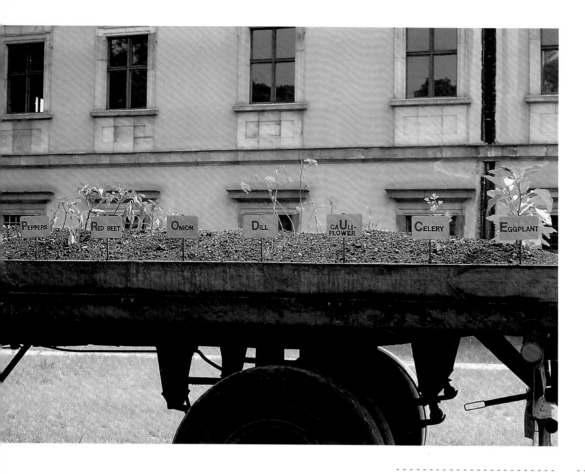

Instant Garden

1992
The Center for Contemporary
Art, Ujazdowski Castle,
Warsaw, Poland

For the exhibition,
Translation, Ericson and
Ziegler planted a vegetable
garden on a flatbed trailer
watered by a fountain-
like sprinkler. Community
members harvested the
vegetables throughout the
exhibition.

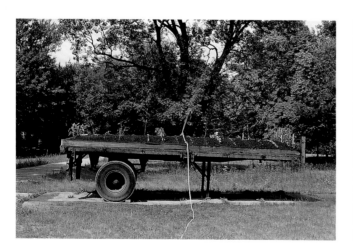 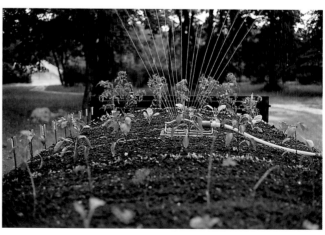

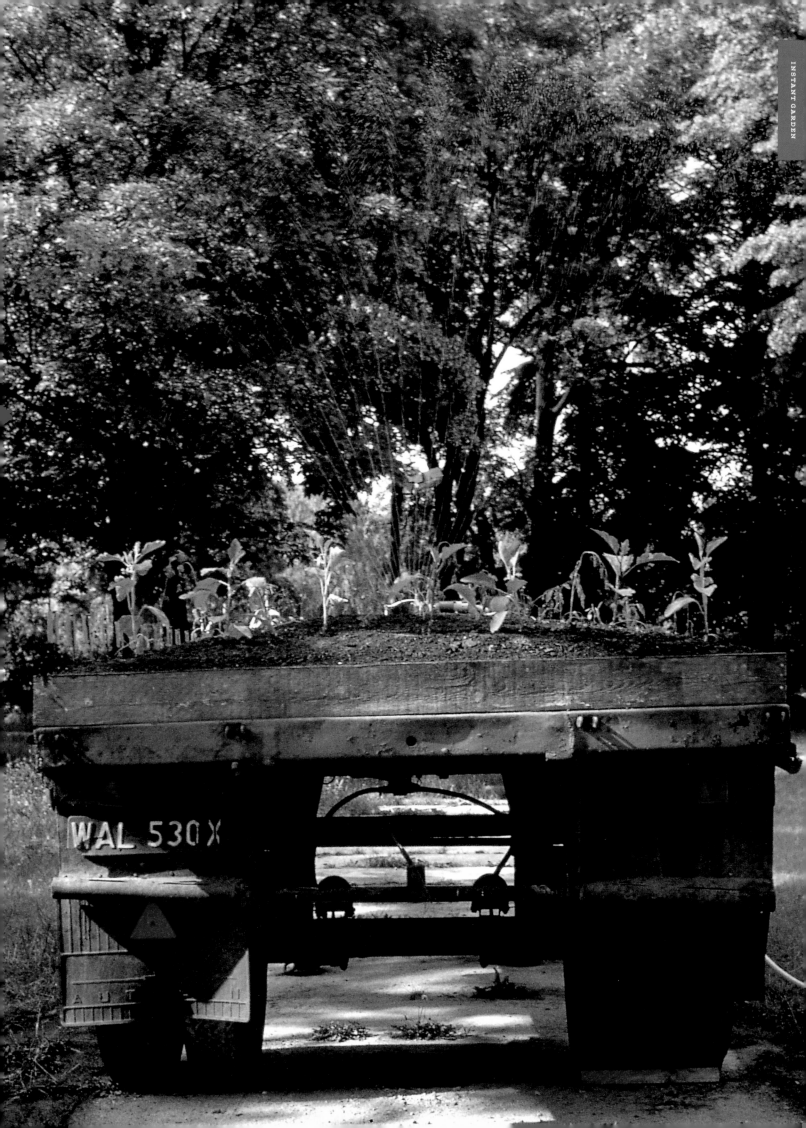

WAL 530 X

Eminent Domain

1992
Sponsored by Sculpture
Chicago, Chicago, Illinois,
March 1992–September 1993

Ogden Courts Apartments
Resident Group: Brenda
Bolden, Iretha Ford,
Loretta Lacy, Arrie Martin,
Elois Smith

For the exhibition, *Culture in Action*, Ericson and Ziegler collaborated with residents of the Ogden Court public housing complex in Chicago to develop an alternative paint chart that dealt with the history of public housing and housing legislation in the United States. New paint names would correspond to existing paints. The plan for the project involved the distribution of the chart through True Value Hardware Stores nationwide.

right, top
Mel Ziegler and Alois Smith

right, bottom
Kate Ericson and Arrie Martin

below
Kate Ericson, Mel Ziegler,
and Arrie Martin

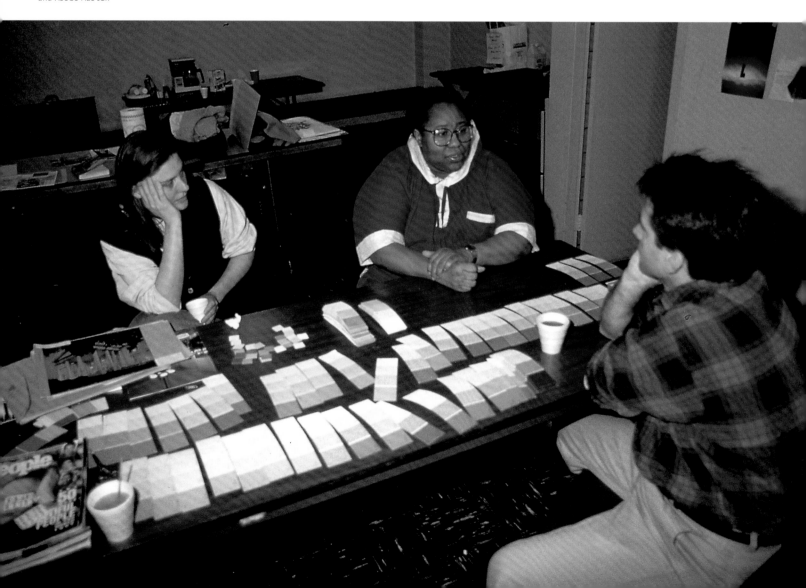

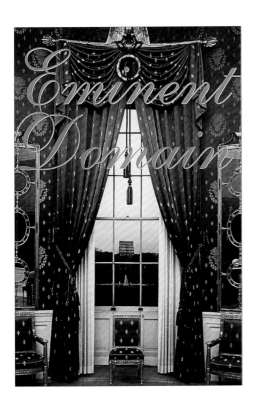

Eminent Domain

The following historic and contemporary government-assisted housing developments and programs presented in this map are: *Alabama* Metropolitan Gardens, Birmingham; *Alaska* Mountain View Senior Center, Juneau; *Arizona* Martin Luther King Apartment Building, Tucson; *Arkansas* Silver City Courts, North Little Rock; *California* elderly housing, Menlo Park; *Colorado* fam'y ... Boulder; *Connecticut* Elm Haven, New Haven; *Delaware* Liberty Court, Dover; *Florida* Griffen Gardens, Lauderhill; *Geor...* ... Techwood Homes, Atlanta; *Hawaii* Kawailehua, Koloa, Kauai; *Idaho* Capitol Plaza, Boise; *Illinois* Robert Tayl... ... Homes Chicago; *Indiana* John F. Kennedy Tower, Evansville; *Iowa* scattered-site, Cli... Ka...ouisville; *Louisiana* Ouachita Grand Plaza, M... ...ortland; *Maryland* Gre... ...Greenbelt; *Massachusetts* ...th, ...ica... *Michigan* Jeffrie... ...oit; ...mi... ...mily unit... ...ppi ...Fer... ...ace, Bil... ...reek V... Lou... ...Anderson Towers, Helena; *Nebraska* Fresh Start Laundromat, ...orthenburg; ...Southgate ...rtments, Carson City; N... ...mpshire Governor Hugh Gallen Ap... ...anchester; *New Jersey* Fairview formerly Yorksh... ...Village, Camden; *New* Mexi... Life Long LearningBernalillo; *New York* First ... Houses, New York Cit... ...North Carolina Hillcrest A... ...ew Horizons Mano... ...; *Ohio* Renaissance Village of King Kennedy Estate, Cl... ...a scattered-site mutual help unit, S... ...; *Oregon* Schrunk Riverview Towe... Portland; *Penns...* ...Franklin Apartments, Carbondale; *Rho...* ...scattered-site, Providence; *South Caro...* model for ...ed/Infill Housing Program, Charleston; *South* ... scattered-site, Sioux F...s; *Tennesse...* Lake Courts, Chatta...; *Texas* ...dar Springs Place, Dallas; *Utah* Romney Park Pl..., Salt Lake City; *...rmont* group home ...ed by Washington Cou... Mental Health, Montpelier; *Virginia* Diggs Town, Norfolk; *Washington* Salishan, Tacoma; *West Virginia* Fairfield Tower, Hu...ncon; *Wisconsin* Highland Park, Milwaukee; *Wyoming* scattered-site, Casper.

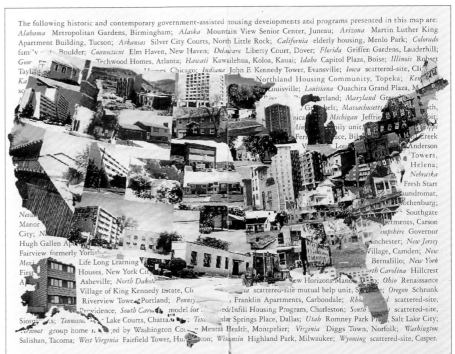

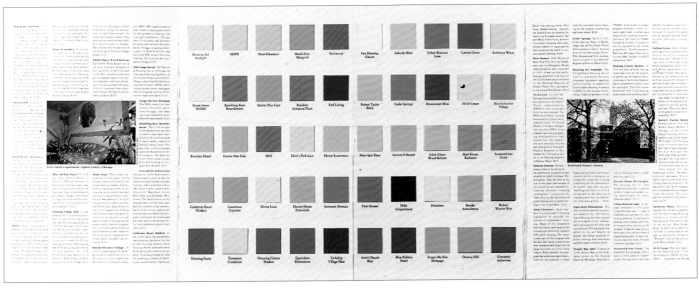

Details of paint chart

171

Squeaky Clean

1993
Bars of soap, soil from the
geographic center of the
United States, nineteenth-
century wooden chest
Open: 37 x 62¹/₂ x 19¹/₂
inches; closed: 21¹/₂ x 62¹/₂ x
19¹/₂ inches
Collection of Themistocles
and Dare Michos: gift to
the San Francisco Museum of
Modern Art

Hundreds of bars of white
deodorant soap are stacked in
an antique wooden box next
to soil from the geographic
center of the United States.

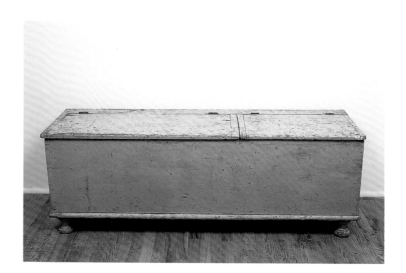

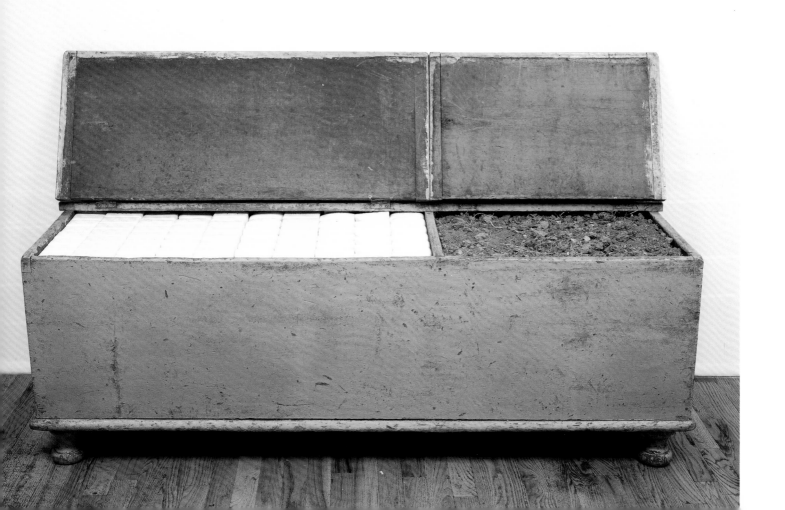

Place Setting

1993
Arnhem, Netherlands,
June 5–September 26, 1993

For *Sonsbeek 93*, an inter-
national exhibition held
in Arnhem, Netherlands,
Ericson and Ziegler replaced
the serving dishes, plates,
cups, saucers, napkins
and tablecloths in a local
restaurant that served
traditional Dutch fare. The
new gold-trimmed plates
were printed with scenes from
Dutch colonial history and
over eight hundred types of
products made by Akzo
Chemicals. Akzo Chemicals,
based in Arnhem, is one of
the leading chemical
companies in the world and
provides the economic
foundation for the city.

VALERIE SMITH

SONSBEEK 93

MY MEMORIES OF MEL ARE INSEPARABLE FROM MY memories of Kate. While our lives have radically changed since our last project for *Sonsbeek 93*,[1] we have seen very little of each other—Mel lives in Texas and I in New York. My image of Mel remains fixed in the era when we worked together, although mostly at long distance, with Kate and Mel in New York and I in Holland.

To get back to that time, I found myself flipping through the *Sonsbeek 93* book to the contributions from Kate and Mel. A pyschological vice tightened over me as I remembered the political and financial stress of the entire exhibition experience, one which I would never give up, even though it posed a constant challenge that naturally leaked into my exchanges with the artists.

Reading our correspondence in the catalogue, which documented the exhibition process through interviews with writers and musicians, as well as other primary materials, I felt I had been hard on them. It was unfair to begin arguing with their ideas before they had fully developed, since refining new ideas is a process that demands patience.

One of their many early proposals was to engage the Mayor of Arnhem "to wear a different style of eyeglasses,

Views of *Place Setting* in use at
the restaurant

selected from the citizens of the town, each day for the duration of the exhibition." The eyeglasses would be on public display and "two words relating to the day's activities would be sandblasted onto each lens."[2] Asking such intensive participation from the Mayor of Arnhem, with whom tensions erupted while fundraising for the exhibition, was clearly not a desirable option. Kate and Mel quickly gained an awareness of local politics, realizing that the ideal often needs rethinking in light of social dynamics, the variables of working with manufacturers, and the skepticism of bureaucrats toward art and artists. Kate and Mel understood that working with service industries and the public made their work so attractive and successful, because the negotiations that inevitably arise between their ideas and those of their collaborators was its object.

The process I had devised for the exhibition was to spend a couple of weeks with every artist. We would explore the sights of Arnhem, a border city of about sixty thousand inhabitants on the Rhine and a seemingly lawless town with its easy sex and drugs just a

train station away for German day-trippers. Having taken in the historic as well as the hallucinogenic possibilities Arnhem had to offer, artists would return to their native countries, their imaginations reeling with proposals for the exhibition.

Knowing Kate's and Mel's interest in history, I took them to the open air museum, a fascinating backward glance at seventeenth-and eighteenth-century Holland. Once saturated in early Dutch domestic culture, they began to visualize the meaning of the concept *gezelijk* ("cozy") in light of the powerful economic omnipresence of the former Dutch empire, making itself at home anywhere in the world, particularly as manifested in the global corporation Akzo. That gave them the essential elements of their project for *Place Setting*.

Ideas came fast and furious. In those pre-e-mail days, the fax ran like a ticker tape machine. I became increasingly excited that they were putting everything into the project, as they always had. Their research and attention to detail were wonderful. They wanted to produce dinnerware decorated in gold

with the list of products Akzo manufactures, although, of course, omitting specific Akzo brand names, together with exotic images from the former Dutch colonies. The *Sonsbeek 93* staff zoomed out to find plate manufacturers to produce the image transfers. We also sought out the right restaurant to agree to use the new dinnerware: Kate and Mel wanted one with a warm Dutch atmosphere to produce just the right combination of irony and critique, "primarily Dutch in character," they said, but "not too 'ethnic,'" so as not to "overburden the concept." As they wrote me,

"We've become very attached to using the form of the plate because it implies issues of the domestic which we keep coming back to in reference to Dutch culture. In thinking about the comfortable house, the plate has connotations of having plenty, the decorative, and the idea of collecting—bringing things together from different places."[3]

We persuaded a restaurant to participate, the type one often finds in Europe on the edge of a national park or forest, a

176

kind of Jagers Inn or former hunting lodge. The owners accepted the special table settings for the three-month duration of the exhibition. Each piece in the set had a gold-printed photograph conveying an "uncomfortable feeling" through the idea of "obsessive comfort." These "uncomfortable feelings" derived from a mixture of the familiar and scientific names of toxic and distasteful products originating from places as far away as South America and East Asia. For example, a saucer imprinted with words such as, "Inhibitors, Initiators, Stabilizers, Extenders, Retarders, Promoters" surround a coffee cup containing an image of a grazing zebra. In another example, the words "Ethical Drugs, Hydrochloric Acid, Diethylenetriamine, Hormones, Vitamins, Fungicides, Catalyst Carriers," and others fill the rims of dinner and salad plates with gold script. Other ideas came spewing out on the fax: "We may wish to deal with the list of 320 locations of Akzo offices and production plants around the world...all having a direct relationship to Arnhem. It could be rather poetic in its sheer impressiveness."[4]

In a very clear and concise way, Kate and Mel had formulated the perfect balance between the biting and the decorative in relation to the acts of eating and socializing. They were very careful not to dominate the work with didactic social critique. Therefore, it had to be "elegantly" framed not to disguise, but to introduce, the subversive in a gentle way. This would ultimately become a more effective strategy, a Trojan horse.

- -

NOTES

1. Sonsbeek is an international exhibition that takes place every seven to ten years in Arnhem, Netherlands. It began in 1949, modeled after the sculpture gardens in England. Usually the exhibition centers on sculpture in the Sonsbeek park. In 1993 I relocated it from the park into the city, and out onto the banks of the Rhine. Approximately forty-eight artists were invited from all over Europe and North America to create site-specific projects in 103 locales, including cultural and non-cultural institutions, the red light district, churches, the prison, restaurants, a barge floating on the Rhine, and so on.

2. Correspondence from Kate Ericson and Mel Ziegler to the author, 1 December, 1992.

3. Correspondence from Kate Ericson and Mel Ziegler to the author, 19 February 1993.

4. Correspondence from Kate Ericson and Mel Ziegler to the author, 8 April 1993.

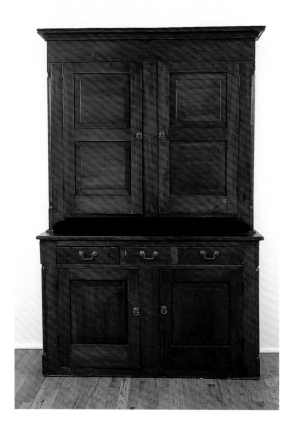

Dutch Cupboard

1993
Gold-printed dinnerware,
silkscreened napkins
and tablecloths, nineteenth-
century wooden cabinet,
Open: 81½ x 82½ x 21
inches; closed: 81½ x 53¾ x
21 inches
Collection of Jack and Nell
Wendler, London

Tableware from the project,
Place Setting, was displayed
in an antique wooden cabinet
as one would display fine
dinnerware. The dishes
and linens are used by its
owner.

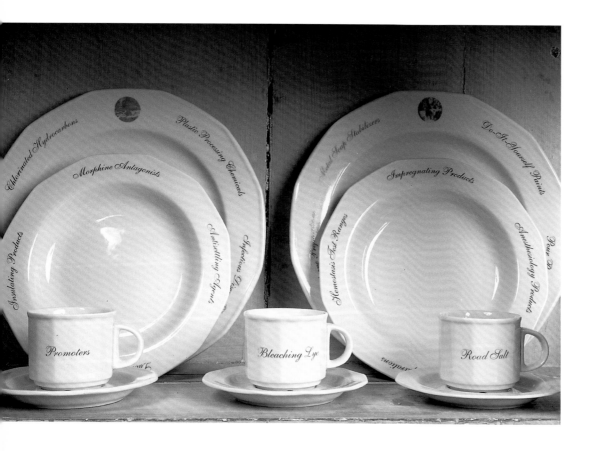

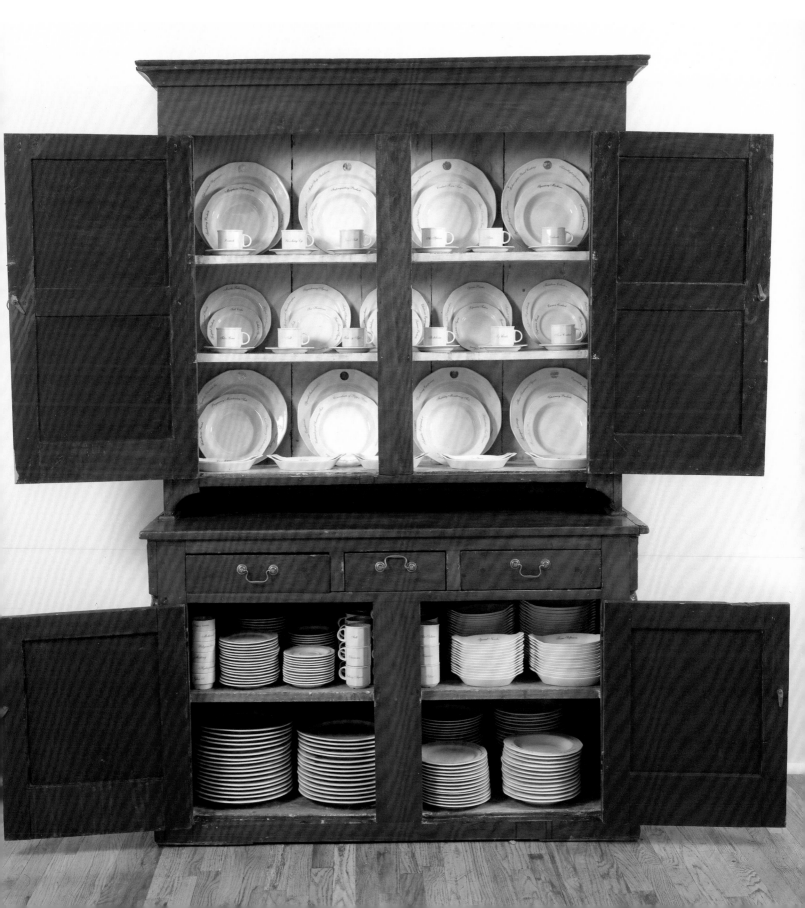

Apple
Peanut

Christ-Right S...
Shaker
Better Than apple
Lemony Cre...
Apple
Chess

...berry Zweiback cream
molasses Peanut
...ine Jelly Chiffon
Winter Fruit
Kentucky Cider Chiffon

Mallow Banana
Pink Party
USDA Pecan
Tawny Pumpkin
Ranch-Style Peach

Mt Pilot Pecan
Mayberry Strawberry
Kentucky Derby
Belleweather Plantation apple Pecan
Sam's Sawdust

Pink Lemonade
Red and Green Christmas
Sunday Best Banana
State-of-the-Union
Mincemeat
Celestial Vanilla Cream

White H...
Old-Fa...
Burg...
Cherr...

...t Apple
Blackberry

Vinegar
Shaker Shoofl
Rhubarb Hone
Lemon Ange
...dy Lemonade Fr...

St. Louis Peanut Butter Banana
Plymouth Cranberry
Butterscotch Meringue
Funeral
Cream

Kiss
Virginia Cheese
Mystery
Old Talbert Tavern Chess
Dutch Cupboard Chess

Southern Grape Nut
Prune Angel Walnut
Washington Cream
almond Bavarian
Ginger Chiffon
Raison Rice

President Tyler's Pudd...
Stark
Wine
Washington
Southern Comfort Pe...

Icebox
Fluffy
Pumpki...
Eye

Jerusalem Artich...
Angel
Vermont Maple
Mississippi

Key West Lime
No-Cook Icecream
Fruit Velvet
Double Lemon Ambrosia
Kitchen

Never Fail Chess
Water Lily
Stella Lee's Punch
Never Fail Chocolate

Old Fashioned Indiana Cream
Texas Peach
Linda Stolzfus
Pumpkin Custard
Southern Nut Eudora

Maple Sugar
Molasses Walnut Chess
Charleston Lemon Chess
Johnny Appleseed

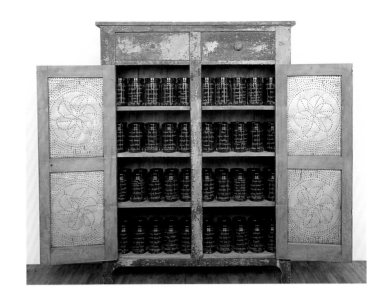

The Smell and Taste of Things Remain

1992
Perfume, sandblasted glass
jars, nineteenth-century
wooden pie cupboard
Open: 62¼ x 73½ x 16½
inches; closed: 62¼ x 48 x
16½ inches
Collection of The Frances
Young Tang Teaching Museum
and Art Gallery at
Skidmore College, Saratoga
Springs, New York,
Gift of Themistocles and
Dare Michos, 2005.4

The names of over four
hundred pie recipes found in
old cookbooks from different
regions of the United States
were sandblasted on jars
containing a liquid scent.
Master perfumer Felix
Buccalato was commissioned
by the artists to create
a scent based on his
interpretation of the smell
of old books and records
held at the National Archives
in Washington, D.C. The
eighty jars are contained in
an antique pie safe.

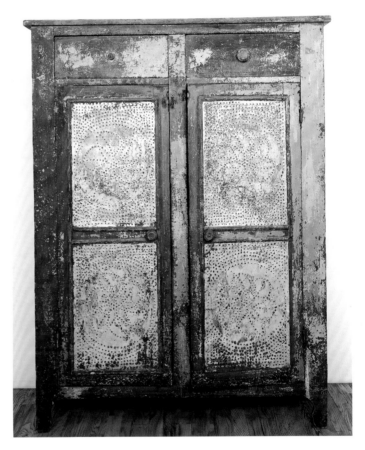

181

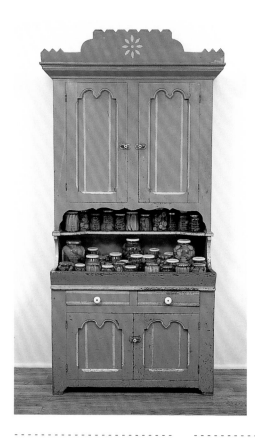

Keep Your Eye on the Pickle

1993
Pickles, sandblasted glass jars, painted antique wooden cabinet
Open: 91 x 69 x 20 inches; closed: 91 x 42 x 20 inches
Private Collection

Over two hundred varieties of pickles were collected. Labels were removed from their jars, which were then sandblasted with the catalogue names of Sears mail-order houses. The jars were displayed in a painted antique cabinet.

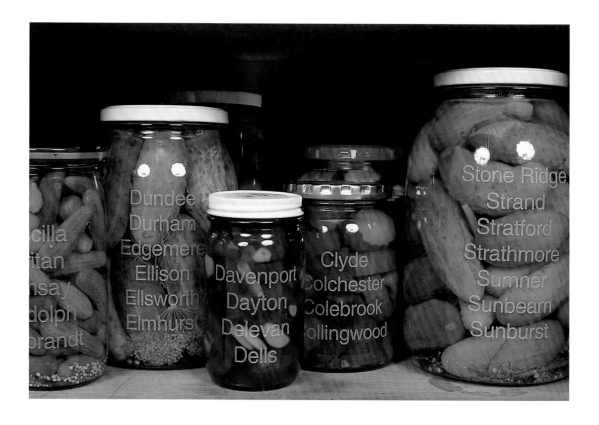

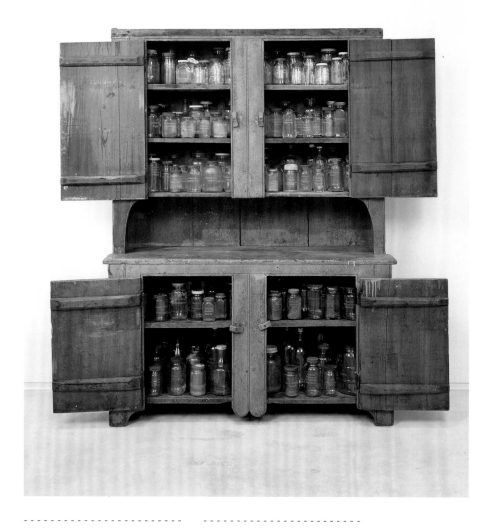

Grandma's Cupboard

1994–96
Air, antique jars, antique
wooden cabinet
75½ x 76½ x 17¾ inches
Collection of Mel Ziegler,
Austin, Texas

Air was collected in and
around buildings and
monuments in Washington D.C.
The air was used to fill
glass jars found in an old
house at the geographic
center of the United States.
The jars were sandblasted
with the names of the
corresponding buildings and
monuments, and were dis-
played in an antique wooden
cabinet.

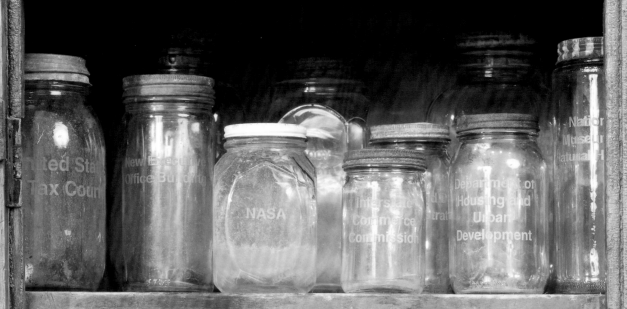

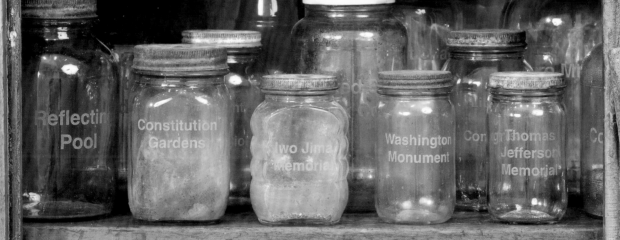

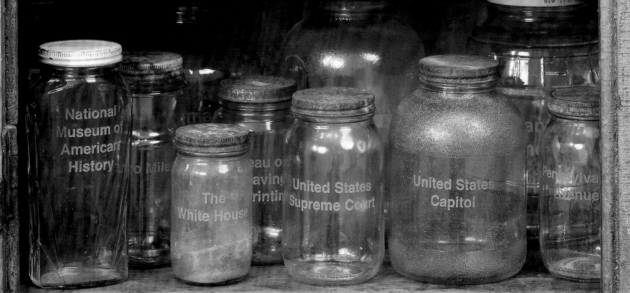

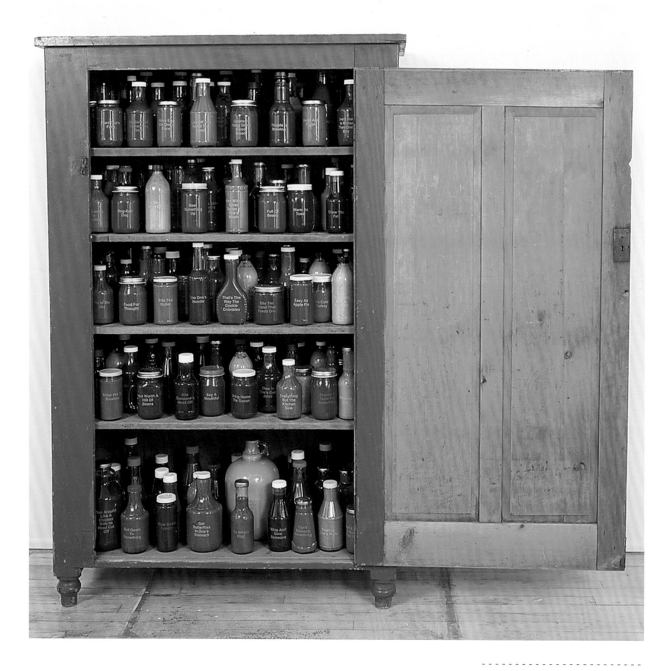

Barbecue

1994
Barbecue sauces, sandblasted
glass jars, painted antique
wooden cabinet
Open: 62 x 64 x 18 inches;
closed: 62 x 40 x 18 inches
Private Collection

Sauces

1993
Sauces, sandblasted glass
jars, painted antique wooden
cupboard
Open: 60½ x 65½ x 17
inches; closed 60½ x 40 x
17 inches
Private Collection

An antique jelly cupboard
was filled with a collection
of two hundred different
sauces. Each glass jar was
sandblasted with an excerpted
cooking instruction from
"The Joy of Cooking."

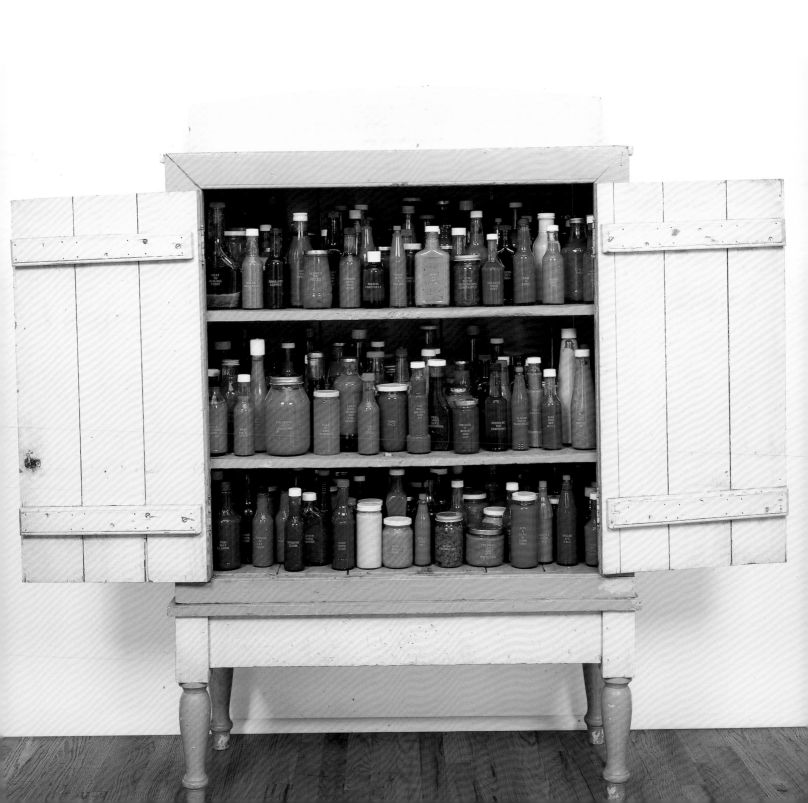

Fruits and Vegetables

1994–1996
Baby food, sandblasted glass
jars, metal shelf
364 jars: 2 x 2 x 2¼ inches;
overall dimensions: 30¾ x
58½ x 2¼ inches
Collection of Eileen and
Peter Norton, Los Angeles,
California

Peas, Carrots, Potatoes

1994–1996
Baby food, sandblasted and
painted glass jars, metal
shelf
364 jars: 2 x 2 x 2¼ inches;
overall dimensions: 30¾ x
58½ x 2¼ inches
Collection of Mel Ziegler,
Austin, Texas

For these two works, Ericson
and Ziegler solicited new
parents to interpret and
describe the pre-linguistic
sounds of their young
children. Three hundred
sixty-four jars filled with
baby food were sandblasted
with those phonetic sounds.
In each case the jars were
arranged to form a different
color-shifted American flag.

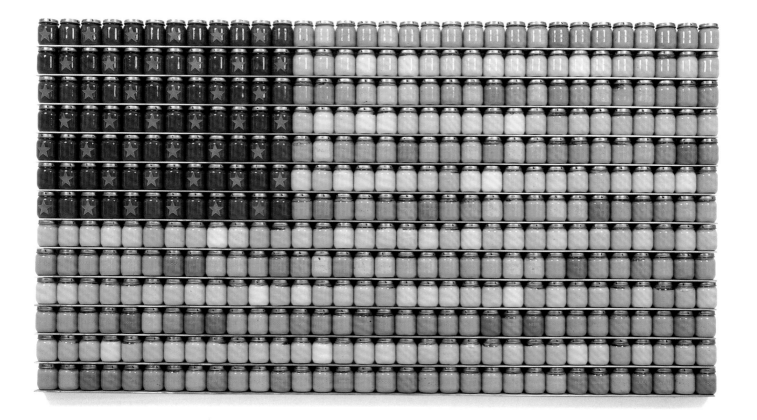

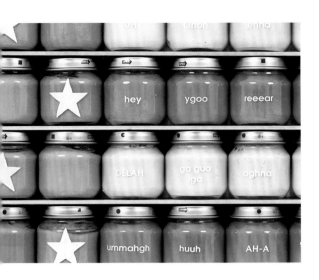

Peas, Carrots, Potatoes,
1994–1996 (detail)

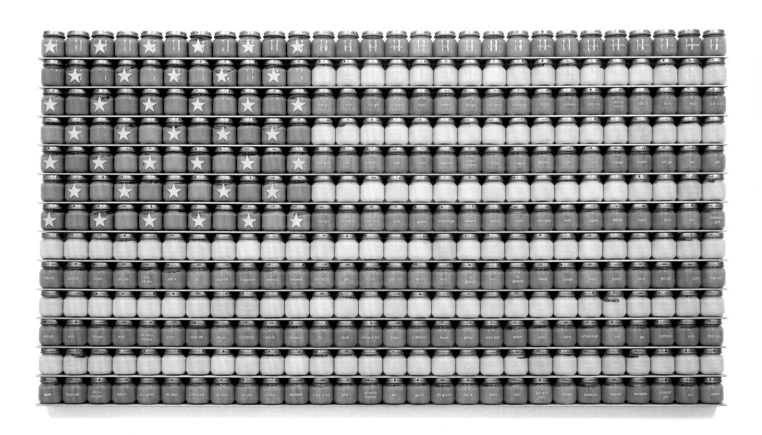

GOOD HUMOR

GOOD HUMOR TRUCK PARKED ON WR. MALL - POPSICLES SOLD SHAPED AS MONUMENTS

genetically altered Rose To create a color

That matches a mix of all historic colors from paint chart 94

"THIS IS NOT A YARD SALE" FURNITURE OF HOUSE DISPLAYED IN FRONT YARD

"Honesdale Pie" invent recipe based on

local History

WASH clothes of construction worker - working on historic 95 monument - SAVE DIRTY WATER

HISTORY OF AN ANTIQUE WRITTEN OUT ON

PAINT SCRAPINGS FROM HOUSE

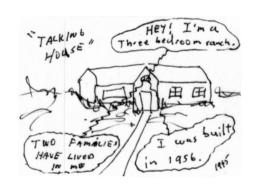

"TALKING HOUSE"

HEY! I'm a Three bedroom ranch.

TWO FAMILIES HAVE LIVED IN ME

I was built in 1956.

95

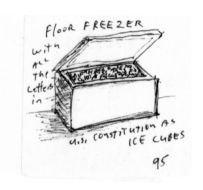

FLOOR FREEZER with all the coffee in

U.S. CONSTITUTION AS ICE CUBES

95

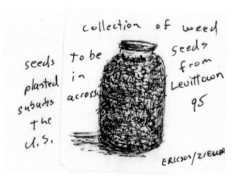

collection of weed seeds from Levittown 95

seeds planted suburbs the U.S.

to be in across

ERICSON/ZIEGLER

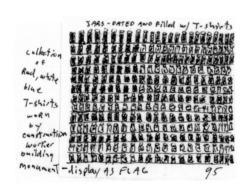

JARS - DATED AND FILLED w/ T-SHIRTS

collection of Red, white, blue T-shirts worn by construction worker building monument - display AS FLAG 95

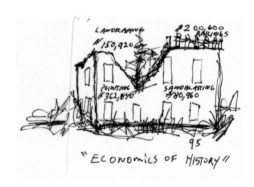

LANDSCAPING $150,920

$200,600 RAILINGS

POINTING $302,845

SANDBLASTING $80,960

95

"ECONOMICS OF HISTORY"

baled grass

from Washington Mall

EXCAVATED FRONT YARD 1995

"House Fountain" Lawn sprinkler

on roof top

CLOTHESLINE WITH CLOTHES FROM SEPARATED NEIGHBORHOODS

AIR FILTERS FROM THE AMERICAN HISTORY museum 94

"PRACTICAL FOUNTAIN"

"HOUSE FLY" project collected flies — from various Houses and rooms of TV House 94

SCRAP wood from the builds of a house 94

"Monumental Mulch" collected grass and leaves from significant places

BURIED BIRDFEEDER '95

"Pickled House" whole house pickled in large barrels 94

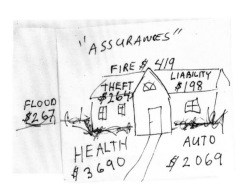

"ASSURANCES"
FLOOD $267
FIRE $419
THEFT $264
LIABILITY $198
HEALTH $3690
AUTO $2069

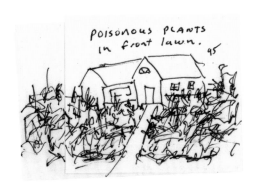

POISONOUS PLANTS in front lawn. 95

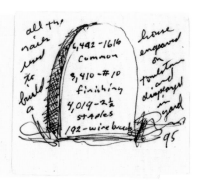

all the nails used to build a house engraved on tombstone and displayed in yard
6,442 - 16¼ Common
3,410 - #10 finishing
4,019 - 2½ staples
192 - wire brads
95

Dianna Drawings

1995
Ink on paper napkins
26 napkins: approx. 3½ x
4¾ inches each
Courtesy of Mel Ziegler,
Austin, Texas

The *Dianna Drawings* were
made when Kate Ericson was
too sick to begin any major
public projects. As part
of their daily routine, the
artists would go to their
local diner in Tyler Hill,
Pennsylvania, Dianna's Place,
to sketch and plan new
projects.

From the Making of a House

1995
Wood
Overall dimensions variable:
approx. 24 x 72 x 72 inches
Courtesy of Mel Ziegler,
Austin, Texas

To create *From the Making of a House*, Ericson and Ziegler asked a neighbor to save all of the off-cuts from a homebuilding project near their studio in Milanville, Pennsylvania. This piece was the last work completed by Ericson and Ziegler before Kate Ericson's death in 1995.

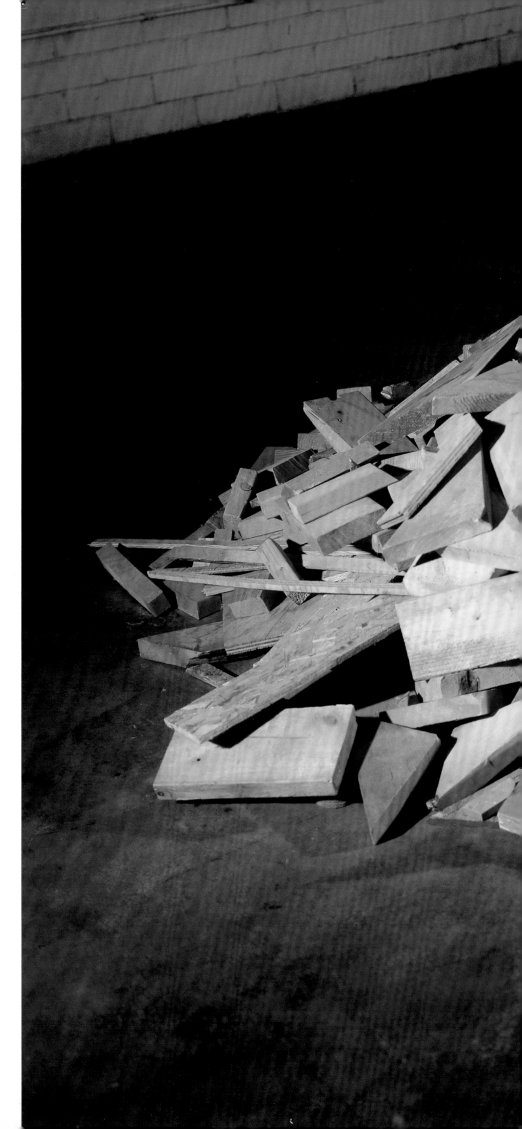

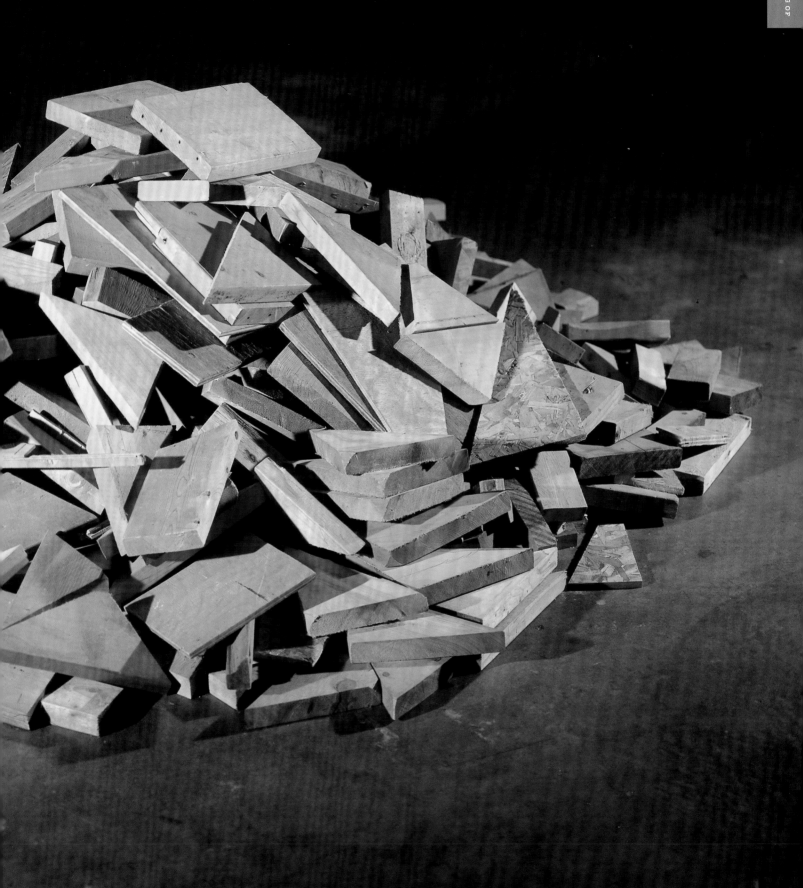

CONTRIBUTORS

Bill Arning is Curator at MIT's List Visual Arts Center. Since joining the List Visual Arts Center in 2000 he has organized such critically acclaimed exhibitions as *Cerith Wyn Evans—Thoughts Unsaid, Then Forgotten—Inside Space—Experiments in Redefining Rooms*, 2001; *AA Bronson's Mirror Mirror*, 2002; and *Influence, Anxiety and Gratitude*, 2003; and *Son et Lumiére* in 2004. Arning was the Director and Chief Curator at White Columns Alternative Arts Space, New York, from 1985–1996, where he organized the first New York exhibitions for many significant American and international artists of the period. Arning's essays have been published in *Time Out New York*, *The Village Voice*, and *Art in America*.

- -

Ian Berry is the Associate Director for Curatorial Affairs and The Susan Rabinowitz Malloy '45 Curator at The Frances Young Tang Teaching Museum and Art Gallery at Skidmore College. He served as Assistant Curator at the Williams College Museum of Art before coming to Skidmore. Among his many exhibitions for the Tang Museum are *Work: Shaker Design and Recent Art* (2000), *Living with Duchamp* (2003), and the Opener series of exhibitions and

catalogues that have featured artists such as Nayland Blake, Lee Boroson, Jim Hodges, Alyson Shotz, and Shahzia Sikander. Among his recent publications is *Kara Walker: Narratives of Negress* (MIT Press, 2003), and *Richard Pettibone: A Retrospective* (Tang, 2005).

- -

Kate Ericson studied sculpture at the Kansas City Art Institute, earning her BFA in 1978. She went on to complete graduate work at the California Institute of the Arts in 1982, studying under pioneering conceptualists like John Baldessari, Michael Asher, and Douglas Huebler. Ericson's early works were concerned with landscape and home commodification, two themes that remained essential when she and Mel Ziegler became formal collaborators in 1985. The pair worked together for over ten years, securing international attention for their unique site-specific and community-based works. Born in New York City in 1955, Kate Ericson died of brain cancer on October 22, 1995, in the Milanville, Pennsylvania home she shared with Mel Ziegler.

- -

Judith Hoos Fox is an Independent Curator based in Boston. She was

formerly Curator of Contemporary Art and Design at the Davis Museum and Cultural Center at Wellesley College in Massachusetts. Fox has published several essays and worked on many exhibitions including *Surrounding Interiors: Views Inside the Car* at the Davis Museum. Her work is mainly centered on contemporary issues in art and design. She is co-author of the book *Over + Over: Passion for Process*, published in July 2005.

- -

Kathleen Goncharov is Adjunct Curator of Contemporary Art at the Nasher Museum of Art at Duke University. Before joining the Nasher Museum of Art, Goncharov served as Curator of Public Art and the Permanent Collection at the MIT List Visual Arts Center and as Curator of the University Art Collection at The New School, New York. She was commissioner of the United States Pavilion at the 50th Venice Biennale (2003), where she worked with artist Fred Wilson to present an installation that commented on Venice's multiracial histories.

- -

Mary Jane Jacob is an Independent Curator based in Chicago. Jacob was Chief Curator at the Museum of

Contemporary Art, Chicago, from 1980 to 1986 and at the Museum of Contemporary Art, Los Angeles from 1986 to 1989. She now serves as program director for Sculpture Chicago, is an advisor to Pittsburgh's Three Rivers Art Festival, and was curator of the Olympic Year project for the Arts Festival of Atlanta in 1996. Mary Jane Jacob has been a faculty member in the Public Practice Program at the School of the Art Institute of Chicago and at Bard's Center for Curatorial Studies, and has published several exhibition catalogues. Her most recent book project was *Buddha Mind in Contemporary Art*, co-edited with Jacquelynn Baas and published in 2004.

- -

Patricia C. Phillips is Professor and Chair of the Art Department at the State University of New York at New Paltz. An independent writer on contemporary art and design, Phillips is editor-in-chief of *Art Journal*, a quarterly devoted to modern and contemporary art published by the College Art Association. Patricia Phillips is also a member of the editorial advisory boards of *Sculpture* and *Public Art Review*. A prominent voice in the field of public art, Phillips has contributed to a number

of critical anthologies and written articles for *Artforum*, *Art In America*, and *Flash Art*.

- -

Lane Relyea is Assistant Professor of Art Theory and Practice at Northwestern University. His essays and reviews have appeared in numerous magazines including *Artforum*, *Parkett*, *Frieze*, *Art in America* and *Flash Art*. He has also written recent monographs on Polly Apfelbaum, Richard Artschwager, Jeremy Blake, Vija Celmins, Toba Khedoori and Monique Prieto, among others, and contributed to such exhibition catalogues as *Public Offerings* (Museum of Contemporary Art, Los Angeles, 2001) and *Helter Skelter* (Museum of Contemporary Art, Los Angeles, 1992). After teaching for a decade at the California Institute of the Arts in Valencia, where he joined the faculty in 1991, he accepted a year appointment as director of the Core Residency Program and Art History at the Glassell School of Art in Houston, Texas, in the summer of 2001.

- -

Ned Rifkin is currently Under Secretary for Art at the Smithsonian Institution, Washington, D.C. From January 2002 to August 2005, Rifkin served as Director of the Hirshhorn Museum and Sculpture Garden. He has also been the Director of The Menil Foundation and Collection (Houston, Texas) and the High Museum of Art (Atlanta, Georgia). Rifkin served as the Chief Curator at the Hirshhorn from 1986 to 1991, the Curator of Contemporary Art at the Corcoran Gallery of Art from 1984 to 1986, and the Curator and Assistant Director of The New Museum of Contemporary Art from 1980 to 1984. He holds an M.A. and Ph.D. in the History of Art from the University of Michigan and a B.A. in Fine Arts and Philosophy from Syracuse University. He has taught at the University of Texas at Arlington and lectured and published internationally.

- -

Valerie Smith served as curator for the alternative gallery Artists Space in New York from 1981 to 1989. Smith also organized *Sonsbeek 93*, an international triennial exhibition in Arnhem, Netherlands, that brought together 103 site-specific installations by artists such as Miroslaw Balka (Poland), Juan Muñoz (Spain), Mike Kelley and Ann Hamilton (United States). She has been Chief Curator at the Queens Museum of Art since 1999, where she won an International Association of Art Critics award for the exhibition *Joan Jonas: Five Works* (2004).

- -

Judith Tannenbaum is the first Richard Brown Baker Curator of Contemporary Art at the Museum of Art, Rhode Island School of Design. From 1986 until 2000, she served as Curator, Associate Director, and Interim Director at the Institute of Contemporary Art at the University of Pennsylvania, Philadelphia. She has organized numerous exhibitions focusing on painting, photography, sculptural installations, and interdisciplinary work with a particular interest in connections between the visual and performing arts. Since moving to RISD, several projects, including *On the Wall: Wallpaper by Contemporary Artists* (2003), have focused on relationships between fine art and design.

- -

Mel Ziegler began his undergraduate studies at the Rhode Island School of Design, later transferring to the Kansas City Art Institute to complete his BFA in 1978 and earning an MFA from the California Institute of the Arts in Valencia in 1982. It was in Kansas City that he met Kate Ericson, his future wife and artistic collaborator. Together, Ericson and Ziegler made influential site-specific installations and objects concerned with mapping trajectories, questioning history, and highlighting the specificity of places and communities—all themes that had also been important for Ziegler in his early solo works. Since the death of his partner Kate Ericson in 1995, Mel Ziegler has continued to show works nationally and internationally. Works from the last ten years are compiled in the 2003 catalogue, *stuffed*, published by Secession, Vienna, Austria, and additional images of recent works can be viewed at www.melziegler.com. Ziegler earned a Loeb Fellowship for study at the Graduate School of Design at Harvard University in 1996, and is currently Associate Professor of Sculpture at the University of Texas, Austin.

All works by Kate Ericson and
Mel Ziegler
Kate Ericson (American, 1955–1995)
Mel Ziegler (American, b. 1956)

All works courtesy of Mel Ziegler,
Austin, Texas, unless otherwise
noted. Dimensions listed in inches:
height x width x depth.

1.
Give and Take, 1986
Broken tools, polyurethane
Dimensions variable
Individual tools from the collections
of Barbara Broughel, Amy Lipton, and
Mel Ziegler

2.
**Stones Have Been Known
to Move**, 1986
Sandblasted stone samples, metal
brackets, vinyl text
Sixty-five stones: 12 x 12 inches each
Overall dimensions variable

3.
**From the Making of Mount
Rushmore**, 1986
Stones from the base of Mount
Rushmore, metal brackets
48 x 12 x 24 inches
Collection of Mel Ziegler, Austin,
Texas

4.
Where the Water Goes, 1987
Water, sandblasted glass jars, metal
shelf
11½ x 56½ x 5¼ inches

5.
America Starts Here, 1988
Broken glass and fiberglass panels,
sandblasted glass, wood frames, two
photographs
105 panes: approx. 21 x 15 inches
each
Overall dimensions: 125½ x 565
inches

6.
Statue of Liberty, 1988
Latex paint, sandblasted glass jars,
metal shelves
Five jars: 8½ x 5 x 5 inches each
Overall dimensions: 63 x 5 x 5 inches
Collection of Michael and Leslie Engl

7.
Leaf Peeping, 1988
Latex paint, sandblasted glass jars,
metal shelves
Thirty-one jars: 3¾ x 3½ x 3½
inches each
Overall dimensions variable
Museum of Contemporary Art, San
Diego, California, Museum purchase,
Contemporary Collectors Fund,
90.9.1-31

8.
Hollow Oak Our Palace Is, 1989
Stenciled cocoa mat
Unlimited edition: approx. 28 x 48 x
½ inches each

9.
MoMA Whites, 1990
Paint, sandblasted glass, hardware
Eight plaques: 5 x 11 x 1 inches each
Overall dimensions variable

.

10.
Feed and Seed (Heisey Farm),
1990
Seed bags, sandblasted acrylic,
hardware
Sixteen bundles of bags: 34 x 18½ x 2
inches each
Overall dimensions: 71 x 169 x 2
inches

11.
Constitution On Tour, 1991
Model train cars and tracks,
sandblasted and painted marble,
metal brackets
28 x 95 x 5 inches
Collection of The Frances Young Tang
Teaching Museum and Art Gallery at
Skidmore College, Saratoga Springs,
New York, 2005.3

12.
**Camouflaged History
(maquette)**, 1991
Painted wood
31 x 21¾ x 32 inches
Collection of Robert Shimshak,
Berkeley, California

13.
Peaks and Valleys (maquette),
1991
Wood, acrylic, shingles, paint,
hardware
36½ x 24 x 31 inches
University of California, Berkeley Art
Museum, Gift of Themistocles and
Dare Michos

14.
**The Smell and Taste of Things
Remain**, 1992
Perfume, sandblasted glass jars,
nineteenth-century wooden pie
cupboard
Open: 62¼ x 73½ x 16½ inches
Closed: 62¼ x 48 x 16½ inches
Collection of The Frances Young
Tang Teaching Museum and Art
Gallery at Skidmore College, Saratoga
Springs, New York, Gift of
Themistocles and Dare Michos,
2005.4

15.
Dutch Cupboard, 1993
Gold-printed dinnerware,
silkscreened napkins and table-
cloths, nineteenth-century
wooden cabinet
Open: 81½ x 82½ x 21 inches
Closed: 81½ x 53¾ x 21 inches
Collection of Jack and Nell Wendler,
London

16.
Squeaky Clean, 1993
Bars of soap, soil from the geographic
center of the United States, nine-
teenth-century wooden chest
Open: 37 x 62½ x 19½ inches
Closed: 21½ x 62½ x 19½ inches
Collection of Themistocles and
Dare Michos: gift to the San Francisco
Museum of Modern Art

top
Peaks and Valleys (maquette)
1991
Wood, acrylic, shingles, paint, hardware
36½ x 24 x 31 inches
University of California, Berkeley Art Museum, Gift of Themistocles and Dare Michos

Made as part of the project *Peaks and Valleys*, commissioned by Capp Street Project, a San Francisco artists' residency program.
(see p. 148)

bottom
Camouflaged History (maquette)
1991
Paint, wood
31 x 21¾ x 32 inches
Collection of Robert Shimshak, Berkeley, California

This model house documents a project for *Places with a Past*, an exhibition of site-specific, public art curated for the 1991 Spoleto Festival to foster works addressing the history of its host city, Charleston, South Carolina.
(see p. 152)

17.
Peas, Carrots, Potatoes, 1994–96
Baby food, sandblasted and painted glass jars, metal shelf
364 jars: 2 x 2 x 2¼ inches each
Overall dimensions: 30¾ x 58½ x 2¼ inches
Collection of Mel Ziegler, Austin, Texas

18.
Oldgloryredbleachedwhite-nationalflagblue, 1995
Latex on paper, sandblasted glass
15½ x 40½ inches
Microsoft Art Collection, Seattle, Washington

19.
Dianna Drawings, 1995
Ink on paper napkins
26 napkins: approx. 3½ x 4¾ inches each

20.
From the Making of a House, 1995
Wood
Dimensions variable, approx. 24 x 72 x 72 inches

EXHIBITION AND PROJECT HISTORY

EARLY WORKS

Exhibitions and projects are followed
by dates where available.
Traveling exhibitions are listed under
initial date and venue.

Compiled by Jen Mergel

**Kate Ericson:
Exhibitions and Public Projects
through 1984**

SOLO EXHIBITIONS AND
PUBLIC PROJECTS

1977
Red Line / Green Line; artist-initiated
project, KCAI (Kansas City Art
Institute), Kansas City, Missouri

1978
Quarry Piece, artist-initiated project
in limestone quarry, Kansas City,
Missouri, autumn.

Quarry; Rocks and Skids, artist-
initiated project, Kansas City,
Missouri, autumn.

Conveyor and Chute, artist-initiated
project, KCAI, Kansas City, Missouri,
autumn.

Coal Chutes and Wall Piece, artist-
initiated project, KCAI, Kansas City,
Missouri, autumn.
(In collaboration with Mel Ziegler.)

1979
San Jacinto Stone Project, artist-
initiated project, Houston, Texas,
summer.

Suspended Brick Wall, artist-
initiated project, University of Texas

at Austin, Austin, Texas, autumn.
Twin Towers, University of Texas at
Austin, Austin, Texas, autumn

1980
Rock Extension, artist-initiated
project with private homeowner,
Houston, Texas.

1981
House Sign, artist-initiated project in
two versions: on the suburban
property of a private homeowner in
Val Verde, California, and on the roof
of a parking garage attached to a
high rise building in Angeles Plaza,
Los Angeles, California.

1983
Tombstone, project for the exhibition
series *Window on Broadway,* New
Museum, New York, December 7–
January, 1984.

SELECTED GROUP
EXHIBITIONS AND PUBLIC
PROJECTS

1980
Public Cathedral, project for the
*Houston Festival Foundation
Exhibition,* Houston Public Library,
Houston, Texas.
(In collaboration with Mel Ziegler.)

1983
A & M Artworks, New York.

1984
The Happy Hour, project for the
exhibition *Art on the Beach 1984,*
organized by Creative Time, Inc.,
Battery Park City Landfill,
New York, July 7–September 16.
(In collaboration with Juergen
Reihm and Ellen Fisher.)

*Selections from the Artists
File,* Artists Space, New York,
November 3–December 1.

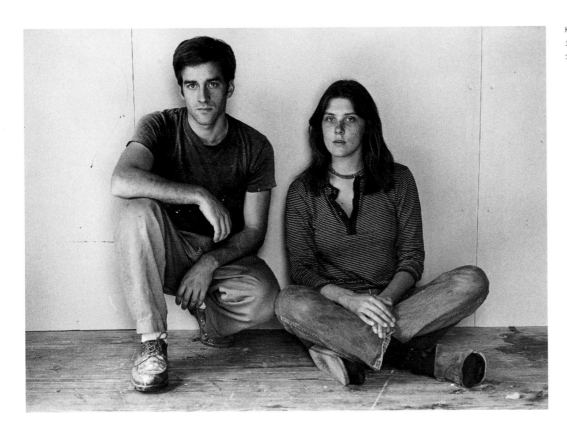

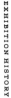
Mel Ziegler:
Exhibitions and Public Projects
through 1984

- -

SOLO EXHIBITIONS AND
PUBLIC PROJECTS

1977
The Front Page, Proposal for blank
front page of the newspaper,
Kansas City Star, Kansas City,
Missouri, summer.

Concrete Mile, artist-initiated project,
Kansas City, Missouri, summer.

1,000 Bobbers, artist-initiated project,
Kansas City, Missouri, summer.

Asphalt Path, artist-initiated project,
KCAI, Kansas City, Missouri, autumn.

Winter Wheat, artist-initiated project,
KCAI, Kansas City, Missouri, autumn.

Elevator and Hayloft, artist-initiated
project, KCAI, Kansas City, Missouri,
autumn.

Cattle & Trailer Chute, artist-initiated
project, KCAI, Kansas City, Missouri,
winter.

1978
Harvestore Blue, artist-initiated
project, KCAI, Kansas City, Missouri,
spring.

Blower Pipe Piece, artist-initiated
project, KCAI, Kansas City, Missouri,
summer.

Red Tower, artist-initiated project,
KCAI, Kansas City, Missouri, autumn.

Coal Chutes and Wall Piece, artist-
initiated project, KCAI, Kansas City,
Missouri, autumn.
(In collaboration with Kate Ericson.)

1979
Red House, artist-initiated project
with private homeowner, Houston,
Texas, summer.

Under Construction, artist-initiated
project with private homeowner,
5319 Crawford Street, Houston,
Texas, September-October.

1980
Newhall Land Project, artist-initiated
project with developer, Newhall,
California, autumn.

Demolishment, artist-initiated project
with private homeowner, Houston,
Texas.

CalArts Project, artist-initiated proj-
ect, Valencia, California, fall/winter.

1981
Front Lawn, artist-initiated project
with private homeowner, Los Angeles,
California.

1983
*Yellow Bulldozer, Red Trailer, Blue
Bridge,* Mail art project, New York.

1984
Pastellus, artist-initiated project,
New York.

On Broadway, artist-initiated project,
New York.

- -

SELECTED GROUP
EXHIBITIONS AND PUBLIC
PROJECTS

1980
Public Cathedral, project for the
*Houston Festival Foundation
Exhibition,* Houston Public Library,
Houston, Texas.
(In collaboration with Kate Ericson.)

1982
Ozymandias, project for the exhibition
Transitional Use, Foundation for Art
Resources, Los Angeles, California.

1983
A & M Artworks, New York.

1984
Selections from the Artists File,
Artists Space, New York, November 3–
December 1.

EXHIBITION AND PROJECT HISTORY

COLLABORATIVE WORKS

In 1985, Ericson and Ziegler decided to work as a full-time artist team on all subsequent projects.

Bastille Column
1992
Installation view, Ma Galerie

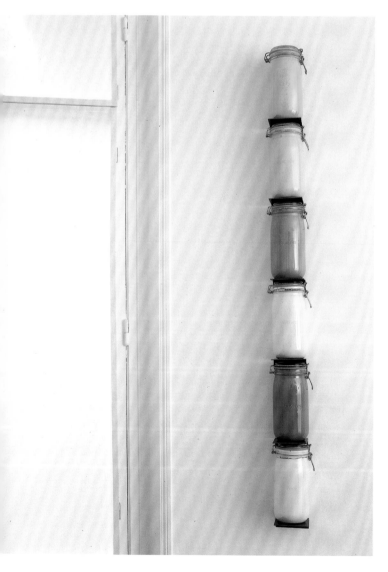

Kate Ericson and Mel Ziegler: Exhibitions and Public Projects

- -

SOLO EXHIBITIONS AND PUBLIC PROJECTS

1985
Unplanted Landscape, artist-initiated project with private homeowner, Bellport, New York.

Traveling Stories, project for Downtown Seattle Transit Arts Program, Seattle, Washington.

Garden Sculpture, project sponsored by Artists Representing Environmental Arts (A.R.E.A.), Ward's Island, New York, September 1, 1985–February 1986.

1986
House Monument, Los Angeles Institute of Contemporary Art, Los Angeles, California, and Costa Mesa, California.

If You Would See The Monument, Look Around, project sponsored by Creative Time Inc. and Central Park Summer Stage in cooperation with the New York City Department of Parks and Recreation and the Central Conservancy, Central Park, New York, August 3–September 14.

Stones Have Been Known To Move, White Columns, New York, October–November 29.

1987
Half Slave, Half Free, artist-initiated project with private homeowner, Hawley, Pennsylvania.

Time The Destroyer Is Time The Preserver, Loughelton Gallery, New York.

If Landscapes Were Sold: An Installation by Kate Ericson and Mel Ziegler, Diverse Works, Houston, Texas, October 30–November 28.

1988
Dark On That Whiteness, Wolff Gallery, New York.

Kate Ericson and Mel Ziegler WORKS, Hirshhorn Museum and Sculpture Garden, Smithsonian Institution, Washington, D.C., March 9–May 30.

Investigations 24, Institute of Contemporary Art, University of Pennsylvania, Philadelphia, Pennsylvania, June 10–July 31.

Projects 14: Kate Ericson and Mel Ziegler, Museum of Modern Art, New York, October 22–November 29.

1989
The Lighting Specialists, Burnett Miller Gallery, Los Angeles, California.

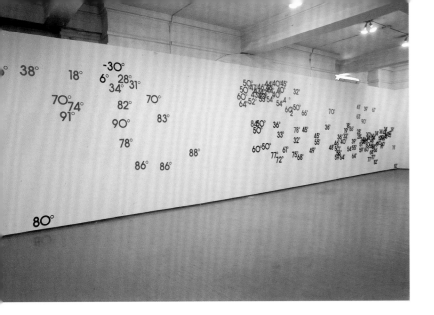

Installation view: Clocktower
Gallery, 1989

Walls Have Tongues, Wolff Gallery,
New York.

Hollow Oak Our Palace Is, Real Art
Ways, Hartford, Connecticut.

College Ivory, University Art Gallery,
San Diego State University, San
Diego, California, April 22–May 24.

Loaded Text, Durham Arts Council,
Durham, North Carolina, June 1–12.

1990
Proposals, Wolff Gallery, New York.

Viaduct Gateway [subsequently
renamed *Viaduct Garden*], a design
team project for *The Hidden
City Revealed Masterplan*, sponsored
by the Committee for Public Art,
Cleveland, Ohio.

The Wellesley Method, Wellesley
College Museum, Wellesley,
Massachusetts, April 6–June 11.

*Augustus Saint-Gaudens
Fellowship Exhibition*, The Picture
Gallery at the Saint-Gaudens
National Historic Site, Cornish,
New Hampshire, May 25–
July 15.

Feed and Seed and *Weeds or
Wildflowers*, SPACES, Cleveland,
Ohio, December 15–January 12,
1991.

1991
Exported Pallet, United States
Information Agency, Cultural
Fundição Progresso Rio de Janeiro,
Brazil. Traveled to Museu Mineiro,
Belo Horizonte, Brazil.

Peaks and Valleys, Capp Street
Project, San Francisco, California,
February 15–March 30.

1992
Wall of Words, Harold Washington
Library Center, Chicago, Illinois,
1992–1994.

Anybody Can Make History, Michael
Klein Inc., New York, April.

Ma Galerie, Paris, France.

1993
Stir From Time To Time, Michael
Klein Inc., New York, New York.

Kate Ericson & Mel Ziegler, James
Hockey Gallery, West Surrey College
of Art and Design, Farnham, England,
April 25–May 29. Traveled to
Metropolitan Galleries, University of
Manchester, Manchester, England,
September 3–October 8.

1994
Lisson Gallery, London, England.

2001
1301 PE projects and editions, Santa

Monica, California.

Doug Lawing Gallery, Houston, Texas.

2005
America Starts Here, The Frances
Young Tang Teaching Museum and Art
Gallery at Skidmore College,
Saratoga Springs, New York, October
1–December 30. Traveled to the
MIT List Visual Arts Center,
Massachusetts Institute of Technology,
Cambridge, Massachusetts, February
9–April 8, 2006; Austin Museum of
Art, Austin, Texas, February 10–
May 6, 2007; H&R Block Artspace,
Kansas City Art Institute, Kansas
City, Missouri, July–October, 2007;
Cincinnati Contemporary Arts
Center, Cincinnati, Ohio, November
10, 2007–January 13, 2008.

- -

SELECTED GROUP EXHIBITIONS
AND PUBLIC PROJECTS

1985
*Highlights from the Kansas City Art
Institute Alumni*, Nelson Atkins
Museum, Kansas City, Missouri, April
20–May 26.

Art and The Environment, organized
by A.R.E.A, Lever House, New York.

1987
Walk Out To Winter, Bess Cutler
Gallery, New York.

The Errant Sign, Milford Gallery,
New York.

Of Ever-Ever Land i Speak, Stux
Gallery, New York.

Real Pictures, Wolff Gallery, New
York.

Private Visions / Public Spaces,
Bellevue Art Museum, Bellevue,
Washington, April 18–May 17.

Nature, Feature Inc., Chicago,
Illinois, April 24–May 23.

CalArts: Skeptical Belief(s), The
Renaissance Society at the University
of Chicago, Chicago, Illinois, May
6–June 27. Traveled to the Newport
Harbor Art Museum, Newport Beach,
California, January 24–March 20,
1988.

1988
*Temporary Public Art: Changes and
Interventions*, Storefront for
Art and Architecture, New York,
January 14–February 13.

Group Exhibition, Lawrence Oliver
Gallery, Philadelphia, Pennsylvania.

La Nature des Choses, 'Cinquieme
Ateliers Internationaux des Pays de
la Loire', Fondation Regional d'Art
Contemporain, La Garenne Lemot,
Clisson, France, Autumn.

Democracy/Politics and Election, Dia Art Foundation, New York.

Detail in the Cottage, Randolph Street Gallery, Chicago, Illinois.

Home Show, Santa Barbara Contemporary Arts Forum, Santa Barbara, California, September 10–October 9.

Group Exhibition, Wolff Gallery, New York.

Public Discourse, Real Art Ways, Hartford, Connecticut.

Group Exhibition, Fuller Gross Gallery, San Francisco, California.

Equation, Barbara Krakow Gallery, Boston, Massachusetts, September 17–October 12.

Collaboration, Gallery at the Plaza, Security Pacific Corporation, Los Angeles, October 16–November 27.

1989
Monochrome, Barbara Krakow Gallery, Boston, Massachusetts, January 14–February 8.

Horn of Plenty: Sixteen Artists from NYC, Stedelijk Museum, Amsterdam, Netherlands, January 14–February 19.

1989 Biennial Exhibition, Whitney Museum of American Art, New York, April 27–July 9.

Ten Years, Randolph Street Gallery, Chicago, Illinois.

Here and There-Travel Series Part Four, The Clocktower, New York.

Contemporary Sculpture '89: Works by Fellowship Recipients of the New York Foundation for the Arts, University Art Museum, Albany, New York, September 5–October 15.

1990
(A) Selection (of) Selections: An Exhibition of 1989 NYFA Fellows, Parsons School of Design, New York.

Notes on the Margin: A Framework in Focus, Gracie Mansion Gallery, New York, February 1–14.

Fifth Anniversary Exhibition, Burnett Miller Gallery, Los Angeles, California.

Preview, Michael Klein Inc., New York.

Team Spirit, Neuberger Museum, State University of New York at Purchase, Purchases, New York. Traveled to Cleveland Center for Contemporary Art, Cleveland, Ohio; Vancouver Art Gallery, Vancouver, Canada; The Art Museum, Florida International University,

Miami, Florida; Spirit Square Center for the Arts, Charlotte, North Carolina; Davenport Art Museum, Davenport, Iowa; Laumeier Sculpture Park, St. Louis, Missouri.

15 Years of RAW, Real Art Ways, Hartford, Connecticut, December 7–January 26, 1991.

1991
Places With a Past: New Site-Specific Art in Charleston, Spoleto Festival U.S.A., Charleston, South Carolina, May 24–August 4.

Tabula Rasa, 9e Exposition de Sculpture, Biel, Switzerland.

Mud, or, How Can Social and Local Histories Be Used as Methods of Conservation?, Hirsch Farm Project, Hillsboro, Wisconsin.

Anninovanta, Galleria Comunale d'Arte Moderna, Bologna, Italy.

Beyond The Frame: American Art, 1960–90, Setagaya Art Museum, Tokyo, Japan, July 6–August 18. Traveled to National Museum of Art, Osaka, Japan, and Fukuoka Art Museum, Fukuoka, Japan.

From the Train, Michael Klein Inc., New York.

Preview, Michael Klein Inc., New York.

Glass: Material in the Service of Meaning, Tacoma Art Museum, Tacoma, Washington, November 2–January 26, 1992.

1992
Teamwork, Lintas Worldwide, New York.

anomie, Patent House, London, England.

Translation, Centrum Sztuki Wspolezesnij, Zamek Ujazdowski [The Center for Contemporary Art, Ujazdowski Castle] Warsaw, Poland, Summer.

Transgressions in the White Cube: Territorial Mappings, Suzanne Lemberg Usdan Gallery, Bennington College, Bennington, Vermont, November 17–December 21.

Culture in Action, Sculpture Chicago, Chicago, Illinois, March 1992–September 1993.

1993
Nature, Memory, Strength, Wadsworth Atheneum, Hartford, Connecticut.

Mettlesome & Meddlesome: Selections from the Collection of Robert J. Shiffler, Contemporary Arts Center, Cincinnati, Ohio, February 6–March 20.

The Naming of the Colors, White Columns, New York, April 30–June 2.

Myths and Legends As Told and Retold, Barbara Krakow Gallery, Boston, Massachusetts, May 1–June 2.

Projet Unite, Firminy, France.

Sonsbeek 93, Arnhem, Netherlands, June 5–September 26.

Integral, Kunstprojekte, Neue Gesellschaft für Bildende Kunst, Berlin, Germany.

Kurswechsel, Michael Klein Inc. at Transart Exhibitions, Cologne, Germany.

Living With Art, The Morris Museum, Morristown, New Jersey.

Money/Politics/Sex, Nancy Drysdale Gallery, Washington, D.C., September–October.

1994
Don't Look Now, Thread Waxing Space, New York, January 22–February 26.

Group Show, Ma Galerie, Paris, France.

An American Landscape, Michael Klein Inc., New York.

Old Glory: the American Flag in Contemporary Art, Cleveland Center for Contemporary Art, Cleveland, Ohio, June 14–August 14.

Die Orte der Kunst: Der Kunstbetrieb als Kunstwerk, Sprengel Museum Hannover, Hannover, Germany, May 29–Septmber 11.

House Rules, Wexner Center for the Arts, Columbus, Ohio, September 10–December 11.

The Body As Measure, Davis Museum and Cultural Center, Wellesley College, Wellesley, Massachusetts, September 9–December 18.

Debut: Selections from the Permanent Collection, Kemper Museum of Contemporary Art & Design, Kansas City, Missouri, October 2–June 30, 1995.

L'object: du magasin au musée, Villa du Parc à Annemasse, Geneva, Switzerland.

1995
Mapping: A Response to MoMA, American Fine Arts, Co., and Colin De Land Fine Art, New York.

KunstKabinett, Center on Contemporary Art, Seattle, Washington, July 8–August 19.

WoodWorks, Michael Klein Inc., New York.

1996
Food for Thought, John Michael Kohler Arts Center, Sheboygan, Wisconsin, June 2–September 8.

The Bare Wall!..., Michael Klein Inc., New York.

Blurring the Boundaries: Installation Art 1969–1996. Museum of Contemporary Art, San Diego, La Jolla, California, September 22–January 29, 1997. Traveled to Memorial Art Gallery, Rochester, New York, February 28–May 3, 1998; Worcester Art Museum, Worcester, Massachusetts, October 4, 1998–January 3, 1999; Scottsdale Museum of Contemporary Art, Scottsdale, Arizona, May 27–September 5, 1999; San Jose Museum of Art, San Jose, California, May 20–August 13, 2000.

1999
Museum as Muse: Artists Reflect, The Museum of Modern Art, New York, March 14–June 1. Traveled to the Museum of Contemporary Art, San Diego, California, September 26–January 9, 2000.

2001
Museum as Subject, The National Museum of Art, Osaka, Japan, October 25–December 11.

The World According to the Newest and Most Exact Observations: Mapping Art + Science, The Frances Young Tang Teaching Museum and Art Gallery at Skidmore College, Saratoga Springs, New York, March 3–June 3.

Locating Drawing, Doug Lawing Gallery, Houston, Texas.

2002
Domestic: Artists Transforming the Everyday, Arlington Museum of Art, Arlington, Texas, September 4–November 2.

Since completing works planned in collaboration with Kate Ericson, Mel Ziegler has continued to produce and exhibit his own projects. Information on the work of Mel Ziegler after 1995 may be found in the comprehensive catalogue: Ziegler, Mel. *stuffed*. Vienna, Austria: Secession, 2003. With an essay by Hedwig Saxenhuber. (Published in conjunction with Ziegler's exhibition at Secession, July 4–September 7, 2003.)

SELECTED BIBLIOGRAPHY

Note: When an author or editor is also an essayist in the same publication, that name does not appear twice in the bibliographic entry.

BOOKS, EXHIBITION CATALOGUES AND BROCHURES

Awards in Painting, Sculpture, Printmaking and Craft Media, 1987.: Louis Comfort Tiffany Foundation, 1987.

Armstrong, Richard, et al. *1989 Biennial Exhibition.* Exh. cat. New York: Whitney Museum of American Art, 1989.

Arning, Bill. *The Naming of the Colors.* Exh. cat. New York: White Columns, 1993.

Bender, Susan and Ian Berry. *The World According to the Newest and Most Exact Observations: Mapping Art + Science.* Exh. cat. Saratoga Springs, New York: The Tang Teaching Museum and Art Gallery at Skidmore College, 2001. Essays by Bernard Possidente and Richard Wilkinson.

Berry, Ian and Bill Arning. *America Starts Here: Kate Ericson and Mel Ziegler.* Exh. cat. Cambridge, Massachusetts: The Tang Teaching Museum at Skidmore College, MIT List Visual Arts Center, and MIT

Press, 2005. Essays by Judith Hoos Fox, Kathleen Goncharov, Mary Jane Jacob, Patricia C. Phillips, Lane Relyea, Ned Rifkin, Valerie Smith, and Judith Tannenbaum. Interview with Mel Ziegler.

Brand, Jan, Catelijne de Muynck, and Valerie Smith, eds. *Sonsbeek 93.* Exh. cat. Ghent, Belgium: Snoeck-Ducaju & Zoon, 1993.

Busta, William. *Howling at the Edge of a Renaissance: SPACES and Alternative Art in Cleveland.* Exh. cat. Cleveland, Ohio: SPACES, 1998.

Carson, Julie. *Notes on the Margin: a Framework in Focus.* Exh. brochure. New York: Gracie Mansion Gallery, 1990.

Ceruti, Mary, ed. *Capp Street Project, 1991–1993.* San Francisco: The Project, 1993.

Cross, Andrew and Liam Gillick. *Kate Ericson and Mel Ziegler.* Exh. cat Farnham, England: James Hockey Gallery, 1993.

Davies, Hugh M., and Ronald J. Onorato. *Blurring the Boundaries: Installation Art 1969-1996.* Exh. cat. San Diego, California: Museum of Contemporary Art San Diego, 1997.

Decter, Joshua. *Transgressions in the*

White Cube: Territorial Mappings. Exh. cat. Bennington, Vermont: Suzanne Lemberg Usdan Gallery at Bennington College, 1992.

_____. *Don't Look Now.* Exh. cat. New York: Thread Waxing Space, 1994.

Eminent Domain. Program Guide. Chicago: Sculpture Chicago, 1993.

Fox, Judith Hoos. *The Wellesley Method.* Exh. cat. Wellesley, Massachusetts: Wellesley College Museum, 1990.

Fox, Judith Hoos. *The Body as Measure.* Exh. cat. Wellesley, Massachusetts: Davis Museum and Cultural Center at Wellesley College, 1994.

Galloway, Munro, ed. *Performative Objects.* Providence, Rhode Island: Brown University and The Rhode Island School of Design, 1995.

Goncharov, Kathleen. *Exported Pallet.* Exh. brochure. Washington D.C.: United States Information Agency, 1991.

Gumpert, Lynn, et al. *Beyond The Frame: American Art 1960–1990.* Exh. cat. Tokyo: Setagaya Art Museum, 1991.

Harvey, Don. *Kate Ericson and Mel Ziegler.* Exh. cat. Cleveland, Ohio: SPACES, 1990.

Jacob, Mary Jane. *Places with a Past: New Site-Specific Art at Charleston's Spoleto Festival.* Exh. cat. New York: Rizzoli International Publications, 1991.

Jacob, Mary Jane, Michael Brenson, and Eva M. Olson. *Culture in Action: A Public Art Program of Sculpture Chicago.* Exh. cat. Seattle: Bay Press Inc., 1995.

Johnstone, Mark and Tressa Ruslander Miller. *Collaboration.* Exh. cat. Los Angeles: The Bank, 1988.

Kane, Mitchell. *Detail in the Cottage.* Exh. brochure. Chicago: Randolf Street Gallery, 1988.

Kane, Mitchell. *Mud, or How Can Social and Local Histories Be Used as Methods of Conservation?* Exh. cat. Northbrook, Illinois: Hirsch Farm Project, 1992.

Klausner, Betty. *Home Show: 10 Artists' Installations in 10 Santa Barbara Homes.* Exh. cat. Santa Barbara, California: Santa Barbara Contemporary Arts Forum, 1988. Essays by Dore Ashton and Howard S. Becker.

Kliege, Melitta and Annette Teitenber. *Integral.* Exh. cat. Berlin: Neue Gesellschaft für Bildende Kunst, 1993.

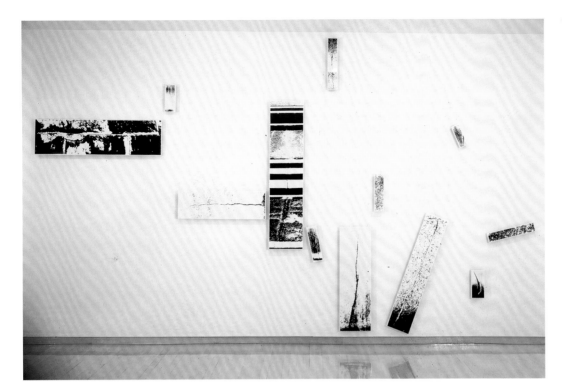

**Things Do Continue to Move
on the Outside**
1987
Porcelain enamel on metal
Twelve panels, various dimensions
Collection of Leonard Rosenberg
and Colombe Nicholas, New York

Kwon, Miwon. *One Place After Another: Site Specific Art and Locational Identity*. Cambridge, Massachusetts: MIT Press, 2002.

Lacy, Suzanne. *Mapping the Terrain: New Genre Public Art*. Seattle: Bay Press, 1995.

Leigh, Christian. *(Of Ever-Ever Land i Speak)*. Exh. cat. New York: Stux Gallery, 1987.

Levin, Kim. *Translation*. Exh. cat. Warsaw: Centrum Sztuki Wspólczesnej [Center for Contemporary Art], 1992. In Polish and English.

Lord, Catherine. *CalArts: Skeptical Belief(s)*. Exh. cat. Chicago: The Renaissance Society at the University of Chicago in association with the Newport Harbor Art Museum, Newport Beach, CA, 1988. Curator Suzanne Ghez.

McShine, Kynaston. *The Museum as Muse: Artists Reflect*. Exh. cat. New York: The Museum of Modern Art, 1999.

Naganashi, Hiroyuki. *Museum as Subject*. Exh. cat. Osaka, Japan: The National Museum of Art, 2001.

Oatman, Michael. *Factory Direct*. Exh. cat. Troy, New York: The Arts Center of the Capital Region, 2002.

Oosterhof, Gosse and Dan Cameron. *Horn of Plenty: Sixteen Artists from NYC*. Exh. cat. Amsterdam: Stedelijk Museum, 1989. In Dutch and English.

Pelenc, Arielle. *Cinquiemes Ateliers Internationaux des Pays de la Loire 1988*. Exh. cat. [Clisson, France]: FRAC, Fondation Regional d'Art Contemporain, 1988.

Phillips, Patricia C. *Investigations 24: Kate Ericson and Mel Ziegler*. Exh. brochure. Philadelphia: Institute of Contemporary Art at the University of Pennsylvania, 1988.

_____. "Public Practice." In *Place, Position, Presentation, Public*, by Jan van Eyck. Exh, cat. Maastricht, Netherlands: Akademie, 1993.

Princenthal, Nancy. *Kate Ericson and Mel Ziegler*. Exh. brochure. New York: Michael Klein Inc., 1992.

Rifkin, Ned. *Works: Kate Ericson/ Mel Ziegler*. Exh. brochure. Washington, D.C.: Hirshhorn Museum and Sculpture Garden, Smithsonian Institution, 1988.

Rifkin, Ned and Phyllis Rosenzweig. *Works*. Exh. cat. Washington, D.C.: Hirshhorn Museum and Sculpture Garden, Smithsonian Institution, 1988.

Ruffner, Ginny. *Glass: Material in the Service of Meaning*. Exh. cat. Tacoma, Washington: Tacoma Art Museum, 1991.

Sangster, Gary. *Living With Art: the Collection of Ellyn and Saul Dennison*. Exh. cat. Morristown, New Jersey: The Morris Museum, 1993.

Shearer, Linda. *Selections from the Artists File*. Exh. cat. New York: Artists Space, 1984.

Slavin, Kathleen. *Projects: Kate Ericson and Mel Ziegler*. Exh. brochure. New York: Museum of Modern Art, 1988.

Sollins, Susan, et al. *Team Spirit*. Exh. cat. New York: Independent Curators Inc., 1990. Essays by Nina Castelli Sundell, Irit Rogoff, and James Hillman.

Tonkonow, Leslie. *Public Discourse*. Exh. cat. Hartford, Connecticut: Real Art Ways, 1988.

Tucker, Marcia, Elaine A. King, Jan Riley, and Robert Shiffler. *Meddlesome & Meddlesome: Selections from the Collection of Robert J. Shiffler*. Exh. cat. Cincinnati, Ohio: The Contemporary Arts Center, 1993.

Weintraub, Linda, Arthur Danto, and Thomas McEvilley. *Art on the Edge and Over: Searching for Art's Meaning in Contemporary Society, 1970s–1990s*. Litchfield, Connecticut: Art Insights Inc., 1996.

Westbrook, Adele. *A Creative Legacy*. New York: Harry N. Abrams, Inc., 2001.

Wheeler, Robert. *The Hidden City Revealed: A Walking Tour*. Cleveland: The Committee for Public Art, 1988.

- -

PERIODICALS AND TEXTS

Alberge, Dalya. "Euro Disney Shown in Artistic Pickle." *The Independent* (3 February 1994).

Allen, Jane Addams. "Hirshhorn's Exaltation of the Truly Ordinary." *Washington Times* (16 March 1988): E3.

Anderson, Michael. "Kate Ericson and Mel Ziegler at Burnett Miller." *Art Issues*, no. 4 (May 1989): 23.

Archer, Michael. "Anomie." *Art Monthly*, no. 157 (June 1992).

Ardenne, Paul. "Ericson & Ziegler: Art, A Sociological Indicator." *Art Press*, no. 176 (January 1993): 30–33, E14–16.

Baker, Kenneth. "Art comes to Santa

Ericson and Ziegler collecting
seeds and roots from the Cleveland
Flats to plant as part of *Viaduct
Gateway project*, 1988

Barbara." *San Francisco Chronicle* (21
September 1988).

_____."Artists in Residences."
House and Garden, (January 1989):
38–39.

Bartelik, Marek. "Translation."
Artforum International 31, no. 4
(December 1992): 106–07.

Bonetti, David. "Joining Peaks and
Valleys." *San Francisco Examiner* (19
March 1991).

Bourdon, David. "Seeing It All, or Six
Weeks in Manhattan Galleries."
Art in America 80, no. 9 (September
1992): 51–61.

Braverman, Sandra. "Seeing Eye to
Eye With Community." *Boston Globe*
(15 April 1990): 9, 11.

Brody, Jacqueline. "Multiples and
Books and Objects." *The Print
Collector's Newsletter* Vol. 10 (Janu-
ary–February 1993).

Broili, Susan. "Sidewalk Artists." *The
Durham Sun* (30 March 1989): D1–2.

_____."Durham Faces Public Art
Issue." *Durham Sun* (2 June 1989): D4

_____."2 Artists Scramble up Side-
walks, Revitalization." *Durham Sun*
(3 June 1989): A1–2

"Business Bulletin." *The Wall Street Journal* (27 May 1993): 232.

"Camouflaged History." *Harper's Magazine* (August 1991): 28.

Canty, Donald J. "Architectural Underground." *Architectural Record* (July 1991): 212–21.

Canogar, Daniel. "La casa herida [The wounded house]." *Lapiz* 9, no. 77 (April 1991): 46–55.

Castaneda, Christine. "Picking Apart the Past." *Charleston Magazine* (May/June 1991).

Cembalest, Robin. "Signature Piece." *ARTnews* 88, no. 2 (February 1989).

Chadwick, Susan. "Conceptual Artists Find New Way To Paint The Town." *Houston Post* (15 November 1987): 11F.

Clement, Melissa. "Public Art in Public Places." *Fayetteville Observer* (1987): E1, E8.

Cleusa, Maria. "Arte em 'Container' na Lapa." *Journal do Brasil* (10 October 1991): B8.

"Collaborative Stars on 45." *Bijutsu Techo* 43, no. 643 (February 1991): 29–90.

Collins, Bradford R. "Report from

Charleston: History Lessons." *Art in America* 79, no 11 (November 1991): 64–71.

Cooper, Dennis. "Kate Ericson and Mel Ziegler–Wolff Gallery." *Artforum International* 26, no. 8 (April 1988): 141–42.

_____."Home Show." *Art Issues* 1, no. 1 (January 1989): 26–27.

Corrin, Lisa and Gary Sangster. "Culture is Action: Action in Chicago." *Sculpture* 13, no. 2 (March/April 1994): 30–35.

Cross, Andrew. "Ericson & Ziegler." *Art Monthly*, no. 174 (March 1994): 17–20.

_____. "Kate Ericson 1955–1995." *Art Monthly*, no. 192 (December 1995/January 1996): 22.

Crossley, Mimi. "Houston Festival." *The Houston Post* (21 March 1980): E4.

_____. "The Public Cathedral." *The Houston Post* (28 March 1980): E3.

_____. "Kate Ericson–Mel Ziegler." *The Houston Post* (11 July 1980): E14.

Crowder, Joan. "There's No Place Like Home." *Santa Barbara News-Press* (9 September 1988): 25–26.

Cullinan, Helen. "Series to explore landscape projects." *The Plain Dealer* (7 May 1990): B18.

De Bruyn, Eric. "Kate Ericson and Mel Ziegler" *Forum International*, no. 14, (September/October 1991).

Decter, Joshua. "Kate Ericson & Mel Ziegler–Wolff." *Flash Art*, no. 140 (May/June 1988): 106–107.

_____. "Ericson and Ziegler." *Journal of Contemporary Art* 2, no. 2, (Fall/Winter 1989): 59–75.

Diaz, Al. "What's With All Those Numbers? New York Artists Jab at 'Ivory Tower'." *The Daily Aztec* (28 April 1989).

Dinoff, Beth. "Places With A Past." *Public Art Review* 3, no. 1 (Spring/Summer 1991): 20.

Dunning, Jennifer. "For 6 Weeks Central Park Is Center Stage." *New York Times* (1 August 1986): C15–18.

Facinelli, Lorie. "'Investigations' Brings Innovative Art To I.C.A.." *Penn Paper* (16 June 1988).

Faverman, Mark. "Elegant Solutions." *Art New England* (December/January 1994): 26.

Fernandes, Cristina. "A Historia

encaixotada." *O Globo* (8 October 1991): 2.

Finger, Bill. "The Politics Of Temporary Installations." *North Carolina Arts* (December 1989): 1–3.

Foster, Stephen. "The Art of Double Glazing." *Punter* (May 1993): 15.

Fox, Catherine and Helen C. Smith. "Spoleto's New Vision." *Atlanta Journal* (19 May 1991): N1, N3.

Freligh, Rebecca. "Green Space at the Old Viaduct." *The Plain Dealer* (1 October 1988).

_____. "'Hidden City' is urban park lure." *The Plain Dealer* (10 May 1990).

"From the Train." *New Yorker* (9 December 1991): 21.

"Fundicao recebe art conceitual dos americanos." *Programa* (4 October 1991): 51.

Gardner, Colin. "Kate Ericson and Mel Ziegler Burnett Miller Gallery." *Artforum International* 27, no. 8 (April 1989): 172.

Gass, Janine. "Denkmal? Denk mal!," *Biel/Bienne* (22–23 May 1991): 2.

Gilson, Nancy. "Exhibit shows 'House Rules' changing in America."

Columbus Dispatch (10 September 1994).

Glueck Grace. "Don't Sit This Out: Home Furnishings Meet Arts and Crafts," *New York Observer* (24 January 1994): 22.

Gorden, Rachel. "No One Drives on These Asphalt 'Streets'." *San Francisco Independent* (5 November 1991): 2.

Graziani, Ron. "Public Art in Private Places." *Santa Barbara Magazine* (November 1988): 53–60.

Greenstein, Jane. "'House Monument' has a Poetic Frame." *Los Angeles Times* (29 April 1986): VI–2.

_____. "A Man's Home Is His Sculpture." *Los Angeles Times* (23 July 1986): Orange County Home Section,1.

Gumpert, Lynn. "Cumulus from America." *Parkett* 29 (1991): 163–69.

Hackett, Regina. "Glass Consciousness." *Seattle Post-Intelligencer* (6 November 1991): C1, C14.

_____. "New COCA exhibit celebrates the gloriously commonplace." *Seattle Post-Intelligencer* (14 July 1995).

Hall, Jacqueline. "New Angles on 'home': '90s cosmetic spaces analyzed, challenged by varied ideologies." *The Columbus Dispatch* (18 September 1994).

Harvey, Don. "The Hidden City Revealed." *Public Art Review* (Issue 5) 3, no. 1 (Spring/Summer 1991): 19.

Hatcher, Thurston. "Spoleto officials: Exhibition a success, Some exhibits may remain in city." *The Post Courier* (28 July 1991): B1, B5.

Heartney, Eleanor. "Combined Operations." *Art in America* 77, no. 6 (June 1989): 140–47.

_____. "Kate Ericson and Mel Ziegler." *Art in America* 82, no. 7 (July 1994): 88–89.

_____. "A Cabinet of Critiques." *Art in America* 87, no. 12 (December 1999): 70–75, 121.

Helfand, Glen. "Objects of Desire." *Artweek* 19, no. 36 (29 October 1988): 4.

Hess, Elizabeth. "Mi Casa Es Su Casa?" *Village Voice* (3 August 1988): 89.

Hillman, James. "Plural Art." *Tema Celeste* (Fall 1991): 52–57.

Hively, Suzanne. "A new twist on sprucing up a park." *The Plain Dealer* (18 October 1990).

James, Merlin. "The Museum as Muse." *Burlington Magazine* 141, no. 1155 (June 1999): 381–82.

Kandel, Susan. "The Lighting Specialists." *Arts Magazine* (April 1989): 110.

Killer, Peter. "Antworten aufs Denkmal: Leise oft verlegen." *Tages Anzeieger* (27 May 1991): 12.

Kimmelman, Michael. "Of Candy Bars and Public Art." *New York Times* (26 September 1993): II–1.

Knight, Christopher. "Artworks That Fill A Corridor Of Modern Ruin." *Los Angeles Herald Examiner* (19 September 1982): E7.

_____. "Los Angeles Art on the Move." *ARTnews* 82, no. 1 (January 1983): 72–75.

_____. "In Santa Barbara Home Is Where The Art Is." *Los Angeles Herald Examiner* (11 September 1988): E2.

_____. "'Specialists' Somewhat Enlightening." *Los Angeles Herald Examiner* (27 January 1989): 40.

Larson, Kay. "The Children's Hour." *New York Magazine* (8 May 1989): 94–95.

Lawrence, Sidney. "'The Conscious Stone' Takes a Rocky Look at D.C.." *The Torch* (April 1988): 6.

Leigh, Christian. "Home Is Where the Heart Is." *Flash Art* no. 145 (March/April 1989): 79–83.

LePalma, Marina. "When The Hammer Breaks." *Artweek* (24 May 1986): 5.

_____. "Kate Ericson and Mel Ziegler." *Village Voice* (3 February 1987): 68.

_____. "Choices." *Village Voice* (21 March 1989).

_____. "Bad Timing." *Village Voice* (6 March 1990).

_____. "Transparent Contradictions: New Glass in New York." *Glass Magazine* (Spring/Summer 1990).

_____. "Choices." *Village Voice* (19 June 1990): 124.

_____. "Collective Conscious: Contemporary Sculpture Collaborations." *Sculpture* (March/April 1991): 33–39.

_____. "Voice Choices." *Village Voice* (4 January 1994): 59.

Lewis, Jo Ann. "Tracking Their Quarry: At The Hirshhorn, A Tour of

Ericson and Ziegler planting seeds at EuroDisney as part of the project *Vinegar of the 48 Weeds*, 1992

the Stones of Washington." *The Washington Post* (9 March 1988): B1–2.

Litt, Steven. "The Public Domain." *Raleigh Times*. (16 June 1989): 3–5.

Luks, Georges. "Die Schwergewichtige Shau wird zur Entdeckungsreise." *Bieler Tagblatt* (25 May 1991): 16–17.

Lyons, Wendy. "The Conscious Stone." *Stone World* (January 1990): 45–55.

Madoff, Steven Henry. "Sculpture – A New Golden Age?" *ARTnews* 90, no. 5 (May 1991): 110–121.

Magalhaes, Neide. "Uma proposta de arte engajada." *Diario da Tarde* (20 November 1991).

Margutti, Mario. "Uma camaleao conceitual." *Journal do Commercio* (10 October 1991): 30.

Maschal, Richard. "Why All The Fuss?" *Charlotte Observer* (9 June 1991): F1, F6.

McCoy, Pat. "(Of Ever-Ever land i Speak), Stux Gallery." *Artscribe International* (January/February 1988): 73–74.

Miller, John. "Kate Ericson and Mel Ziegler at Burnett Miller." *Artscribe International* (April 1989): 86.

Montvidas-Kutkus, Kristina. "'Places with a Past' tries to make sense of chaos." *Charleston News & Courier* (30 May 1991): A5–6

Moore, Holly. "At Home With Art." *Houston Home and Garden* (November 1979): 57.

Moser, Charlotte. "Playing Cowboys and Artists in Houston." *ARTnews* 79, no. 10 (December 1980): 124–128.

Nesbitt, Lois. "Kate Ericson and Mel Ziegler." *Artforum International* 32, no. 9 (May 1994): 104

Nievergelt, Gery. "Stadtwanderers Entdeckungseriese zur Kunst." *Sonntagzeitung* (26 May 1991): 23.

Novakov, Anne. "Kate Ericson and Mel Ziegler, Capp Street Project." *Art Press*, no. 159 (June 1991): 96.

Ostrow, Saul. "Ericson and Ziegler." *Flash Art* 27, no. 176 (May/June 1994).

Padon, Thomas. "Reviews in Brief: Kate Ericson & Mel Ziegler." *New York Review of Art* (April 1994): 15.

Pagel, David. "The Implications Of Small Differences." *Artweek* 20, no. 5 (4 February 1989).

_____. "Kate Ericson & Mel Ziegler."

Lapis Magazine (Summer 1992): 70.

Park, Edwards. "Around the Mall and Beyond." *Smithsonian* (January 1989): 24, 26.

Pener, Degen. "Local Color." *New York Magazine* (17 June 1991): 25.

Phillips, Patricia C. "Stones Have Been Known To Move—White Columns." *Artforum International* 25, no. 6 (February 1987): 119.

_____. "Out of Order—The Public Art Machine." *Artforum International* 27, no. 4 (December 1988): 92–97.

_____. "Public Art: The Point in Between." *Sculpture* 11, no. 3 (May/June 1992): 36–41.

_____. "Kate Ericson 1956–1995." *Public Art Review* 7, no. 2 (Spring/ Summer 1996): 48.

_____. "Critique and Compliance: Artists on Display." *Sculpture* 19, no. 4 (May 2000): 40–47.

Pincus, Robert L. "Artists Mix Art and Life in People's Homes." *San Diego Union* (25 September 1988): E10.

_____. "'Ivory' has artists numbers." *San Diego Union* (27 April 1989): E6.

_____. "Two Artists at S.D.S.U. Go by the Numbers in Exhibit." *San Diego Union* (n.d.): D1, D11.

_____. "Four Artists Look at the Landscape… Sort of." *San Diego Union* (7 May 1989): E1, E8.

Plagens, Peter. "Clinkers to Clevers to Chance." *Newsweek* (14 January 1991): 50.

Rankin, Mary. "Investigations 1988." *Art Matters* 7, no. 10 (July/August 1988).

Rankin-Reid, Jane. "On the verandah." *Artscribe* (November/December 1991): 86.

Ruas, Charles. "Clisson: In the Shadow of History." *ARTnews* 87, no. 10 (December 1988): 79–81.

"Reducing Art Sidewalk to Art Rubble-Editorial." *Durham Morning Herald* (8 June 1989): A4.

Reid, Calvin. "Spoleto USA." *Arts Magazine* 66, no. 2 (October 1991): 104–106.

Relyea, Lane. "Kate Ericson and Mel Ziegler's Open House." *Forehead* 1, no. 1 (Winter 1987): 4–23

"Review." *New Yorker* (11 May 1992): 14.

Rifkin, Ned and Suzi Gablik. "Value Beyond the Aesthetic." *Art Papers* 16, no. 2 (March/April 1992): 26–30.

Robinson, Walter. "Artworld: Obituaries." *Art in America* 83, no. 12 (December 1995): 112.

Sailor, John. "Stones Have Been Known To Move." *Stone World* (September 1987): 70–71, 78–80.

Sebastio, Walter. "Ericson e Ziegler quebram a arte formal." *Estado de Minas* (24 November 1991).

Smith, Emily. "Art for the Public." *Durham Morning Herald* (8 June 1989): B1.

Smith, Roberta. "Kate Ericson and Mel Ziegler at White Columns." *New York Times* (28 November 1986): C28.

_____. "More Women and Unknowns in the Whitney Biennial." *New York Times* (28 April 1989): C32.

Snook, Debbi. "Spaces boldly enters a new era." *The Plain Dealer* (29 December 1990): C1, C3.

Sozanski, Edward. "ICA Hightlights Artists Who are Conceptualists." *Philadelphia Inquirer* (12 June 1988): E1.

_____. "What the Spoleto fuss was about." *Philadelphia Inquirer* (7 July 1991): I1, I6.

Sparks, Amy. "Feed, Seed and wide open spaces." *Cleveland Edition* (27 December 1990): 18.

"Spoleto Patchwork." *The Evening Post* (17 April 1991): 1.

Stapen, Nancy. "The 'Wellesley Method' as seen through 32 eyeglasses." *Boston Herald* (6 May 1990).

Stephens, Richard. "Kate Ericson and Mel Ziegler at Burnett Miller Gallery." *New Art Examiner* (April 1989): 56.

Tanner, Marcia. "Down On The Roof." *Artweek* 22, no. 12 (28 March 1991): 10.

Temin, Christine. "Visions of Vision at the Wellesley College Museum." *Boston Globe* (15 April 1990): A2.

_____. "Wellesley's 'Body' also has a Brain." *The Boston Globe* (23 September 1994): 49.

Tennant, Donna. "Home is Where the Arts Is…" *Houston Chronicle* (22 June 1980): 15.

Teyssot, Georges. "Boredom and Bedroom: The Suppression of the

Habitual." *Assemblage,* no. 30 (August 1996): 44–61.

Thorson, Alice. "Contemporary? Maybe. Beautiful? Absolutely." *Kansas City Star* (2 October 1995):

Utter, Douglas. "Feed and Seed." *Dialogue* (March/April 1991): 20.

Van Houts, Catherine. "Kate Ericson and Mel Ziegler." *Het Parcoal* (14 January 1989): 43.

Van Nieuwenhuyzen, Martijn. "Horn of Plenty-Besides Plenty of Horn, the More Subtle Voices Can Also Be Heard." *Flash Art*, no. 145 (March/April 1989): 102. Translated from the Dutch by Rose Berl.

Vergara, Camilo José, Kate Ericson, Mel Ziegler, et al. "Camilo José Vergara, Kate Ericson and Mel Ziegler, James Casebere, Allan Wexler, Dan Graham." *Assemblage,* no. 24 (August 1994): 20–21, 38–39, 76–77, 94–95.

Vinzant, Carol. "Eclectic Exhibit Investigates Art Frontiers." *The Summer Pennsylvanian* (16 June 1988).

Volk, Gregory. "Kate Ericson and Mel Ziegler—Michael Klein." *ARTnews* 93, no. 4 (April 1994): 171.

Welchman, John. "Cal-Aesthetics."

Flash Art, no. 141 (Summer 1988): 106–08.

"Wexner Center Presents Social Constructions and Electronic Game by Artists." *Flash Art* 27, no. 177 (Summer 1994): 35.

Wilson, William. "Radical Things Are Happening In Orange County." *Los Angeles Times Calendar* (28 February 1988): 93–96.

Woodard, Josef. "Home Is Where The Art Is." *Santa Barbara Independent* 2, no. 94 (8–14 September 1988): 30–36.

Yarrow, Andrew. "14 Reasons Why New York Is New." *New York Times* (3 October 1986): C28.

Yngvason, Hafthoe. "The New Public Art, As Opposed To What?" *Public Art Review* (Winter/Spring 1993): 4–5.

Zimmer, William. "Real Art Way in Hartford Celebrates 15 Years of Innovation." *New York Times* (3 January 1991): C20.

ACKNOWLEDGMENTS

KATE ERICSON AND MEL ZIEGLER BUILT AN INSPIRING HOUSE OF work over almost two decades of collaboration. From early site-specific sculptures that utilized stone walls and front lawns though exhibitions made of period wainscoting, interior lighting, cabinet doors, and fine dinnerware, to public art projects that involved re-painting and re-roofing in ways never before imagined, their work together inspired us not only as curators, but as citizens and people. Memories of their important interventions into diverse communities are now seamlessly part of each locale, and are an indelible part of our lives as fans, friends, and now collaborators. To be invited in to examine the wealth of ideas contained in the artists' archives provided a thrill of discovery that not only opened our eyes but our hearts. Photographs, letters, transcripts, newspapers, slides, paint charts, and hundreds of drawings and sketches revealed a story that impressed upon us the importance of making this touring exhibition and catalogue a reality.

We have shared the labor of this endeavor with many and have a long list of thanks. First we extend our appreciation to Mel's home team in Austin, Texas: his wife Lisa Germany, and sons Atticus and Phineas Ziegler, who shared their dad with us for the past few years while we organized this extensive project. Several lenders have generously offered us access to their works and have helped us as we fashioned the exhibition's tour. Thanks to Robert Shimshak, Berkeley, California; University of California, Berkeley Art Museum; Microsoft Art Collection, Seattle, Washington; Mel Ziegler, Austin, Texas; Amy Lipton; Barbara Broughel; Museum of Contemporary Art, San Diego; Jack and Nell Wendler Collection, London; Themistocles and Dare Michos, San Francisco; Michael and Leslie Engl; and The Frances Young Tang Teaching Museum and Art Gallery at Skidmore College.

An exhibition and publication of this scope requires a supportive community and we are most grateful to the foundations and agencies that assisted us with our project. Thank you to the National Endowment for the Arts, a federal agency; the Peter Norton Family Foundation; The Judith Rothschild Foundation (given in recognition of Kate Ericson); and the Elizabeth Firestone Graham Foundation.

This project is a collaboration between The Frances Young Tang Teaching Museum and Art Gallery at Skidmore College and the List Visual Arts Center at the Massachusetts Institute of Technology, and we would like to thank the boards of trustees, advisory committee members, and members and friends of both institutions for supporting our work. Special thanks to John Weber, Dayton Director of the Tang, and Jane Farver, List Visual Arts Center Director, for their support of our collaboration. They stood with us to champion the works of Ericson and Ziegler at many points along the way, and we appreciate their continued encouragement.

At the Tang Museum thanks to the entire staff including Ginger Ertz, Lori Geraghty, Susi Kerr, Gayle King, Barbara Schrade, and Kelly Ward who have provided great support, as have student interns Laura Beshears, Laura Champi, Justin Hirsch, Miles Montgomery-Butler, Meredith Mowder, Kylie Paul, Annie Powers, Leah Wohl-Pollack, and Caitlin Woolsey. Also thanks to Laura Cocas, Gabriel Einsohn, and Theron Russell for their assistance. Several members of the Tang staff labored above and beyond the call of duty to prepare this extensive exhibition. Head of Installations Nicholas Warner and acting Assistant Preparator Torrance Fish worked long hours to carefully install the works with expert assistance from Sam Coe, Abraham Ferraro, Dan O'Connor, Cynthia Zellner, and former Chief Preparator Chris Kobuskie. They deserve great thanks for their attention to detail with fabrication as we prepared for this exhibition and its initial installation.

At the MIT List Visual Arts Center thanks to the staff for all their help and guidance on this project including David Freilach, Patricia Fuller, Barbra Pine, Hiroko Kikuchi, John Osorio Buck, and Tim Lloyd. Also at MIT, Stacie Slotnick and Caroline Jones gave us valuable feedback at many stages along the way. Thanks to the many interns and volunteers at the List who worked on all aspects of this project: Jessica Gath, Claire Grace, Amy Sunners, Anna Lovecchio, Amy Louise Brandt, Christophe Perez, Daniel Gallagher, Katherine O'Conner, Sarah Schoemann, Maria Vittoria Martini, Eenah Eoh, Jae Rhim Lee, and Elizabeth Wing. Special thanks to Jeremy Chu, who was the most tenacious researcher Bill has ever seen, and was very helpful in dealing with the

plethora of arcane topics covered by Ericson and Ziegler.

Among our many wonderful colleagues we would like to specially thank List Registrar John Rexine and Tang Registrar Elizabeth Karp for their hard work in organizing all the pieces, arranging for proper shipping for the tour, and handling the artwork and conservation details with such grace. Thanks to Patrick O'Rourke, Tang Designer, who not only worked on exhibition signage and installation texts, and scanned hundreds of the artists' images, but also created the two flatscreen animations that survey the artists' work in the gallery. Also special thanks to Ginny Kollak, Tang Curatorial Assistant, who researched and drafted texts for us along the way and helped immensely with her great editing of catalogue texts. Her work is critical to this project and we thank her for her great spirit of teamwork, commitment, and hard work.

Our colleagues at the Austin Museum of Art signed on as a venue as soon as they learned of our initial plans and we are most grateful for their steadfast excitement and recognition of Ericson and Ziegler's work. Thanks to Dana Friis-Hansen, Director and Andrea Mallard, Exhibition and Education Assistant. Thanks to Linda Shearer, Director, and Matt Distel, Associate Curator at the Cincinnati Contemporary Arts Center and Raechell Smith, Director of the H&R Block Art Space at the Kansas City Art Institute for hosting the project at their institutions.

This extensive and beautiful publication is the first of its kind for Ericson and Ziegler and we are most grateful to the team that helped create it. Our sincere gratitude to the entire staff of The MIT Press, our co-publishers, especially Roger Conover, Editor, and staff members Erin Hasley, Marc Lowenthal, and Janet Rossi. Our designers Barbara Glauber and Beverly Joel of Heavy Meta guided our production with perfect solutions at every step in the process. They succeeded in utilizing some of the artists' conceptual processes in their exquisite design. Sandra Colosimo and her team at Conti Tipocolor in Florence, Italy were great collaborators in printing and binding the book. Special thanks to our friends and fellow curators Judith Hoos Fox, Kathleen Goncharov, Mary Jane Jacob, Patricia C. Phillips, Lane Relyea, Ned Rifkin, Valerie Smith, and Judith Tannenbaum for their revealing and moving testimonies, and to Jen Mergel, Tang intern, who deserves special thanks for her research and compilation of the artists' biography, exhibition history, and bibliography. Thanks to the many photographers whose work graces the pages of this book, and to Jay Rogoff for his vigilant and timely editing of all the texts.

In addition to the lenders and authors previously listed, many friends and colleagues freely shared their practical information, unique insights, and memories of Ericson and Ziegler with us. Thanks to Polly Apfelbaum, John Baldessari, Suzanne Bocanegra, Barbara Broughel, David Cabrera, Mel Chin, Lisa Corrin, Mark Dion, David Gray, Renee Green, Susan Harris, Michael Klein, David Lange, Simon Leung, Amy Lipton, Joe MacDonald, Ed Mayer, Michael Oatman, Patrick Owens, J. Morgan Puett, Stephen Prina, Leonard Rosenberg, Joe Scanlon, Linda Shearer, Leslie Tonkonow, Andrew Witkin, and Jamie Wolff.

Thank you also to our colleagues at other museums who helped arrange access both to potential loans and archival materials: Amy Ruffo at the John Michael Kohler Arts Center; Lisa Calden at the University of California, Berkeley Art Museum; Laura Matzer at the Microsoft Corporation Collection; and Heidi Jacobson Zuckerman, formerly of the Berkeley Art Museum and Pacific Film Archive.

We speak for all the individuals who worked with us when we say that this endeavor was driven by a great love and admiration for the works of Kate Ericson and Mel Ziegler. We save our most heartfelt thanks for Mel, who not only introduced us to each other at the outset of this project, but who guided us through his and Kate's life with a calm confidence that pushed us to work hard to get it right. Each of our projects involves creating relationships between artists and curators, but this experience feels more like the forming of an extended family, with all of the bonds that accrue by way of a common mission. We are honored by Mel's trust and pleased to see our names alongside his. At Mel's suggestion we dedicate our work to the memory of Kate Ericson. The inspirational stories we heard around the table and the transformative influences we witnessed out in the world are her greatest testimony.

Ian Berry and Bill Arning
Curators

opposite
House Monument
1986
Construction view,
Costa Mesa, California

THE CULMINATION OF THIS EXHIBITION AND CATALOGUE IS A bittersweet moment for me. I wish Kate could be here to share this accomplishment. I can only have faith that in some spiritual way she is present and, I am sure, very pleased. Thank you, Kate, for a wonderful and productive eighteen years of my life.

I have nothing but the utmost respect for Bill Arning and Ian Berry. These two curators have put a tremendous amount of work into this exhibition and catalogue. After several three-day visits to my studio to look through archives and sitting through a twelve-hour slide lecture of our work I could begin to sense the intensity of Bill and Ian's belief in the historic importance of this project. All artists can only hope that the love of making art meets up with the love of preserving it. This was a perfect match and I thank Bill and Ian for their passionate belief in Kate's and my work, their commitment to it, and the excellent and considerate job they have done on both the exhibition and catalogue.

I would also like to thank the Tang and the List, and their respective directors, John Weber and Jane Farver, for agreeing to take this project on. I particularly want to offer special thanks to John for his work on the interactive website, and the staff and crew of the Tang for their work editing, repairing, and fabricating at the originating venue—they are by far one of the best installation crews and staff I have ever worked with.

Without the many supporters of our work over the years, some of whom have written for this catalogue, our careers would not have been so productive. So much is owed to those who shared and in essence collaborated with us on projects and exhibitions, this includes our many gallery representatives, but especially Michael Klein and David Gray, our loyal collectors, our many supportive friends and the many people behind this exhibition and catalogue already acknowledged by Ian and Bill.

I want to thank the University of Texas at Austin for several research grants that helped in archiving and preparation of this project; Leona Scull-Hons for her careful attention to listing and organizing the Ericson and Ziegler research files; and Myranda Bair, my current assistant, who diligently helped complete the work needed for this exhibition.

A special thank you to my dear friend, my wife, and my love, Lisa Germany. This was a difficult time for me, revisiting these files, these memories, and these stories. Thank you, Lisa, for your devotion, your support and understanding of this long and emotional process.

Mel Ziegler

215

front cover
Camouflaged History
1991
Spoleto Festival U.S.A., Charleston,
South Carolina, 1991

back cover
MoMA Whites
1990
Paint, sandblasted glass jars,
metal shelf
10 x 56 x 5 inches
Private Collection

Eight glass jars are filled with the
various white paints preferred by
curators at the Museum of Modern Art,
New York. The name given to each paint
by the museum preparators was
sandblasted onto the jars. From left to
right the jars read; Clemente White,
Decorator White, High Hide White,
Linen White, McShine White, Photo
White, Riva White, and Rubin White.

page 2
Signature Piece
1988 (detail)
Museum of Modern Art, New York,
New York, 1988

page 6–7
Kate's pasture, Milanville,
Pennsylvania

endpapers
Travel slides by Kate Ericson and
Mel Ziegler

above
View of Ericson and Ziegler's
studio/home in Milanville,
Pennsylvania

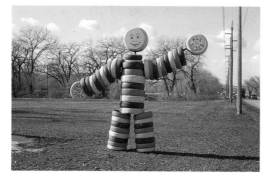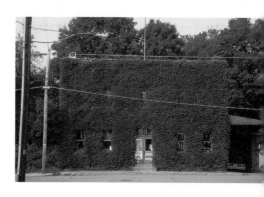

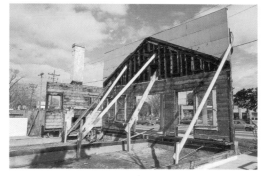

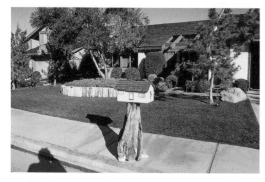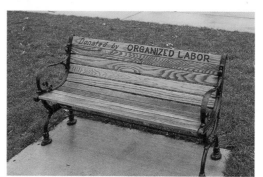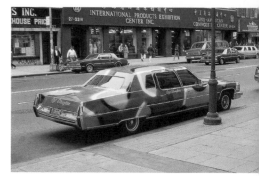